TRADITIONS AND REVISIONS

Themes from the History of Sculpture

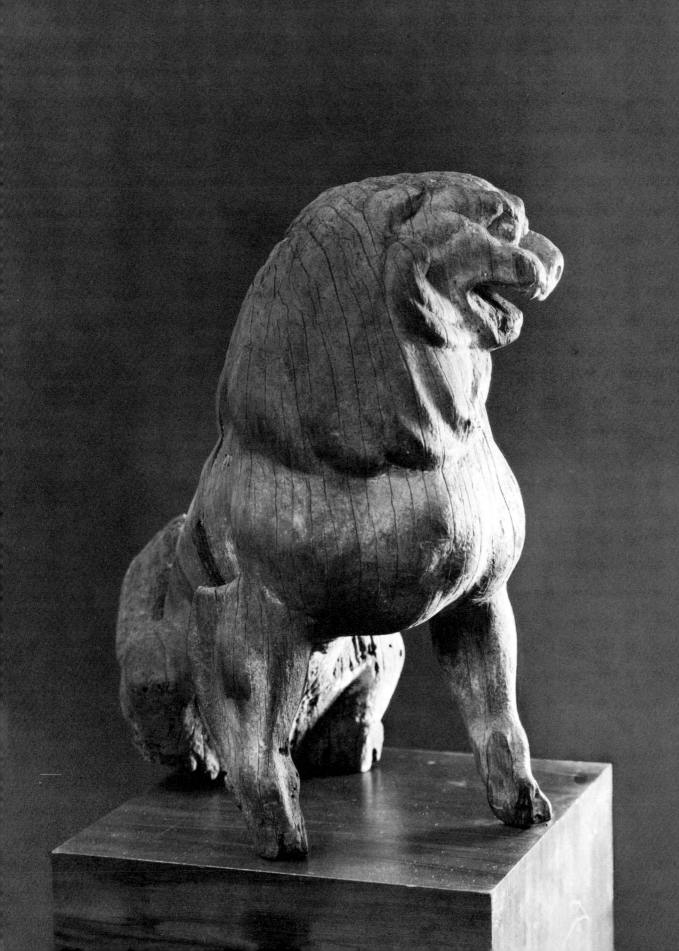

TRADITIONS AND REVISIONS
Themes from the History of Sculpture

Text and Catalog by Gabriel P. Weisberg
Curator of Art History & Education, The Cleveland Museum of Art

Introduction by H. W. Janson
Professor, Department of Fine Arts, New York University

The Cleveland Museum of Art

The publication of this catalogue is partially supported
by a supplementary grant from Case Western Reserve University.

Frontispiece: **84** *Kara-shishi ("China Lion")*, wood, originally colored,
Japan, Kamakura Period, 1185-1333.

Distributed by The Kent State University Press, Kent, Ohio 44242.

© by The Cleveland Museum of Art
University Circle, Cleveland, Ohio 44106
Typesetting and Printing by Great Lakes Lithograph Company, Cleveland, Ohio 44109.
Designed by Merald E. Wrolstad.

Library of Congress Cataloging in Publication Data

Cleveland Museum of Art.
 Traditions and revisions: themes from the history of sculpture.

 An exhibition held Sept. 23-Nov. 16, 1975, as part of a joint
program in art history with Case Western Reserve University.
 1. Sculpture—Themes, motives—Exhibitions. I. Weisberg,
Gabriel P. II. Janson, Horst Woldemar, 1913- III. Case Western
Reserve University. IV. Title.
NB16.C55C553 1975 730'.074'017132 75-26708
ISBN 0-910386-23-4

iv

Contents

Foreword

Baudelaire's *The Salon of 1846* contains a notorious chapter, "Why Sculpture Is Boring," equating sculpture with "Carib art"—that is, primitive art incapable of "profound thought." I suppose the substantiality of sculpture really disturbed the evanescent dreaming of Baudelaire and his fascination with the pictorial images of painting, so close to, and yet so far from, dreams. The substantiality of sculpture would seem to make it particularly appealing to the substantial bourgeois—and yet it was not, and is not. If we think of the Frick Collection, of the National Gallery, and of many more of our art museums, we must think of painting. American museum collections are generally deficient in sculpture, partly because of its very weight and substance—which make transport difficult—but mainly because of the greater appeal of painting to innocent eyes and subtle eyes alike.

This deficiency is historically grotesque when we recollect the achievements of ancient, medieval, and modern artists, whether in East or West. The sites of popular pilgrimage—Angkor, Lung Mên, Athens, Chartres, The Medici Chapel, Watts—are sculptural sites. Granting that the smaller units in the universal fabric of sculpture are not comparable to such great sites, the still accepted "boringness" of sculpture is nevertheless a curious anomaly. Anyone who doubts its existence need only look at the number of purchases on the art market—which are, as duly recorded, lengthy for painting and bibelots but minimal for sculpture—and also compare the prices themselves, which for sculpture are mere fractions of those recorded for pictorial and decorative arts.

Despite this, or because of it, The Cleveland Museum of Art has made a conscious effort to develop its sculpture collections, and one happy result of this effort is Traditions and Revisions: Themes from the History of Sculpture. This exhibition is an attempt to display works of sculpture from the Museum's permanent collection outside of their cultural-historical context and to revel in a festival of sculpture, understood as an art form in its own right, with its own assumptions and its own achievements.

Such a use of the permanent collections of any art museum is becoming more and more appropriate and is being practiced both by choice and by necessity. The choice is made because museums realize that the elucidation of their collections often requires more than just adequate labeling. In 1965 the Cleveland Museum presented an exhibition called Juxtapositions, organized by what was then called the Department of Education. Drawn entirely from the Museum's own collections, it revealed similarities, contrasts, and differences in pairs of juxtaposed works of art, supported by germane literary quotations. The surprise, even shock, of the spectator was enhanced by seeing previously familiar works in new contexts. Many pieces were seen as if for the first time. These brief encounters outside the basic organization of the Museum collections are a creative and worthwhile educational device.

Necessity increasingly participates in the decision to hold special exhibitions drawn from the permanent collection because of the soaring costs and risks of loan exhibitions composed of materials from outside the Museum. It is no longer possible to afford or to justify many loan exhibitions unless they make a real contribution to knowledge incapable of being made any other way. And it is probably too early to adopt any definitive opinions on the use or abuse of international exhibitions of works of art for foreign policy or business purposes. Obviously there have been some extremely fruitful exhibitions of this type in recent years. But one should not forget the dangers implicit in this category of loan exhibitions. This is all the more reason to make people aware of the extraordinary treasures in their own backyards.

Finally, this exhibition catalog has been made possible by a generous special grant-award from Case Western Reserve University, as part of its support of the Joint Program in Art History which it shares with this Museum. The happy co-existence of CWRU and CMA as cheek-by-jowl neighbors in University Circle made it possible in 1965 to begin a formal joint program, with curators teaching as adjunct professors and university faculty teaching in the Museum's new Educational Wing. There are inevitable problems and tensions in such a program. If curators believe that professors study and teach the history of slides and photographs, then professors believe that curators subscribe to a kind of unthinking osmosis between original works of art and students. But the gaps in understanding are narrowing from year to year, and the present "sculpture semester" with H. W. Janson as visiting professor and contributor to this catalog and exhibition—as well as with the other sculptors, lecturers, special courses, etc.—is a very real achievement and gives much impetus to the further development of the joint program. University students, Museum members, and visitors will all benefit from this festival of sculpture and will discover that the medium is not boring, but lively—certainly not dead, but very much alive.

Sherman E. Lee, Director
The Cleveland Museum of Art

Preface

The purpose of Traditions and Revisions: Themes from the History of Sculpture is to show sculpture in new relationships, removed from historical sequences, in order to examine basic themes that have been universally used since sculptors first began to carve during prehistoric times. Sculptural examples, arranged in thematic groups and drawn from the permanent collection of The Cleveland Museum of Art, have been selected from Eastern and Western cultures. They have been placed in close proximity to one another in order to show the same timeless category from different parts of the world. Occasionally new relationships emerge from such juxtapositions as one sculptural grouping leads into the next, reiterating a continual quest to find motifs that can be reinterpreted by succeeding generations.

By using examples from the Museum's permanent collection and placing them within a temporary exhibition, it is possible to see whether claims for universal themes can be supported by the works themselves. If categorical sub-divisions are supportable, then it can be useful to see how these basic concepts can be permanently used, increasing, through this process, our understanding of sculpture as an art form.

This exhibition has been arranged with first emphasis on "The Single Form": the nude, the seated figure, the columnar figure, the figure in motion, and the caryatid. Purposes for which the examples were created are suggested and relationships with other categories noted. In subsequent thematic areas—"The Group Arrangement," "The Portrait," or "The Relief"—sculpture is extended into subject areas not at first as apparent as were monuments dedicated to a single individual.

In addition to these divisions are categories which show how sculptors have reacted to other forms of life, real or imagined—namely, animals and monsters. The remaining themes are more difficult to assess: "The Mask" is studied as an example of sculpture, and newer categories, most appropriate to the modern period— "The Self-Contained Fragment," "The Environment," and "The Abstraction"—are also presented.

Once the complexity of these juxtapositions is clarified, the narrow historical restrictions frequently imposed on sculpture will appear removed. An important aid in this process is the introductory essay to this catalogue prepared by H. W. Janson, visiting professor for the fall semester 1975 in the joint program between the Museum and Case Western Reserve University. Dr. Janson traces the historical vicissitudes in Western civilization's attitude toward sculpture and in doing so achieves his stated purpose: to stimulate our

awareness of the qualities which set sculpture apart from other art forms and may relate one piece of sculpture to another. It is hoped that this exhibition will attain the same goal.

Gabriel P. Weisberg
Curator of Art History and Education

Introduction: About Sculpture

Traditions and Revisions: Themes from the History of Sculpture has a novel—and unique—purpose that may not be immediately evident: its frame of reference is neither style nor subject matter but the specific qualities which set sculpture apart from the other visual arts. It invites the beholder to become aware of these qualities, to think about sculpture as something to be judged on its own terms rather than on those it shares with painting and drawing. The following remarks are meant to stimulate this awareness, and to explain why it is needed.

In present-day parlance, sculpture is an "art form," it being understood that "art" refers to a class of objects whose core is the "fine arts" of painting and sculpture but which also covers the "minor," or "decorative," or "applied" arts such as jewelry, ceramics, furniture, and textiles, insofar as their aim is beauty rather than mere utility. That the "fine" in "fine arts" serves as a somewhat awkward synonym for "beautiful" is evident from the equivalent terms in the other Western languages—*les beaux-arts, le belle arti, las bellas artes, die schönen Künste*. Architecture shares the fate of the other applied arts, in that it may be excluded from the fine arts or art (as in *The Art and Architecture of Italy*). Even though it is clearly not a minor art, its aim has traditionally been threefold: stability, usefulness, and beauty, with the order of priority governed by the purpose of the structure. Aesthetic ambition, we presume, is what distinguishes architecture from mere building, but this ambition is always circumscribed by the demands of stability and usefulness. When we speak of art, then, we mean what we find in art museums—painting and sculpture, along with a sampling of the more ambitious decorative arts, often including architectural fragments (ornamental carvings, doorways, sometimes whole rooms).

Why should beauty be the distinguishing mark of the fine arts? Is beauty not equally the goal of all the other arts as well? Are poetry, music, or the dance less concerned with it? No one would seriously advance such a claim today, yet our terminology implies it, reflecting (we must assume) an older and by now outmoded attitude. When did this attitude originate, and how did it come about? Words are the tools of thought, hence it is always instructive to inquire into the history of their meaning.

The oddity of the special link between art and beauty becomes even more apparent when we consider the term "museum." It means, of course, the home of the Muses. There were nine of them, each with her own domain, but none had anything to do with the fine arts.

They reigned, rather, over what we, following the Greeks and Romans, still call the liberal arts or the arts and sciences. Originally, a museum was a scholar's study, which might contain, besides books, other things related to the pursuit of learning, such as rare shells, fossils, or ancient coins and gems. Until about two hundred years ago, an art museum would have been unthinkable, not only because the Muses were not concerned with art, but because the very concept of art as we know it today had not yet been coined. When Vasari, in the mid-sixteenth century, wrote his famous *Artists' Lives*, he could not call them that, since the term "artist" did not then mean what it does to us; he had to title his work *The Lives of the Most Excellent Painters, Sculptors, and Architects*. Until modern times, then, art did not exist. Instead, there were "the arts," divided into the liberal arts (that is, those which the ancient philosophers had declared suitable for free men) and the mechanical arts or crafts, based on manual skill rather than theory. Painters, sculptors, and architects belonged to the latter, inferior class, and stayed there until the Renaissance. Not until then did they begin to aspire to liberal-arts status. The most famous of them, such as Leonardo, Michelangelo, and Raphael, were credited with "genius," an attribute hitherto reserved for poets, and with the ability to "create" rather than merely "make," thus emphasizing their superhuman qualities. Many artists learned Latin and acquired a literary culture; some wrote poetry, others produced autobiographies, *Lives*, and treatises on perspective or other theoretical aspects of their art. The traditional apprenticeship method of training gradually gave way to a new system, the academy, which combined manual and theoretical instruction. Yet the artist's rise in status was slow and uneven. His claim to a place among the liberal arts might be asserted by poets and scholars, but the philosophers, like their Greek and Roman predecessors, showed little interest in him or his work. Aesthetics as a systematic inquiry into all the arts was not conceived until the mid-eighteenth century, the Age of Enlightenment. Only then were painting, sculpture, and architecture grouped together in a single category, the fine (actually, as we have seen, the beautiful) arts, in order to distinguish them as a particular family among all the arts that the aesthetician claimed for his domain. And the museum of fine arts, or art museum, followed soon after, both as a term and as an institution.

But we still need to understand the peculiar choice of the adjective in "fine arts." We can see why the more neutral term "visual arts" might have been thought

1

misleading, since theater and the dance are also visual; yet "beautiful," which seems even more misleading, was accepted without cavil. Apparently beauty, to the philosophers of the Enlightenment, meant first of all visual, physical beauty, and more especially the beauty of the human body. Thus understood, beauty could indeed be proclaimed the specific goal of the fine arts in the age of the Greek Revival. Even architecture could be seen as deriving its beauty from that of the human form; was it not based on the scale and proportions of man's body, and did not the Ancients themselves view it in anthropomorphic terms? But if the human body was the primary source of the concept of the Beautiful, then the art that exemplified beauty most fully and directly was sculpture, not only because it shared the three-dimensionality of actual bodies, but because bodies, human and animal, had been the sculptor's chief concern since time immemorial. The architect, in contrast, could draw only indirect inspiration from the body beautiful, and the painter dealt with man's environment as much as with man himself. Moreover, had not the Greeks' cult of beauty found its most perfect expression in sculpture? And did not Greek sculpture, as Winckelmann maintained, mirror the superior physical (and spiritual) beauty of the Greeks themselves? No wonder that in the days when the concept of the fine arts originated, sculpture was the most prestigious member of the triad, the fine art *par excellence*. The Italian sculptor Antonio Canova (1757-1822) became the most famous artist of the Western world in his lifetime, and Napoleon is reported to have exclaimed, "If I weren't a conqueror I would wish to be a sculptor."

Never before had sculpture enjoyed such high regard. Among the Ancients, the fact that the sculptor's work involved harder physical effort and more dust and dirt than the painter's gave rise to such remarks as that of the Roman philosopher Seneca: "Although we admire the statues of the gods we despise their makers." The painter was viewed as closer to being a gentleman than the sculptor; Alexander the Great might cede his mistress to Apelles but bestowed no such token of his appreciation on Lysippus. This less-favored status did not keep the sculptors of classical antiquity from creating what is surely one of the most splendid achievements in the history of art. Whether the Ancients were right in according greater esteem to their painters we shall never know, since so little of classical painting has survived.

With the advent of Christianity a different danger, far more serious than low social status, came to threaten the sculptor: the early Church, mindful of the Biblical injunction against graven images, regarded any statue as a potential idol. In consequence, monumental sculpture soon disappeared altogether; only reliefs,

preferably low and of small size, were tolerated. Not until the eleventh century did sculpture on a large scale reestablish itself, although to some churchmen it remained suspect even then. What made the new development possible was the sculptor's subordination to the architect: stone carvings quite literally began to sprout from the interior and exterior surfaces of the house of God, lending a more direct, tangible reality to Christian doctrine. It was this immediate sensory appeal to the layman that accounts for the extraordinarily rapid growth of monumental sculpture at the time of the Crusades. The great High Gothic cathedrals of thirteenth-century France, such as Amiens and Reims, demanded enormous numbers of statues and reliefs, produced by vast workshops; and the style of these sculptures, despite the formal discipline imposed by their architectural framework, soon reached a degree of realism far beyond the capacity of any painter of the period. Painting caught up only around 1300, when Giotto created the pictorial equivalent of Gothic sculpture. Without it, his achievement would have been unthinkable.

Still, Gothic sculpture remained an "applied art," unable to cast off its dependence on architecture and thus to recapture the freedom of classical antiquity. Nor did the medieval sculptor have a distinct professional identity; he was part of a workshop organization whose membership ranged from the simple stonemason at the bottom to the master architect at the top. It took a revolutionary step to break this bond, and that step was taken in Florence soon after 1400 by Donatello, the founding father of Renaissance sculpture. He not only revived the free-standing statue, banished since the end of antiquity, but the sensuous beauty and expressive power of the nude human body, coining a new image of man for a new era. Once again, as it had been two centuries before, sculpture was in the lead—but only for a few decades. Renaissance painters quickly adopted the new image of man, along with another revolutionary discovery, scientific perspective, which had been worked out by the architect Brunelleschi as a rational method of projecting space on a flat surface. Thus armed, the painter could claim the entire visible world for his province; indeed, he insisted that his was the surest way to gain knowledge of that world. Such was the attitude of Leonardo da Vinci, the artist-scientist, in asserting the superiority of painting over sculpture—whatever the sculptor can do, the painter can do as well, and an infinity of other things besides. The sculptor's greater physical effort is no match for the superior intellectual effort of the painter, which makes his art the more truly "liberal."

Leonardo's *Paragone* ("comparison") that sets forth these views was followed by similar discourses on the rivalry of the two arts, almost all of them heavily

weighted in favor of painting. The counter-argument—that sculpture produces a reality while painting only creates an illusion—counted for little so long as the discussion centered on the range of the two. The Renaissance painter also enjoyed yet another, and crucial, advantage: he was far less dependent on commissions. Because of the modest cost of his materials he could, if he wanted, afford to produce pictures not for specific patrons but "for the market," in the expectation of finding buyers later on, often with a dealer as intermediary. By the seventeenth century the trade in paintings had become a major business, and while it exposed the artist to new risks—the public's taste is proverbially fickle—it also gave him, within limits, more freedom to do as he pleased. The sculptor, in contrast, continued to depend, as he had for centuries past, on the patronage of Church and State. To do large-scale statuary "on speculation" would have meant a ruinously high investment in stone or bronze. His domain was churches, palaces and their gardens, and public squares, for which he provided altars, tombs, niche statues, architectural sculpture, fountains, and monuments to sovereigns. All of these, needless to say, were done "to order"; they had to fit into predetermined locations and to serve the needs of the patron. The same patrons also collected ancient sculpture, but these "classics," such as the *Laocoön Group* or the *Apollo Belvedere* (to mention two of the most famous) belonged to a different realm: they were venerated as embodiments of an aesthetic ideal, undisturbed by the exigencies of time and place. Winckelmann, in the mid-eighteenth century, urged every modern artist to imitate these masterpieces if he wanted to achieve greatness, and Canova followed his advice. To him, the "ancient classics" revealed the true nature of the sculptor's calling. If the modern sculptor was to escape from his condition of subservience, he had to create "modern classics," works that demanded to be judged on a basis of equality with the *Laocoön* and the *Apollo Belvedere*, that is, monumental sculpture done on the artist's initiative rather than on commission, in the hope that critical acclaim would eventually attract buyers. But how to overcome the barrier of expensive materials? Canova found a way: he modeled his statues in clay, made a plaster cast of the clay original (which perished in the process), and then exhibited this plaster "ghost," of which the buyer would have replicas made in marble or bronze. The neutral quality of the plaster, far from being a handicap, actually stressed the resemblance of Canova's sculpture to the "ancient classics," since these were being constantly reproduced in the same material.

Canova, then, redefined sculpture—its style, its technique, and its very purpose—and he did so at a time of revolutionary change in Western society, when the traditional sources of sculptural patronage were beginning to run dry. Little wonder that he achieved such enormous authority as a role-model for the other sculptors of his day, and that sculpture in the age of Neo-classicism became the fine art *par excellence*. But its triumph was to be short-lived. In 1846, less than a quarter century after Canova's death, the young Baudelaire published a famous essay, "Why Sculpture is Boring," in which he revived the old *Paragone* arguments in favor of painting and added some new ones of his own. Sculpture, he contended, was in essence a primitive, simple-minded art, fit only to be subservient to a larger whole, as it had been in the past (he cites the Gothic cathedrals); now that it had lost this life-sustaining framework, it tended to revert to the level of the fetish or, at best, to become a mere travesty of the masterpieces of the Greeks. The most revealing passage of Baudelaire's essay concerns the sculptor's inability to control the response of the beholder. Since he can predetermine neither the lighting nor the angle of view, his work is quite likely to produce effects contrary to his intentions, while a painting makes the viewer see only what the artist wants him to see, and in the exact way he wants him to see it. By thus charging sculpture—not just the sculpture of his day but all sculpture—with a failure of communication, Baudelaire betrays his characteristically Romantic sensibility; if the arousing of emotions is assumed to be the highest—indeed, the only valid—goal of art, then the solid physical "thingness" of sculpture, the multiple and varied ways it can be experienced, may seem a crucial shortcoming. Sculpture simply was not subjective, not tentative enough to interest Baudelaire, that ardent admirer of Delacroix. Moreover, Romanticism expected every true artist to be a misunderstood genius, a "glorious failure," and sculptors inevitably found it more difficult than did painters or poets to live up to this bohemian ideal. Baudelaire's negative view of sculpture, then, was very much in tune with the most advanced critical opinion of his time. Sculpture survived this assault, as it had earlier ones, and in fact produced a good deal of adventurous and fascinating work during the middle third of the nineteenth century, even if the full extent of it is being rediscovered only today. It was the sculptors whom Baudelaire so despised that laid the groundwork for the rise of Auguste Rodin, whose achievement redeemed sculpture from its low estate—so much so, indeed, that by the year 1900 he had become the most famous living artist. Rodin is at once the last heir of Canova and the founding father of twentieth-century sculpture. Thanks to him, sculpture has shared fully in the growth of the modern movement during the past seventy-five years. Some of the great leaders of that movement, notably Matisse and Picasso, have been equally important as sculptors and

painters. The *Paragone* tradition, with its invidious comparisons, has at long last been laid to rest.

This thumbnail sketch of the role of sculpture in our cultural tradition since the Greeks brings out several points relevant to the present exhibition. Ever since Winckelmann, art historians have tended to assume that the history of art is essentially the history of styles, and that the same period style manifests itself simultaneously in all the fine arts at a given time and place, since it springs from the unique "personality" of the civilization which produced it, just as an artist's individual style expresses his personality. If this were true, it would mean that architecture, painting, and sculpture have been marching through the centuries in a kind of lockstep. At first glance, they may indeed appear to do so, but the closer we look, the less disciplined the lockstep of the arts turns out to be. It is not that sculpture alone is out of phase with the other members of the triad—they all seem to be out of phase with each other, even though they are also interdependent. The history of each has a far greater degree of autonomy than we have been in the habit of admitting, so that their relationship might be likened to a dialogue, or to the competing voices of polyphonic music. If we venture a more up-to-date simile, we could think of the history of art as resembling a forest composed of various species of trees and underbrush: while they must be adjusted to each other in order to form a common environment, these species do not all grow to the same height, or flower at the same time, or occur with the same frequency, and each has its own distinct ecological role. Moreover, their relationship shifts over time, owing to factors such as changes of climate or animal life, which may even cause the extinction of one or more species.

We have caught a glimpse of the role of sculpture in the Western "ecology of art" during the last 2,500 years. What it shows us could be enriched, but not changed in its essentials, by extending our survey to the preliterate cultures and the great civilizations of the Near and Far East, all of them well-represented in the current exhibition. The qualities that set sculpture apart are evident wherever we turn, once we are attuned to them. We note, first of all, that sculpture has a longer and more continuous history than painting or architecture; no exhibition devoted to either of those arts could draw upon as many periods and cultures as this one does. Yet this diversity of origins is counterbalanced by an underlying sense of kinship. The same basic themes recur in the most widely separated times and places, so that a *Shiva Nataraja* [27] and a *Dancer* by Degas [30], an African chief's stool [37] and a late seventeenth-century European console table [35] invite comparison despite their obvious differences. In part, these recurring motifs reflect the fact that sculpture has

always been a more public art than painting, hence more closely linked with the established imagery of religious or secular institutions. Above all, however, what links all sculpture, regardless of the circumstances of its creation, is a common impulse: to introduce into our environment a "duplicate reality" of tangible bodies, to render concrete—and thereby to bring within our power—what would otherwise remain beyond our grasp, be they ancestors, totemic animals, monsters, deities, heroes, or other objects of fear or desire. Unlike the painter's world, which leaves us forever on the outside looking in, sculpture shares our own physical space; it is a presence to be lived with as painting is not. The Italian early Renaissance humanist Leone Battista Alberti explained the origin of sculpture in a way that conveys a fundamental truth about its nature: the primeval sculptors, he wrote, were men who perceived in certain tree trunks and clumps of earth a resemblance to living shapes, and then made the likeness more perfect by adding or taking away; later on, they learned how to make statues without having to depend on such chance resemblances. The idea that any tree, rock, or lump of clay can become the dwelling place of a spirit if given appropriate form can be sensed to this day behind the sculptor's urge to animate dead matter. Even Richard Hunt's *Forms Carried Aloft, No. 2* [119], the most abstract piece in the exhibition, has the articulation of a living body, however attenuated (note the placement of the joints suggesting leg, hip, and shoulder).

Looking at this work—or any other work in the exhibition, for that matter—we quite spontaneously adopt an active stance very different from the way we view a picture: we want to see it from all possible angles and at various distances, we have a strong impulse to get the "feel" of it by touching the surface. In other words, we treat a piece of sculpture as we would a living person if politeness set no limits to our curiosity. And the work itself obviously invites such exploratory behavior; this, after all, is how the artist must have come to know it in the process of making it. It seems safe to say that no sculptor ever worried about the impossibility of channeling the beholder's response along a single predetermined path. What to Baudelaire was a failure of communication strikes us as the very opposite, once we have experienced it.

H. W. Janson
New York University

4

THEMES FROM THE HISTORY OF SCULPTURE

Gabriel P. Weisberg

I. The Single Form: The Nude

The naked human body has been the central theme for artists during several different periods. The nude held an important position not only as a formal exercise to be undertaken in art class, but, once mastered, as a demonstration of technical competence. It is also the one basic theme which has survived from the classical past, since it was invented by the Greeks of the ancient world.

In examining the nude, sculptors often modified what they saw, creating the illusion of perfection in their own work. Through examination of the human body, sculptors were often reminded of other basic human qualities, including harmony and eroticism, as they tried to find expression of universal truths. As Kenneth Clark has written, "like a building the nude represents a balance between an ideal scheme and functional necessities. The figure artist cannot forget the components of the human body. . . . But the variations of shape and disposition are surprisingly wide." It is just these variations that are mirrored in examples from sixth-century Greece to the twentieth century.

The *Kouros* (youth) [1] is among the group of pieces which celebrate the prowess of youth. To the Greeks, achievements of their athletes and warriors were most significant, and the outward appearance of budding maleness was often captured in commemorative sculptures. The mastery of modelling the human form, the sensuous surface which captures the impression of skin, create a model of the nude youth, central to the Greek culture.

Egyptian art, since it followed extremely conservative canons of presentation, did not develop a progressive study of the human body as a nude form. Upon occasion, however, as in the *Torso of Amun-Pe-Yom, Priest and General* [2] (280-250 BC), departures from the traditional theme of the rigid upright figure were undertaken. The reason for the subtle modelling of the upper part of the torso, which reveals a sensuous feeling for material and the creation of a life-like quality, can be inferred from the influence of Greece on Egypt after 332 BC. A striking comparison can be made with the Greek *Kouros*. The fact that the Egyptian torso represents an individual, the priest and commander Amun-pe-yom, should not prevent an understanding of the same love of naked human form established by the Greeks, from emerging in other locations where Greek influence was apparent.

During the classical period of Indian sculpture, images were created similar in perfection to those of the Ancient Greeks. A *Buddha* [3] (Gupta Period, 5th century) in traditional posture recalls the treatment of the human figure in Egypt, where sculptors achieved independence by subtly revising a basic pose. Here the Buddha is clothed in garments of transparent or "wet" drapery, almost classical in inspiration, which cling to the body and create a sensuous quality; the contours of the figure are soft; the stance of rest on one foot creates a graceful, relaxed mood which also evokes comparison with the Greek *Kouros*.

In the eighteenth century, once innovations of the baroque period had been achieved, German artists did sensuous interpretations of the human figure. Franz Ignaz Günther [4] in his *Male Figure* conveys a sense of inner agitation through the twisting pose and movement of the hair, which give the work a lifelike quality. The carving of the musculature helps achieve a similar youthfulness to that of the Greek *Kouros*—without there being any direct contact with the ancient world.

By the twentieth century, artists had revised their basic outlook on sculptural nudes several times, so that direct imitation of the classical past was frowned upon, even if the same striving for simplicity of purpose and the search for absolutes were inherent in their pieces. This certainly seems the case in Constantin Brancusi's *Male Torso* [5] in polished brass, where he has taken one section of human anatomy and transposed it into a work that almost suggests a self-contained fragment. The slight bulge in the lower abdomen area conveys Brancusi's aim to reconstitute reality according to a system of abstract geometry, which has as its goal the same integration of parts and a similar mood of restraint which the earlier Greek models had. Few pieces convey the essence of nudity as well as this example, where eroticism and subtle integration of forms are perfectly mastered to create an "ideal" state.

The simplicity of Brancusi's nude strikes a different note from the *Fragmented Figure Construction* of Richard Hunt [6]. Here the positioning of a figure in space, devoid of accompanying garments, helps in setting this piece against the tradition of "nudes" that has been previously established. However, Hunt also wanted to capture the essence of his model, and he manages to convey the effect of the constructed quality of his piece by relating it forcefully to the human figure. A suggestion of muscle, bones, and the tension between these parts is conveyed in this particular piece as the nude stands completely revealed—totally naked.

Until now examples of female nudes have not been presented in this exhibition, although they did emerge in Eastern and Western cultures, somewhat later than the treatment of the male form. In India the *Yakshi* [7],

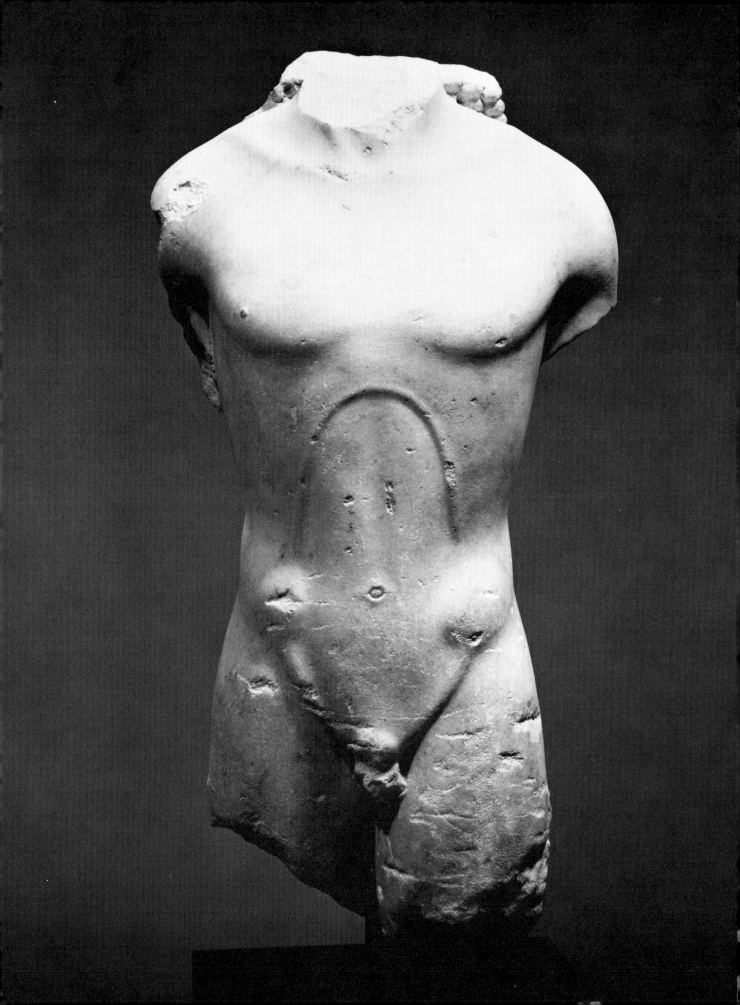

1 *Kouros*, island marble, Greece, second quarter 6th century BC.

2 *Torso of Amun-pe-Yom*, *Priest and General*, gray granite, Egypt, Ptolemaic Period, ca. 280-250 BC.

often a figure which supported an architectural member, conveyed a sense of vitality and sensuality. By emphasizing the swelling roundness of form, especially in the bust and hips, the softness and warmth of the flesh are shown. Undoubtedly the sculptor followed a canon of attitudes by which he was meant to record these qualities, similar to the treatment of figures in Egypt or Greece, so that the sense of independent adventure and imagination conveyed in modern examples is not always possible. By subtly conveying differences in stance or garment such as in *Gangā, Goddess of the Ganges* [8], a more sophisticated rendering of womanly beauty is possible, one that transports us from earth mother to goddess, suggesting an ideal state so longed for by artists who examined the nude.

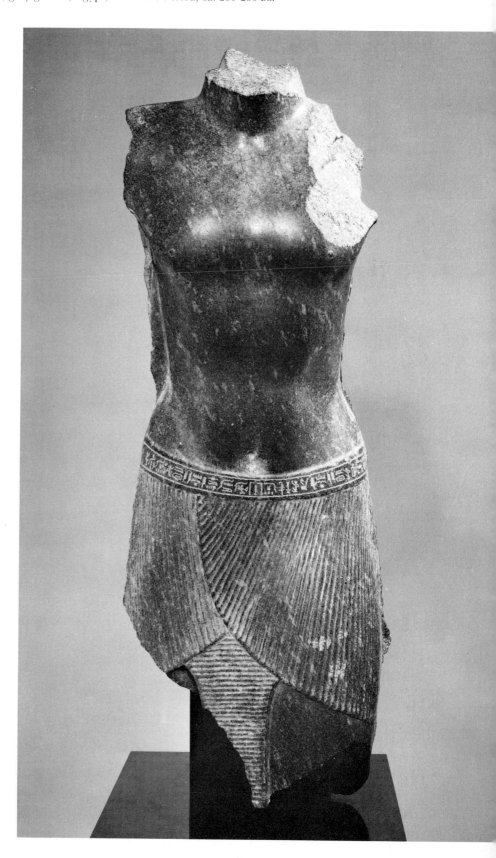

3 *Standing Buddha*, cream sandstone, India, Gupta Period, 5th century.

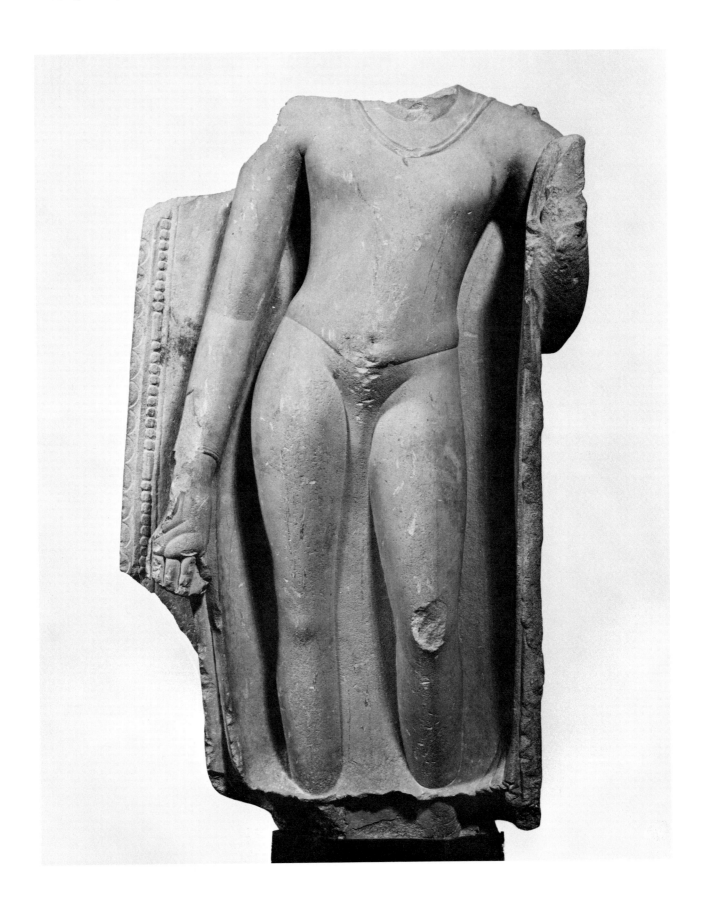

4 Franz Ignaz Günther, *Male Figure*, wood.

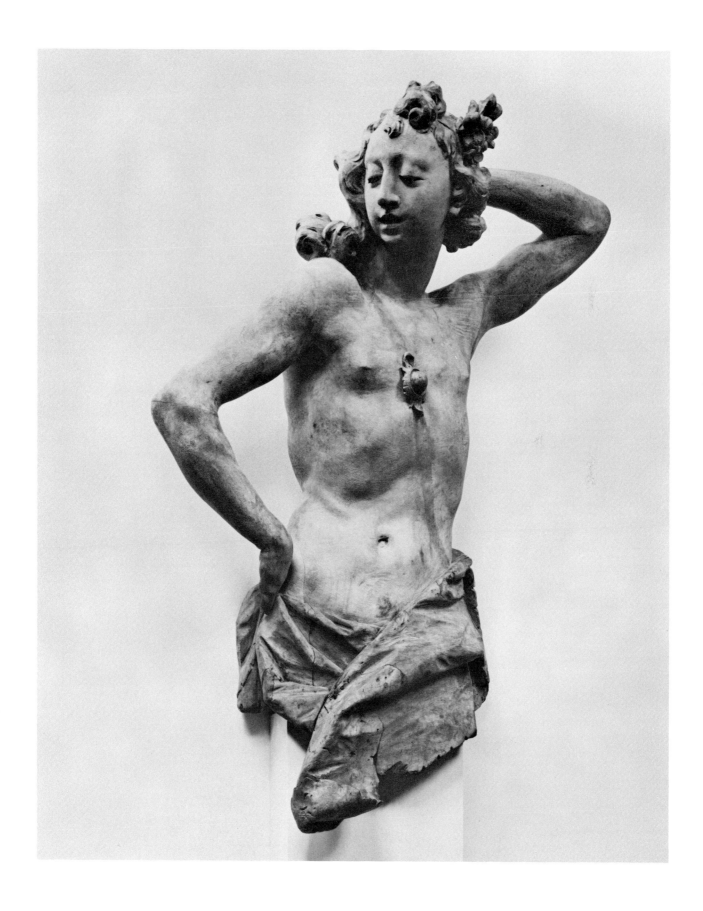

5 Constantin Brancusi, *Male Torso*, brass.

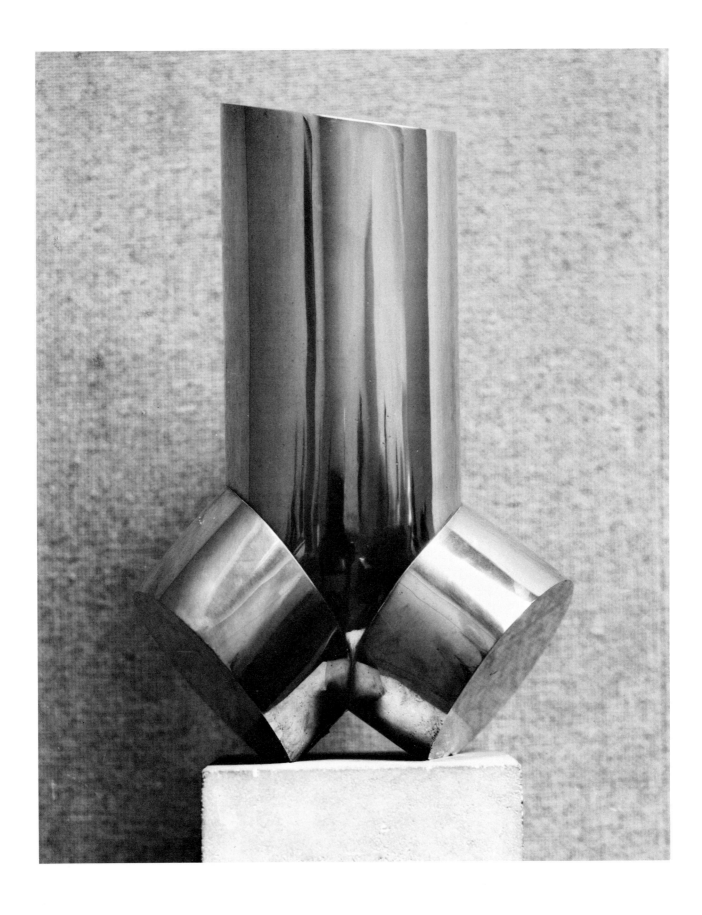

6 Richard Hunt, *Fragmented Figure Construction*, welded steel.

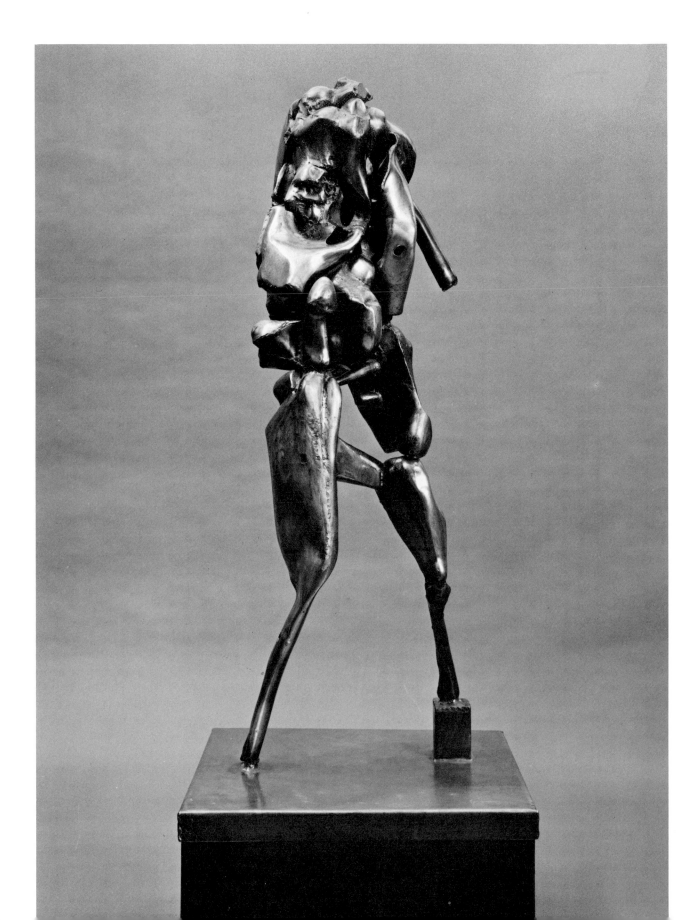

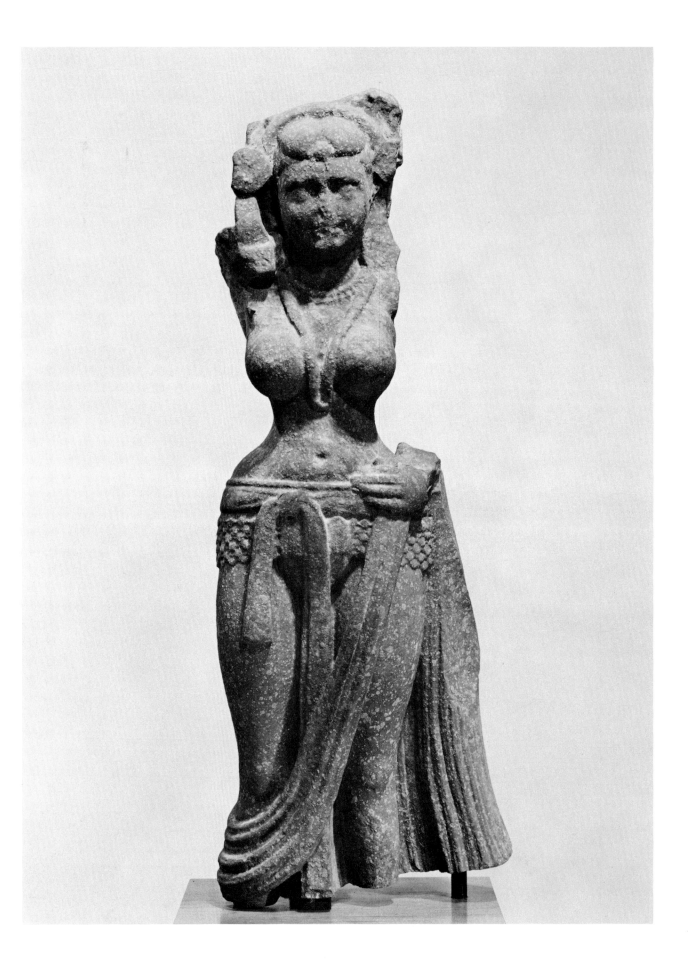

7 *Yakshi*, red sandstone, India, Mathura, Kushan Period, 2nd century.

8 *Gangā, Goddess of the Ganges*, stone, India, Mathura, early Medieval Period, early 7th century.

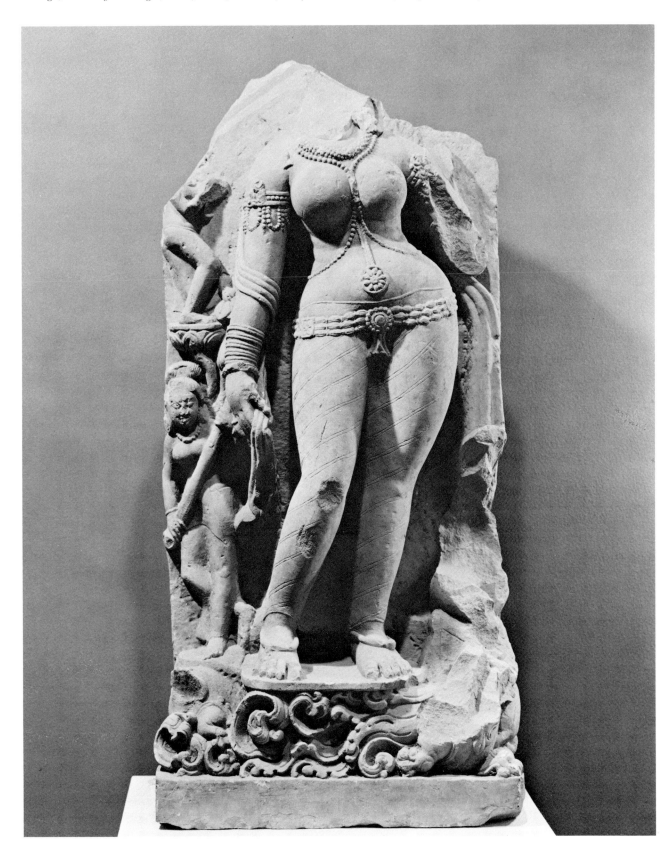

I. The Single Form: The Seated Figure

In part, many of the recurring motifs in sculpture have been dictated by the general belief that sculpture is a more public art than painting. This is borne out by the consistent repetition of themes which can be used to help educate the general public through the regularization of gestures and poses that are immediately understood. The seated figure, often placed upon a throne and only occasionally brought close to the ground, to the people, conveys a separation between the general public and the higher realm represented by the figure. In this way, sculpture was used as a reinforcement of the idea of divine presence on earth, an embodiment of secular government, and often was meant to exert a direct and lasting impact upon a beholder who came upon memorials to rulers and gods in shrines and sanctuaries, often as part of a carefully prepared ceremony.

The rigidly posed ruler, whether from Syria [9] or Egypt [10], was meant to be approached from the front, so as to interact directly with those who understood the place that this figure occupied in real life. Even when a sculptor presented individuals at a lower rank in society (often placed nearer to the ground and without a high pedestal), the sternly frontal attitude of the figure was maintained [11]. In the Far East, the seated pose was also used to express religious and secular attitudes. The poses of figures in bronze [12] or other mediums reinforced already well-established gestures which were understood by those who came to prostrate themselves before these images [13, 14]. Occasionally a wood sculpture, using the timeless immobility of the seated figure, developed a realistic presentation which conveyed the pietistic heritage of a meditative priest [15].

The public presence of seated figures was underscored in the West by the consistent use of the Madonna and Child theme. The throne [16] on which both figures sit serves as a metaphor for the Virgin as seat of Wisdom and reiterates the close bond between visual representation and the teachings of the Church. Undoubtedly the tender relationship evoked by this frontally arranged group expresses the symbolic union between the two figures.

In later centuries, when religious and secular traditions loosened, sculptors saw other possibilities in the motif of the seated form. Gods were shown in relaxed poses [17], and by the twentieth century the human figure had almost been removed from its pedestal. Suggestions of movement, the swaying of the human figure in song [18, 19], began to remove the conventionalized attitudes of this pose. The need to glorify rulers and gods was no longer as paramount a concern to the sculptor, who tempered this pose with increased human warmth and inner vitality, moving away from traditional inhibitions.

16

9 *Seated Prince*, metamorphosed limestone, North Syria, early 15th century BC.

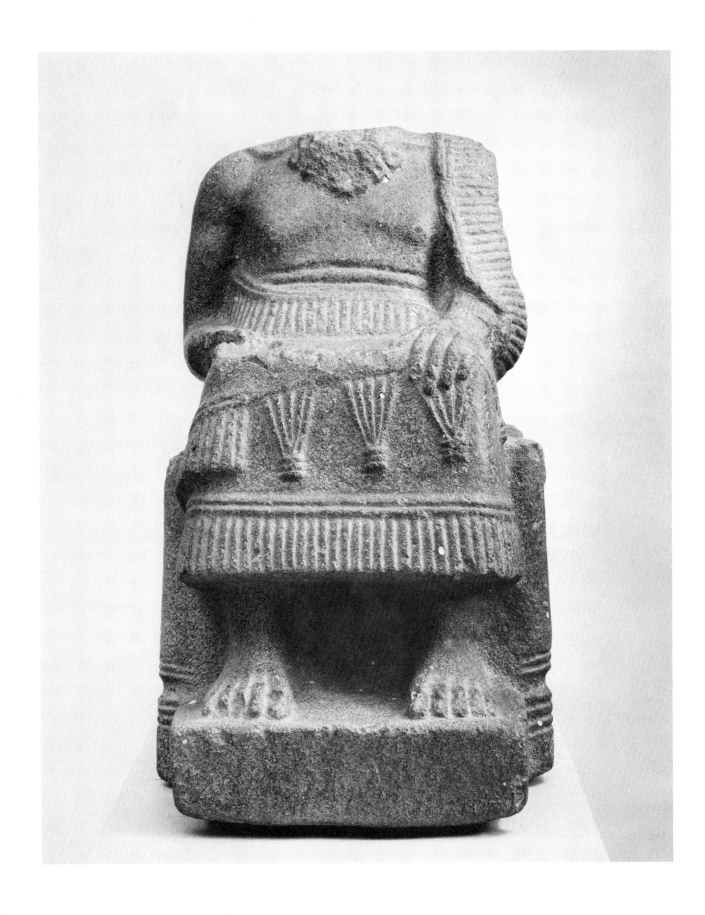

10 *Portrait of Superintendent of Granary, Med-thu*, limestone, colored, Egypt, Salamieh, Dynasty XVIII, ca. 1552-1306 BC.

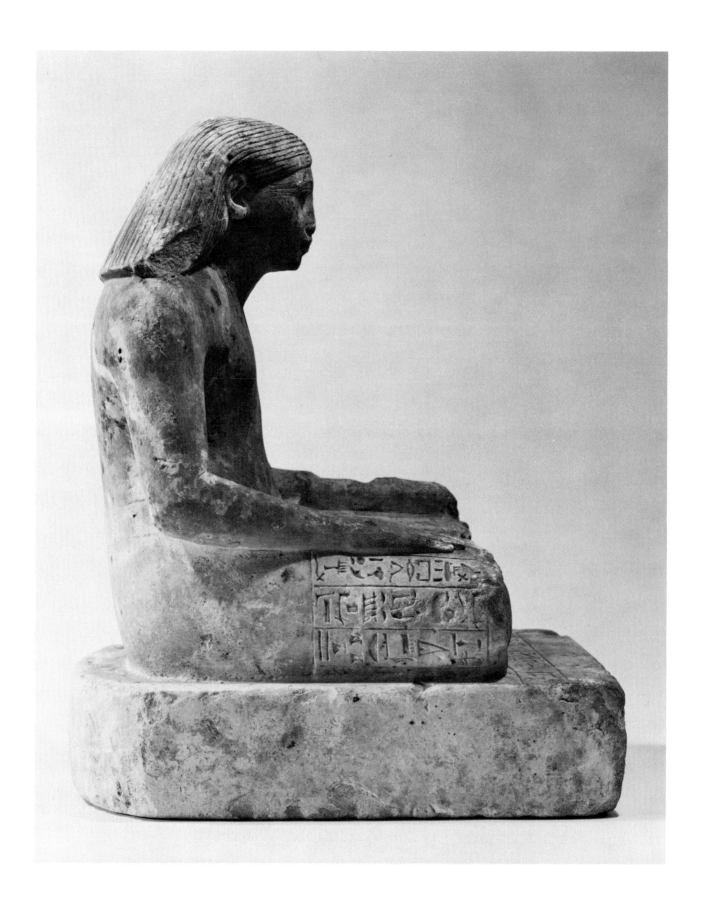

11 *Portrait of Djed-bast-iuf-ankh, son of Wennefer,* brown limestone, Egypt, early Dynasty XXVI (660-650 BC).

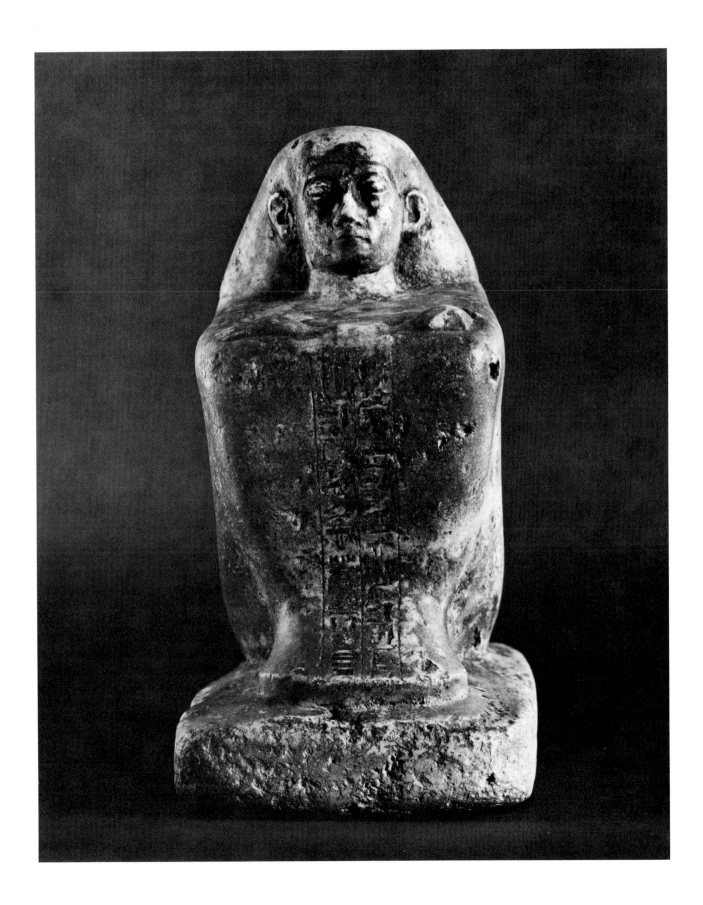

12 (Below) *Narasimha Yoga Murti (Lion Incarnation of Vishnu)*, bronze, India, late Chola Period, ca. 13th century.

13 *Nikko, the Sun Bodhisattva*, Japanese yew, Japan, Kōnin Period, ca. 800.

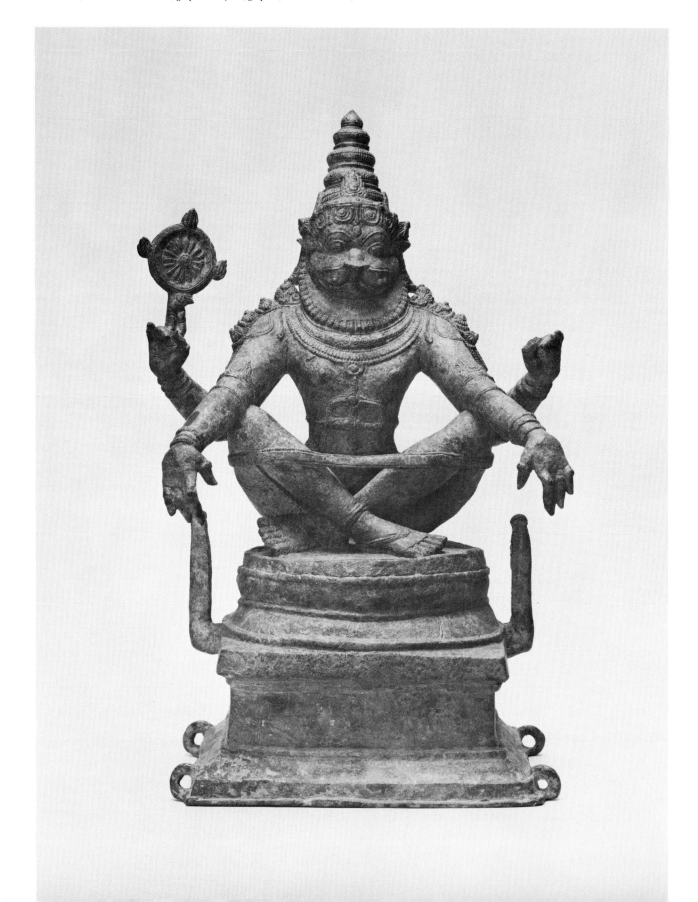

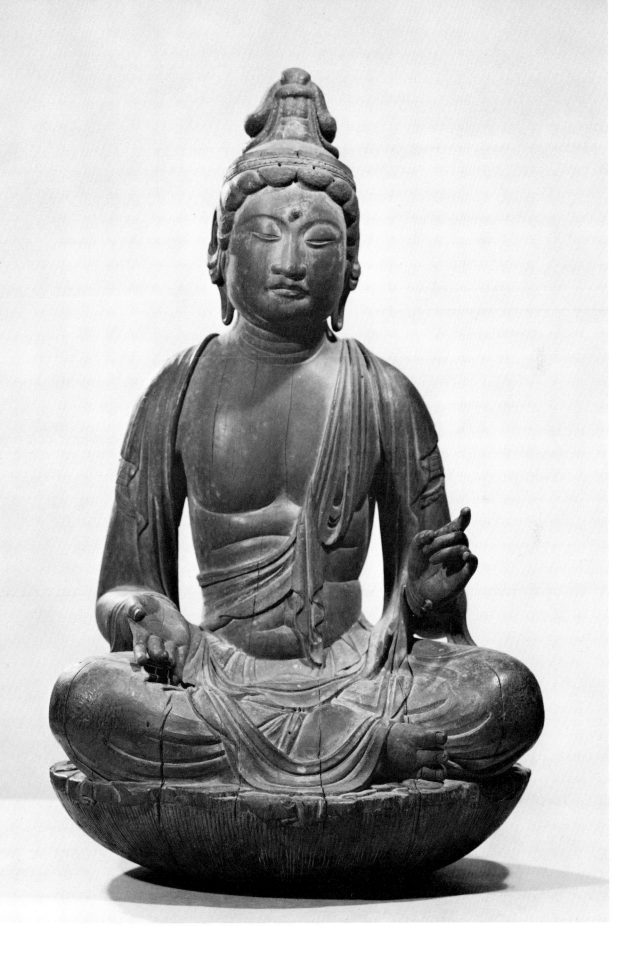

14 (Below) *Maitreya in Meditation (Hanka-shiyui-zo)*, bronze, Japan, Suiko Period, 7th century.

15 *Portrait of Hōtō Kokushi*, wood, Japan, Kamakura Period (1185-1333), ca. 1286.

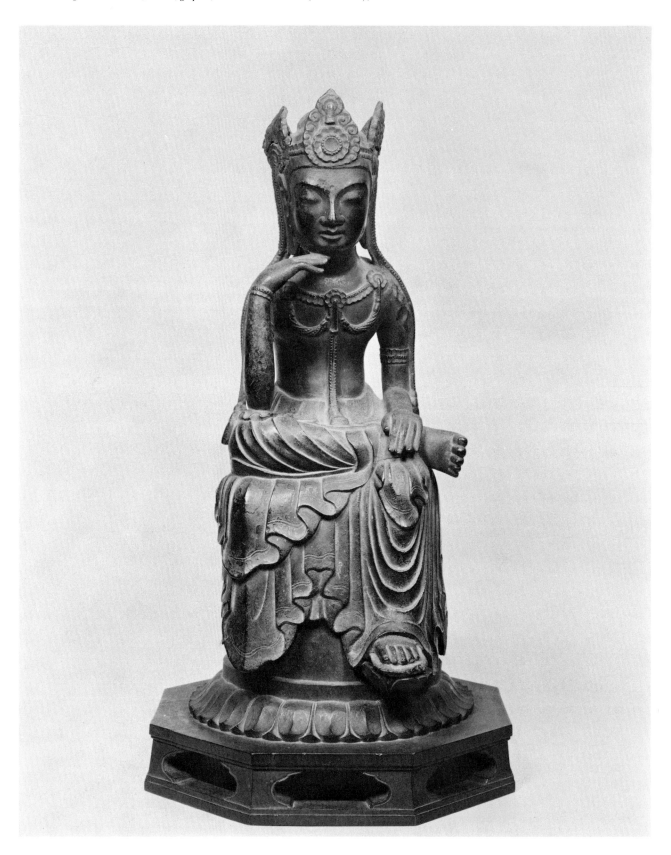

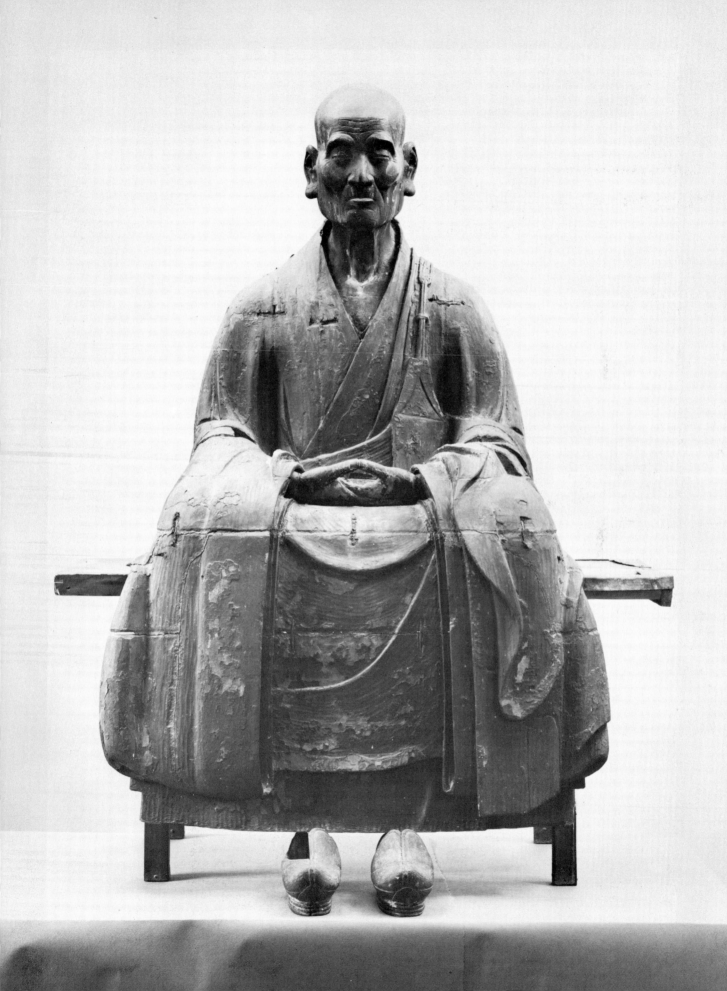

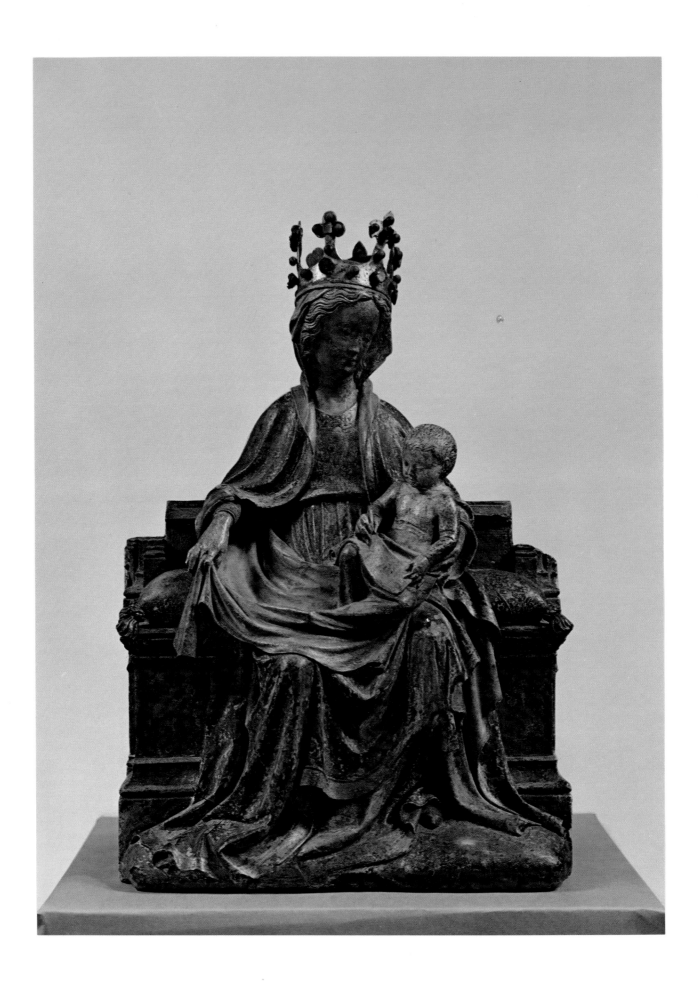

16 *Enthroned Madonna with the Writing Christ Child*, limestone with paint and gilding, France-Netherlands, ca. 1400.

17 Giovanni Marchiori (attr.), *Bozzetto of a River God*, terra cotta.

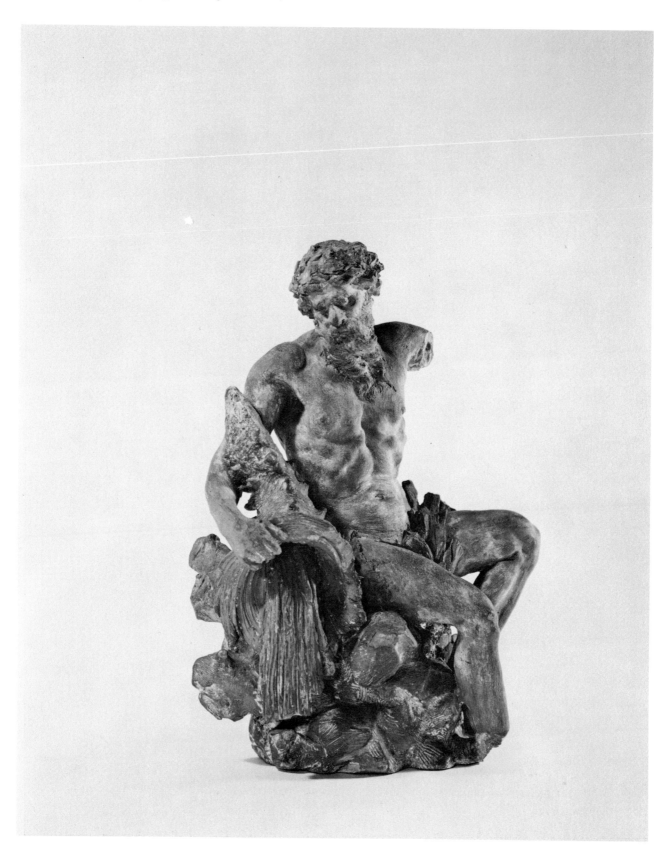

18 Gerhardt Marcks, *Ragazzo*, bronze.

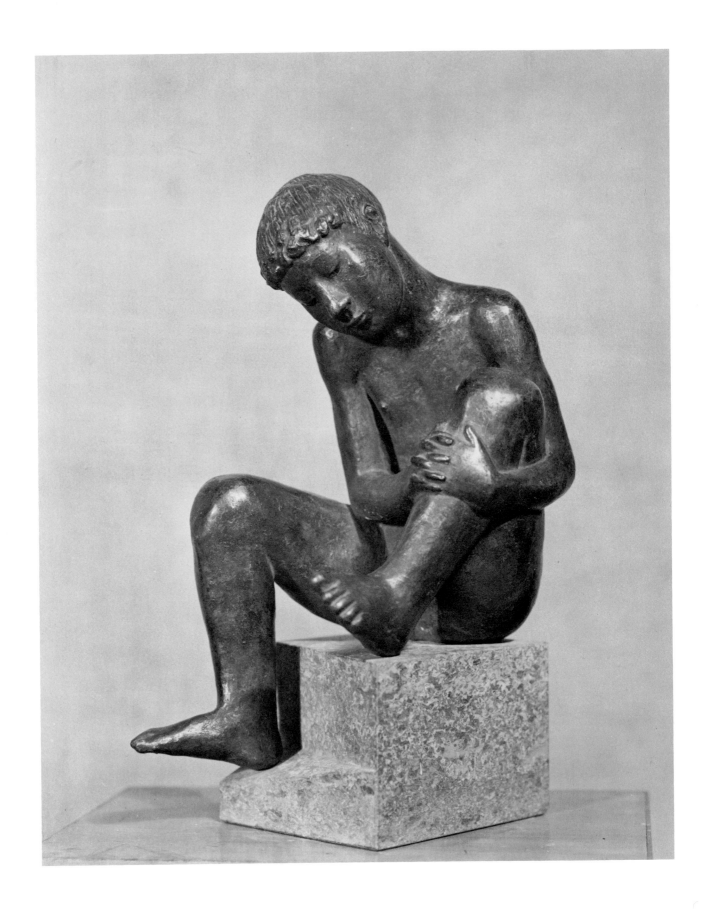

19 Ernst Barlach, *Singing Man*, bronze.

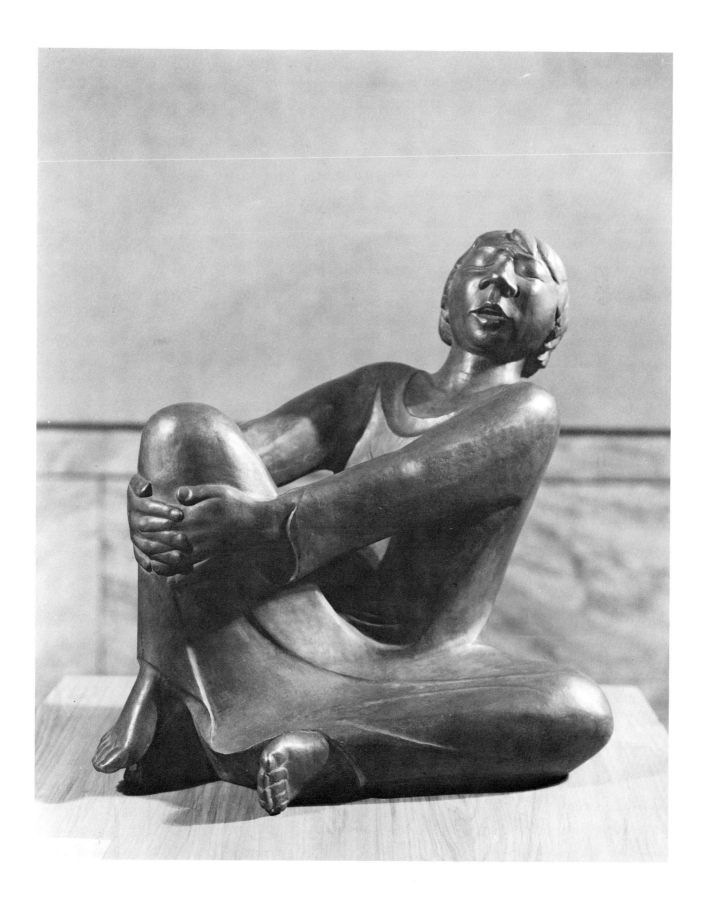

I. The Single Form: The Columnar Figure

Closely related to the seated figure, the columnar representation of the human body conveys the same general attitudes of frontality and imposing massiveness which were used by the sculptor to prevent a close relationship from developing with a viewer. It is as if these memorials in stone or wood were constructed to keep the viewer at a distance, so that no intimate contact could be established.

The broadly modelled features, the gestures of clasped hands [20], the use of a book with an easily understood expression of mourning [21], or the suggestion of a throne [22] demonstrate how instructive these objects were when viewed from a distance. The exaggerated details were also clearly legible to an audience who viewed these pieces and learned to identify the subjects and their moods by these expressive and iconographic details.

The fact that these pieces were meant to suggest a relationship with architecture should not be overlooked. Their massive size, the verticality of design, and the immobility of stance suggest the integration of these pieces with the architectural members that surrounded them. Once again the public nature of these pieces is revealed by the purpose and location for which they were intended—audience halls or other architectural settings—where their imposing size and drama were significant.

20 *Gudea, Ensi of Lagash*, dolerite stone, Mesopotamia, Lagash, Neo-Sumerian Period, ca. 22nd century BC.

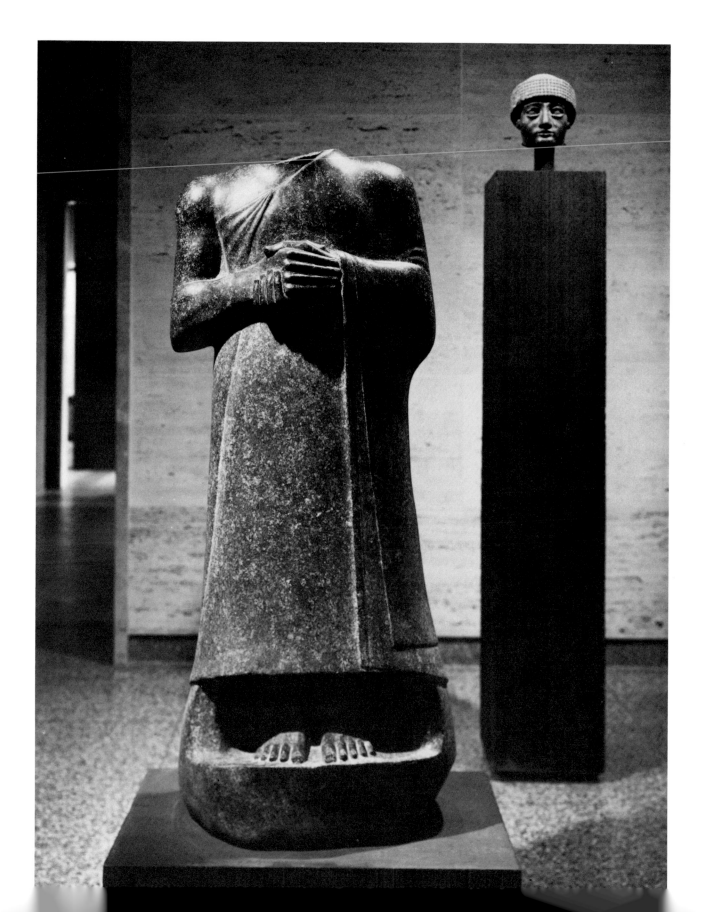

21 (Left) *Saint John from a Crucifixion Group*, painted and gilt wood, Spain, Castile, ca. 1275.

22 *Seated Madonna as the Throne of Wisdom (Sedes Sapientiae)*, lindenwood with traces of paint, Northern Europe, 12th century.

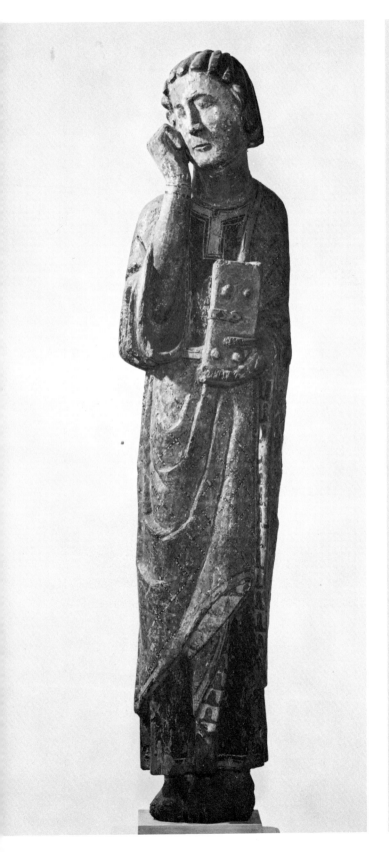
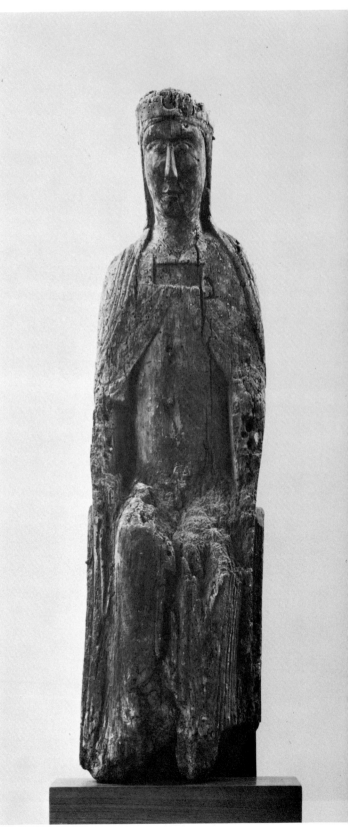

I. The Single Form: The Figure in Motion

Sculptors examining the single figure frequently developed themes which emphasized animation of the human form. Various subjects were selected to convey this quality—from athletes and heroes to a moving dancer. Indeed, effects of energy, the inherent grace and poise of the human body, were well epitomized by the dancer, whose tradition goes back to the ancient world.

The fascination with this theme recurs continuously in civilizations widely separated by both time and distance. The Etruscan *Dancing Maenad* [23], a female devotee of Dionysus, is shown being summoned to the ritual of the dance. Poised with one foot on a tortoise (a symbol of music), she presents with clasped fingers an offering to Dionysus, while her body rhythmically sways in answer to an urge to dance. Curiously the activity of this figure is confined to one plane, with her torso and legs moving in one direction and her head and arms in the other. A striking silhouette is created which, through its irregular outline, captures inner vitality. While the vigor of the shape is important, the dancer also forms an important link with still another thematic group which involves the single figure, the caryatid, since she was part of a utilitarian ensemble and was used in a candelabrum, her head supporting a dish.

As sculptors worked with the human figure in many poses, the complexity of the *Piping and Dancing Satyr* [24], in a lively dance, would have fired their ingenuity. Half animal, half human (the attempt to make visible forms beyond our grasp), satyrs were nature spirits who were also attached to the god Dionysus. They were fond of wine, music, and dancing—all of which seem to be summed up in this example. This satyr is poised on the toes of his right foot, his left raised in a dance step. Probably he held a musical instrument, which has long since vanished. The opportunity to place the human figure in such a complicated posture led the Hellenistic artist to choose this pose, which creates movement in keeping with the satyr's personality.

In the Far East dancing figures are also found. Two examples are *Attendant of Manjusri* [25] from China, where a dancing movement is given to this heavenly guide for Manjusri's vehicle—the lion; and a *Frieze of Dancers* [26] from Cambodia, where the performers move in rhythmic unison. The classic example of a Far Eastern dancing figure is the *Shiva Nataraja, Lord of the Dance* [27]. The Indian sculptor placed the dancing figure, as the personification of all forces of the cosmos, in the forefront of his artistic pantheon, imbuing it with cultural as well as aesthetic importance. Shiva's dance personified his universe in action and destruction and so summed up the basic reasons why sculptors chose this theme to stress the quality of inner energy. The Dionysian frenzy of the whirling dance forces one to think beyond the immediate present toward unseen truths which Shiva symbolized and which are connected to renewal, birth, and death. An examination of sculpture in movement is possible against a time sequence, since form has been distorted for expressive purposes [28, 29].

Edgar Degas conveyed animation in his sculptures of dancers, often selecting unusual angles or moments in time. In his *Dancer* [30], he has dramatically captured the sequence when the dancer raises her foot to examine it and will soon place it firmly on the ground. He has selected the moment of "suspended animation," recalling Greek sculpture of athletes in similar poses, when one activity is about to cease and the next ready to begin. While the dancer is carefully balanced, Degas has distorted certain features—such as the left arm—in order to have attention focus on the key gesture and to follow the twisted pull of the upper torso in this specific direction.

In *Detachable Figure* [31], Jacques Lipchitz uses the sense of bodily weight seen in a walk to demonstrate his interest in new technical innovations of the twentieth century. It is possible to detect hints of regulated energy which the artists working with this theme of animation have sought to release for well over two thousand years.

23 *Dancing Maenad*, bronze, Italy, Etruscan, late 6th century BC.

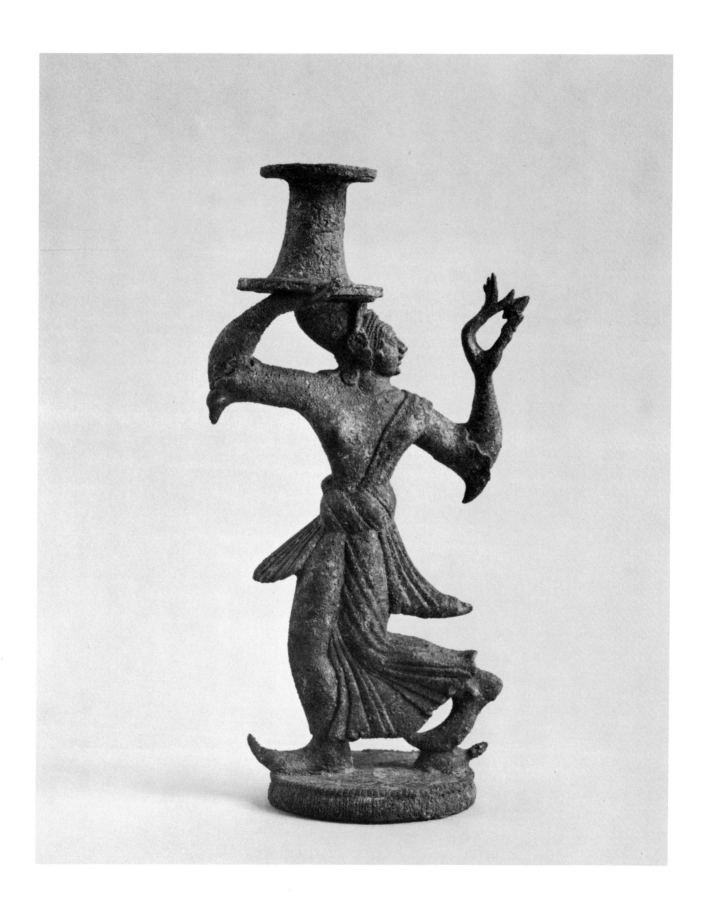

24 *Piping and Dancing Satyr*, bronze, Alexandria (?) Greek, Hellenistic, 3rd-2nd century BC.

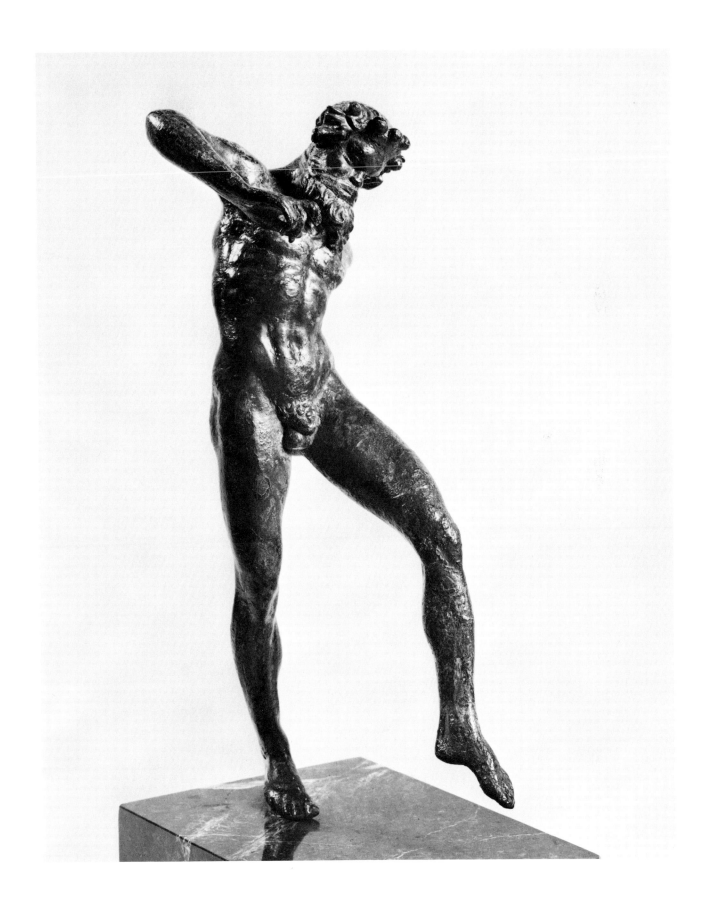

25 *Attendant of Manjusri*, dry lacquer, China, late T'ang Dynasty or early Five Dynasties, 9th-10th century.

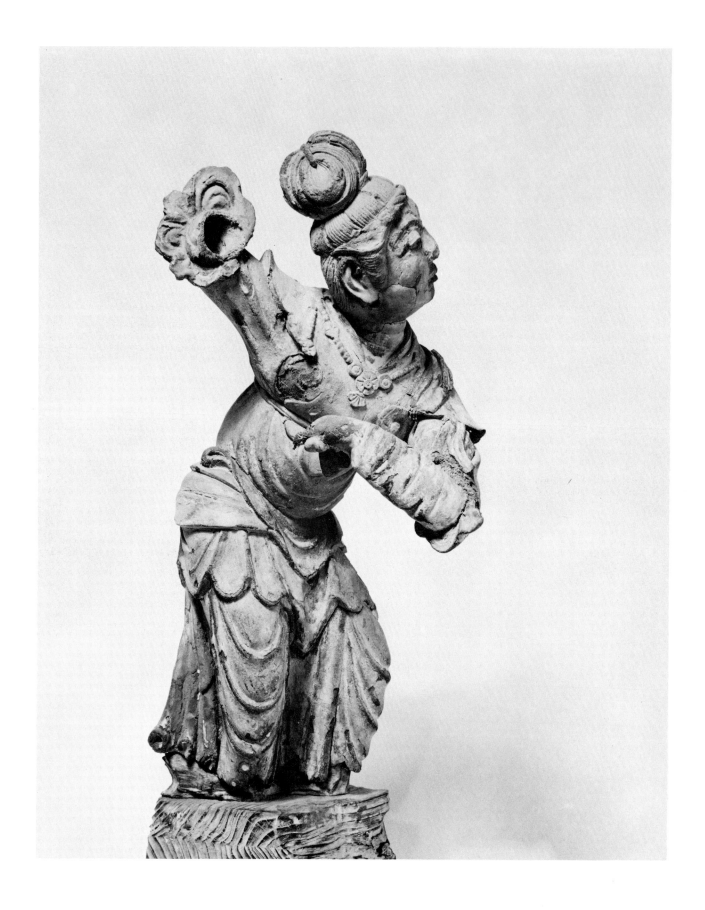

26 *Frieze of Heavenly Dancers*, pink sandstone, Cambodia, Angkor Thom, reign of Jayavarman VII, ca. 1181-1218.

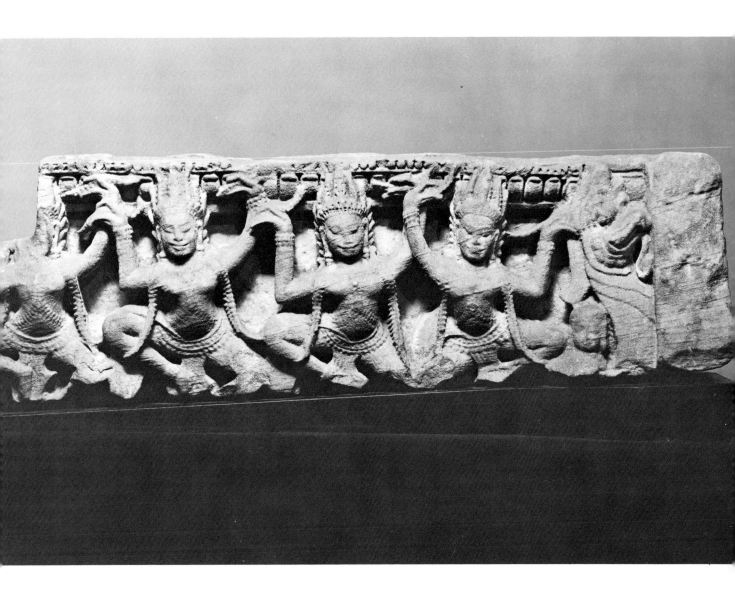

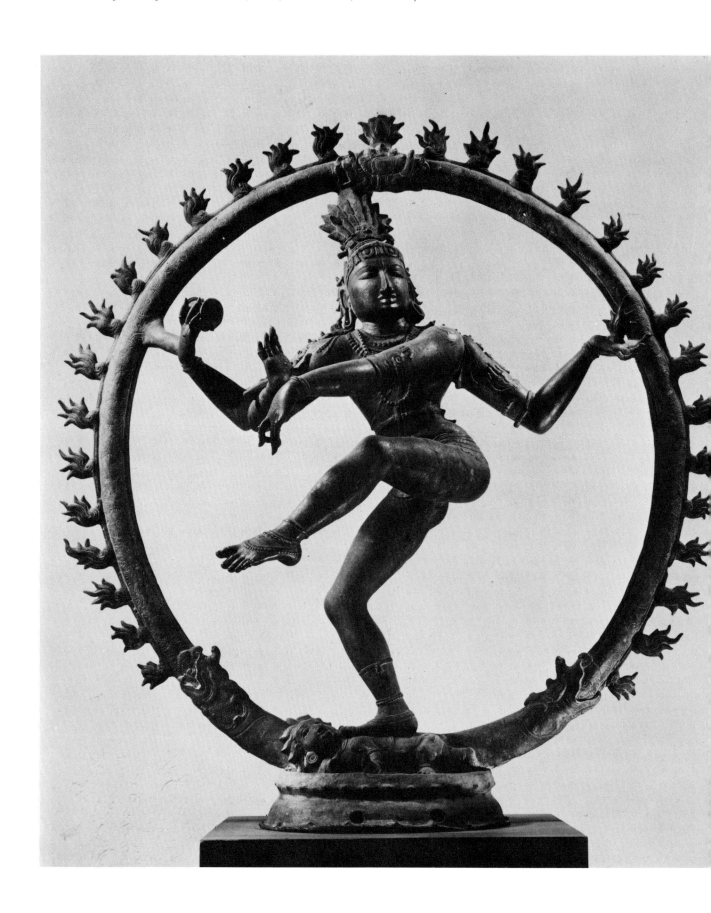

28 *Figure of Zao-Gongen, a Shintoist manifestation of the Buddhist guardian deity*, wood, Japan, Kamakura Period, 13th century.

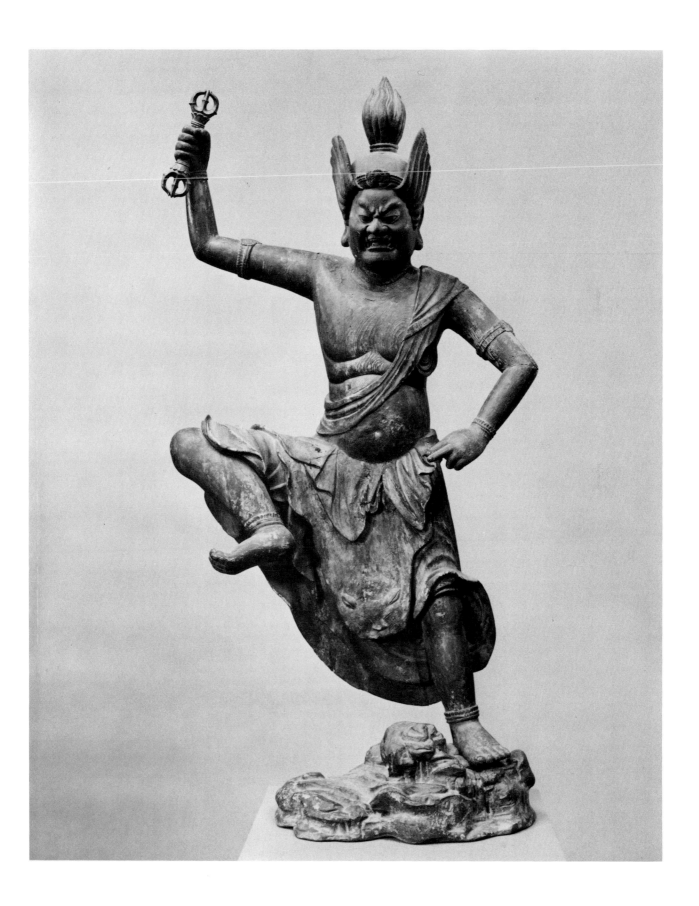

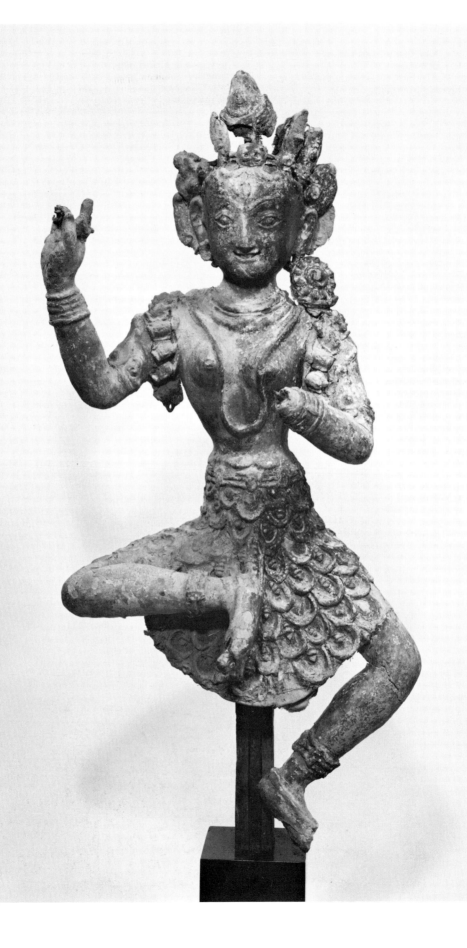

29 *Vajravarahi, Dancing Tantric Deity,* lacquer and stucco, Nepal, 16th-17th century.

30 Hilaire-Germain Edgar Degas, *Dancer,* bronze.

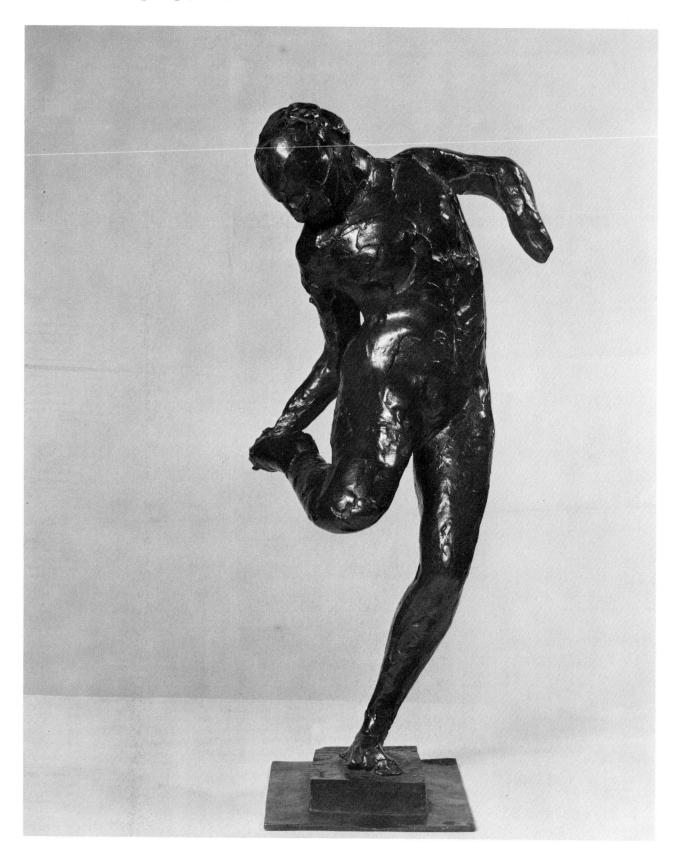

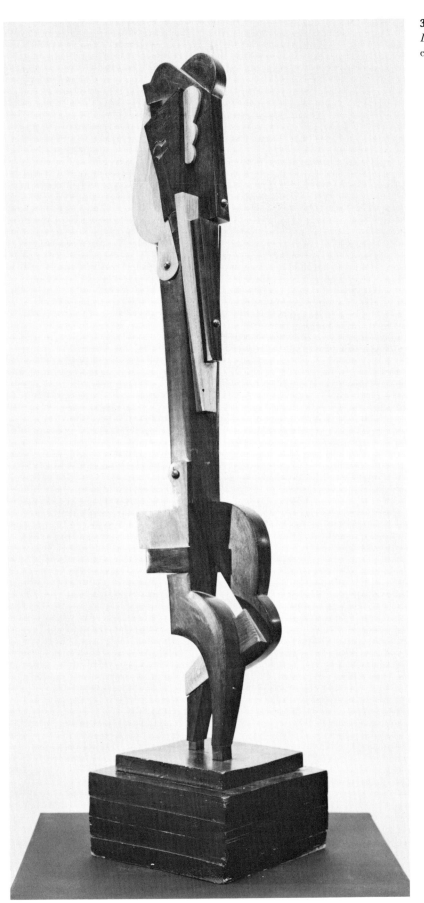

31 Jacques Lipchitz,
Detachable Figure (Dancer),
ebony and oak.

I. The Single Form: The Caryatid

In studying the human figure sculptors as well as architects recognized that it was possible to combine utilitarian function with studies that provided a greater range for exploring the postures of man. In the process the theme of caryatid sculpture developed (appearing in Classical Greece in the Erectheum and its "Porch of the Maidens"), where pieces amusingly involve the spectator.

A bronze *Mirror* [32] from Greece is an example of caryatid sculpture, as the base, in the form of a standing figure, supports the circular mirror on her head. Since the *Mirror* can also be seen as an example of the decorative arts, it convinces us that a tradition for unifying the arts—so prevalent in later periods—has a heritage in the ancient world. In China during the seventh century, the supporting form—first used in Greece—did not appear alone, but as part of a group of figures arranged in zones on the base of a *Pedestal* [33] used to support another object. Here the symbolic function of the entire piece, that of supporting the object above, is crystallized in miniature by the activity of the small dwarf-like creatures who, each in their separate registers, are representative of the four Lokapala—male spirits antedating Buddhism.

Other examples of the wide use of the caryatid theme abound. The *Kneeling Figure* [34], used as a base for objects, increases the sculptor's involvement with the solidity of the human figure as expressed in a crouching pose. A humorous rendition of the caryatid theme is found in a *Console Table* [35] from the late seventeenth century. Symbolism is conveyed by the image of father time not only as reaper, but as one who bears the weight of his job upon his shoulders—metaphorically rein-forcing his actual role as supporter of the flat platform of the table top. The fact that one hand reassuringly moves to bolster the platform is mirrored in the sagging musculature of the old man caught in his timeless role.

By the nineteenth century, in the work of Rodin, the caryatid [36] returns to a traditional pose, supporting a heavy slab of stone across one shoulder. Curiously, Rodin—in response to the late nineteenth century's interest in symbolism, which was partly derived from literary sources—conveys a mood of remose or sorrow through the crouching pose of a figure who tries to hide while shoring up her load.

The same theme of the caryatid surprisingly appears in another culture—in an African *Chief's Stool* [37] completed around 1900—where the same integration of human figure with functional purpose, as seen in the *Console Table*, again demonstrates that differing cultures can and will use the same universal theme.

By examining the caryatid category, one can move closer to an integration of differing units within one piece and away from admiration of the single sculptural form.

41

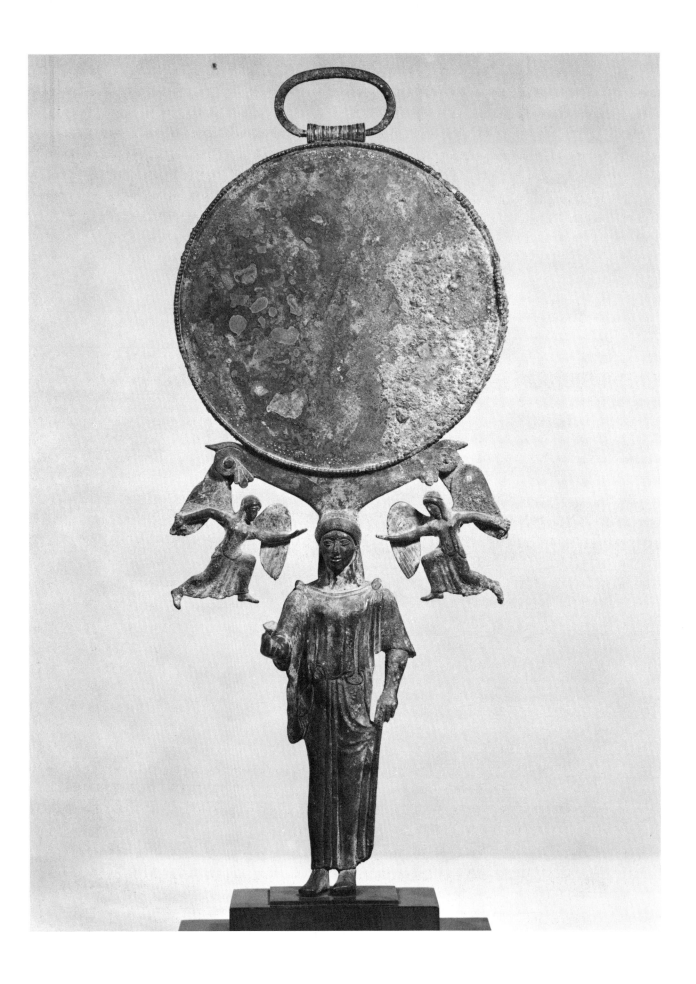

32 *Mirror*, bronze, Greece, Sicyon (?), ca. 470-460 BC.

33 *Pedestal*, ivory, China, early T'ang Dynasty, 7th century.

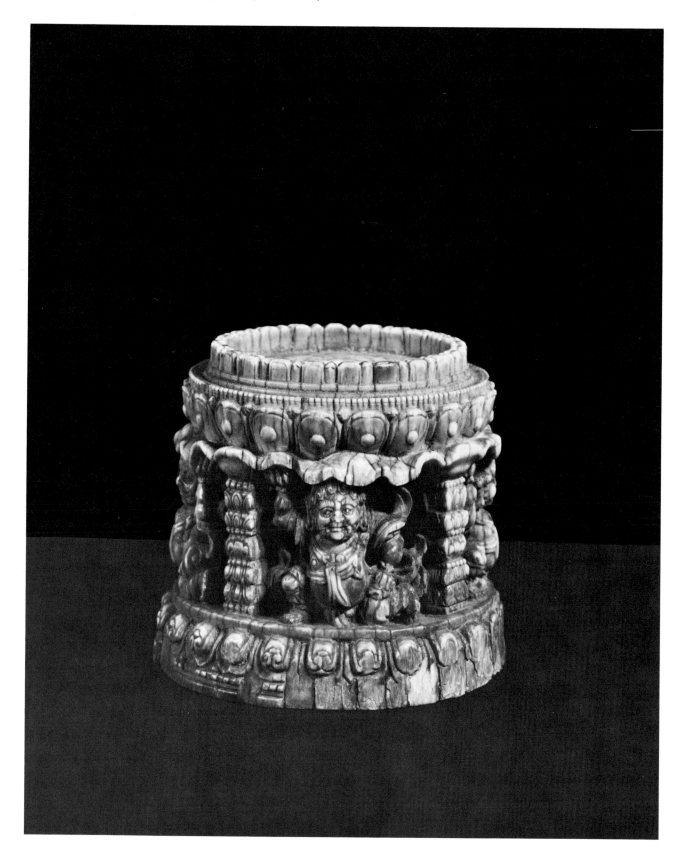

34 *Kneeling Figure*, probably one of the six supporting figures for the *Reliquary of Saint Germain*, gilt bronze, France, Paris, following the contract February 8, 1408 (1409 new style).

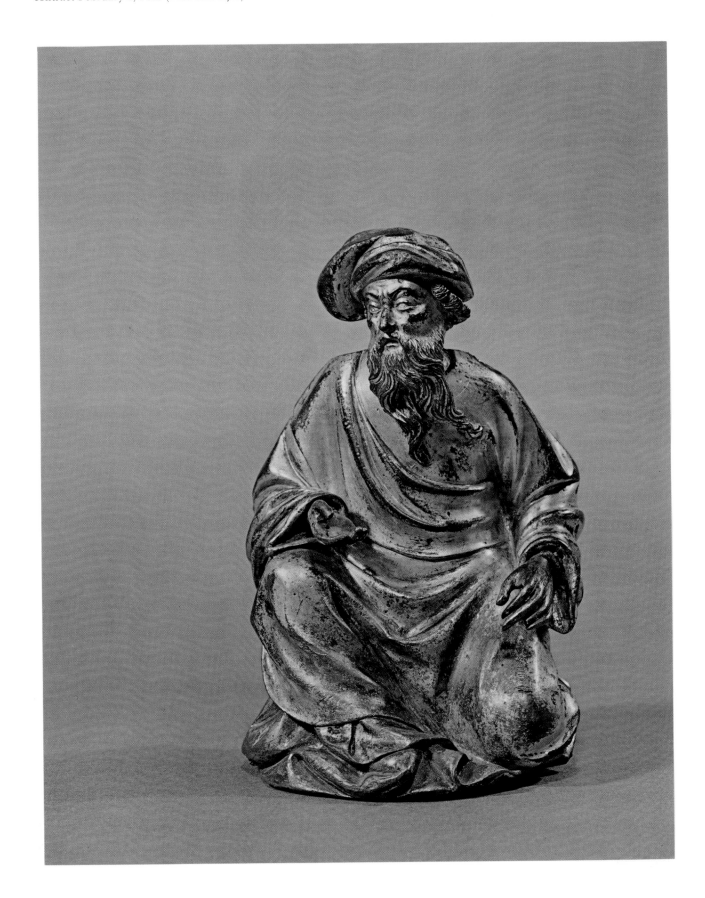

35 *Console Table*, painted and gilded wood, marble, Italy, Rome, late 17th century.

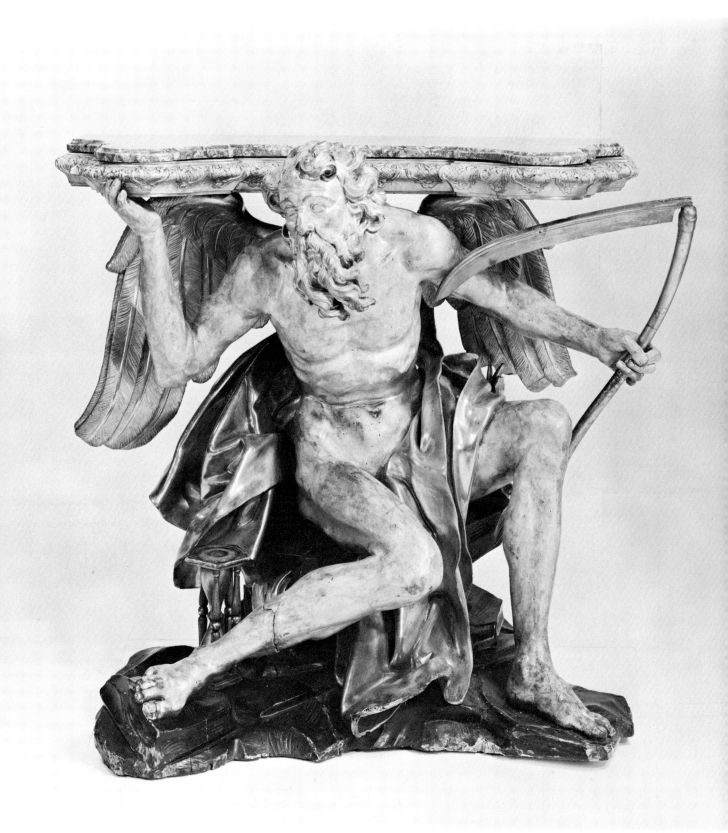

36 (Below) Auguste Rodin, *Fallen Caryatid Carrying Her Stone*, bronze.

37 *Chief's Stool with Caryatid Figure*, wood, Zaire, Southern Savannah Style Region: Upper Lualaba Area, Baluba Tribe, ca. 1900.

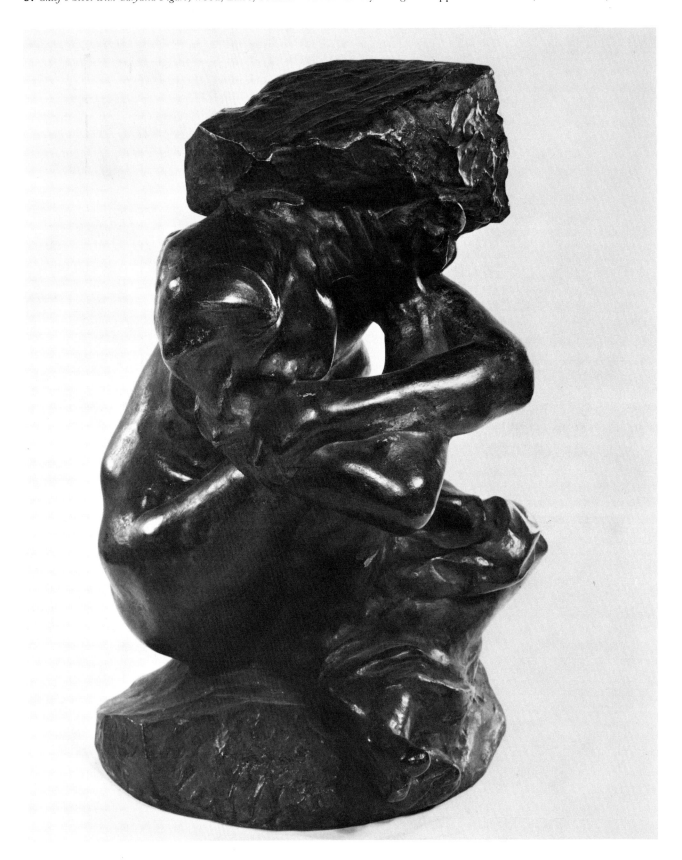

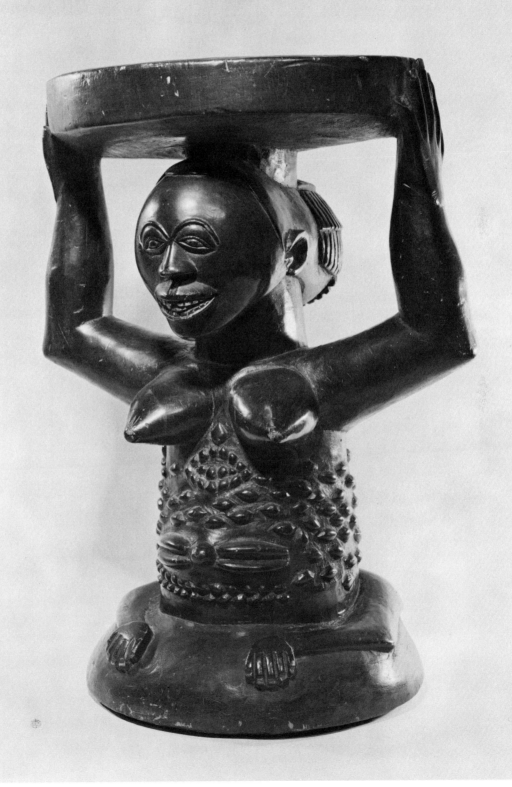

II. The Group Arrangement: The Moveable Figural Group

Some pieces of sculpture provide the opportunity to be moved into new arrangements. This theme emerges from examples that were originally intended as part of an altarpiece, but, through the vicissitudes of time and changes in taste, were removed from their original location and are now seen in tandem with other examples from the same arrangement or by themselves. Other pieces can often be traced back to tomb arrangements or mystical uses, where their present setting is far different from the original intention.

Two cases in point are the *Mortuary Figures of the Zodiac* [38 a-d] from the Six Dynasties Period in China and the processional *Mourning Figures* [39] by Claus de Werve and Claus Sluter from the tombs of the Dukes of Burgundy in Dijon, France. The Chinese animal figurines were probably meant to be arranged in a specific way, such as a circle, so that the images would correspond to astrological signs. In their present circumstance the pieces can be organized freely, permitting changes from the original use, where they symbolized the zodiac signs in animal form.

A similar situation arises with the *Mourning Figures*, which were part of a procession at the base of a tomb. Without the interconnected sections of the tomb, the overhanging architectural arcades, and other examples from the entourage, these pieces must stand on their own, removed from their original context. Since they are fully carved in the round, and therefore can be viewed from every angle, they permit the same freedom of rearrangement as the zodiac figures. Undoubtedly in their original placement as tomb figures they were never meant to be moved. It is also true, however, that since these pieces were not firmly attached to a base or wall, they invited moveability. When the tombs were removed from their original area, the transportation of the figures was possible, and several of them entered private collections and museums. While the sculptors might never have intended their pieces to be moved once they were installed as part of a tomb complex, the fact that the pieces were moveable probably allowed them to be saved for future generations without their being marred or desecrated.

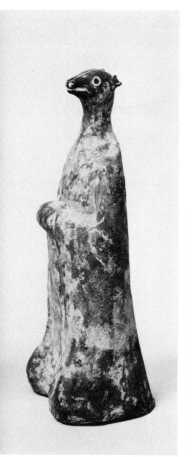

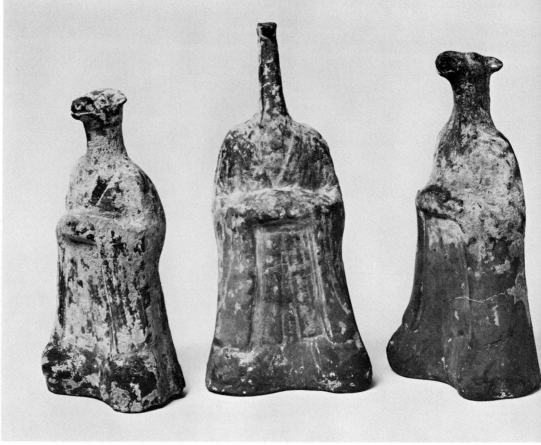

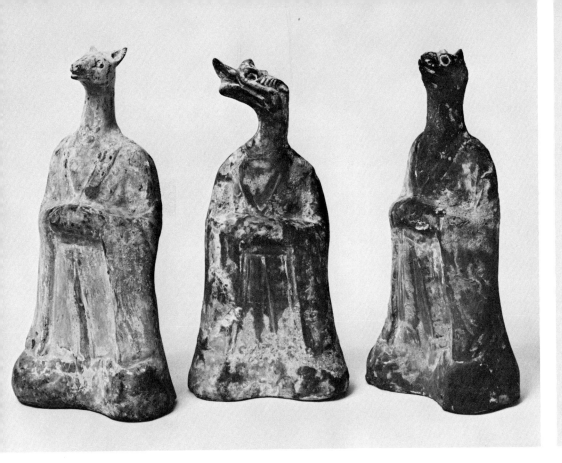
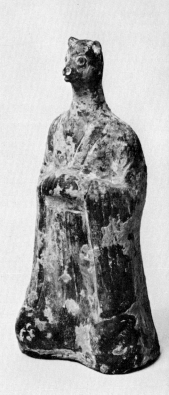

38 *Mortuary Figures of the Zodiac,* gray clay with traces of slip, China, Northern Wei Period, ca. 525.

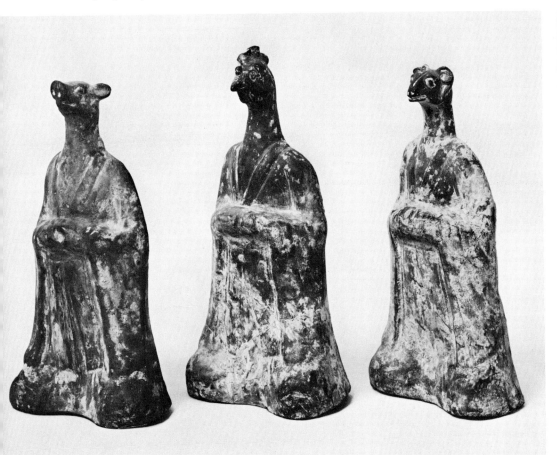
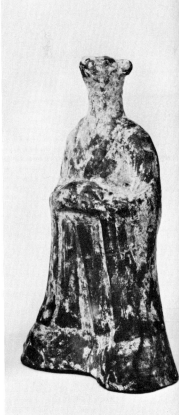

Larger pieces, originally designed as part of an altarpiece or with a specific location in mind, can also provide variants for rearrangement. Two *Guardian Figures* [40, 41] from the Kamakura Period in Japan not only had a function to perform and were posed in a predetermined spot by the sculptor, but they were also meant to interact forcefully with the space surrounding them and with the viewer. These works create a violent sense of agitation which almost borders on the grotesque. Two saints, *St. Lawrence* and *St. Stephen* [42, 43], carved by the late-Gothic sculptor Tilman Riemenschneider underscore a similar sense of three-dimensional presence as part of an altarpiece ensemble which has since been dismantled. Riemenschneider was careful to study the personality of the saints and to capture their features realistically. Both saints encourage interaction with a viewer through their stances rather than with the wild movements into space created by the Japanese guardians.

Two smaller African works, designed with a specific role in mind—to serve as substitutes for dead twins—provide the same opportunity for rearrangement [44]. The pieces were to be fed, washed, and clothed by the mother as if they were alive, serving to provide her with a psychological substitute. Since these objects were meant to be handled, moved, and cared for, they are fitting examples of sculpture's serving as a substitute for a human being. They are also imbued with qualities of animation which move them into another sphere where they constantly are found in new arrangements. Undoubtedly these *Twin Figures* from the Yoruba tribe can be compared with other moveable pieces for just these reasons.

The dismantled altarpiece, objects created for specific purposes but which have been transported elsewhere, tomb effigies, and memorial figures provide examples which are often preserved and rearranged by succeeding generations of admirers. While it is necessary to be aware of the traditions from which these pieces come and how they were originally intended to be shown and used, this should not impede assessment of these works in new settings. The fact that many of these examples are portable, and hence not tied to a specific location, encourages the everchanging relationship between sculpture, its original purpose, and its new position for later generations.

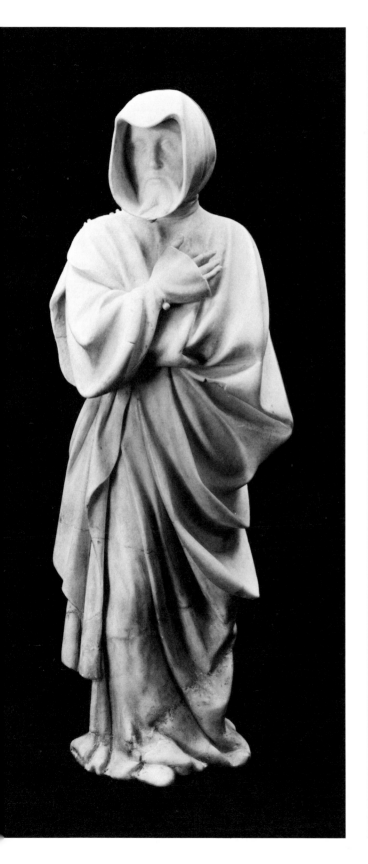
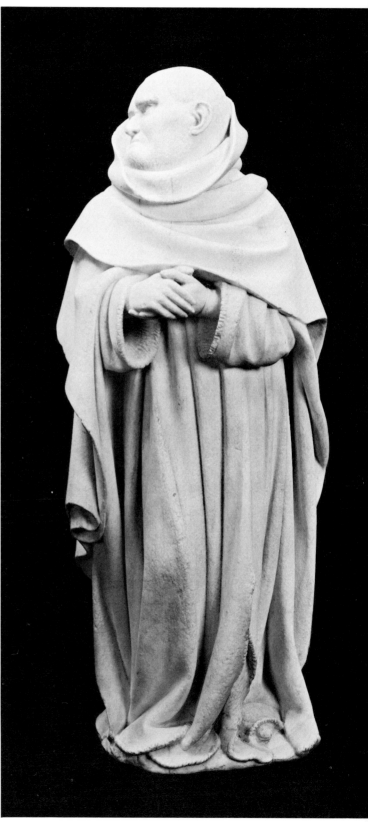

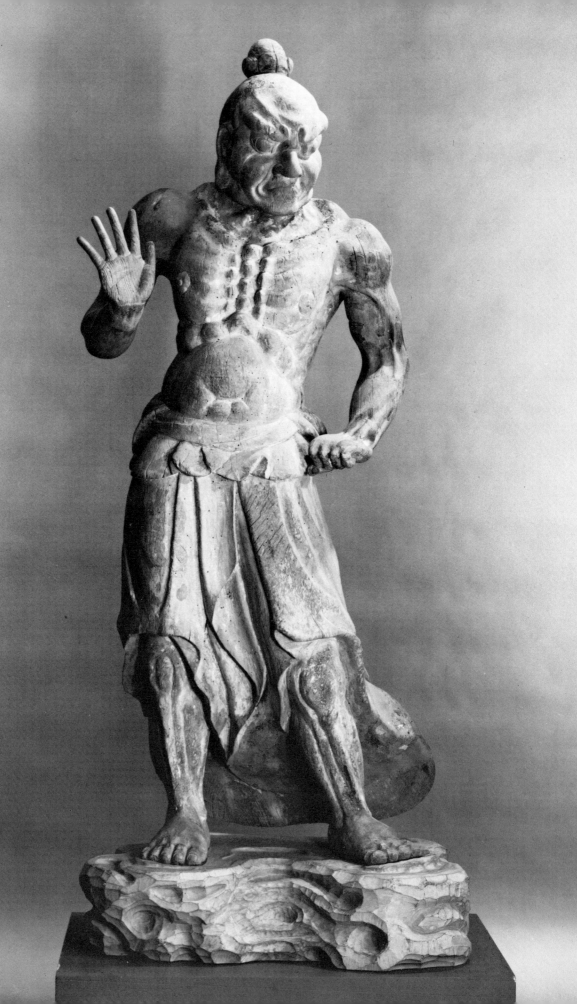

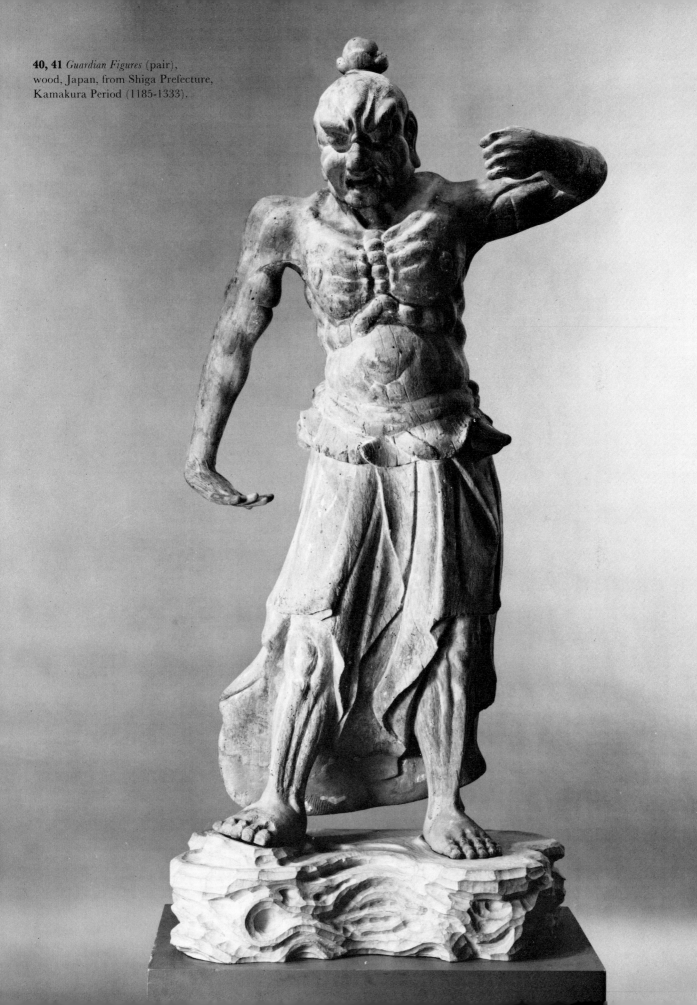

40, 41 *Guardian Figures* (pair),
wood, Japan, from Shiga Prefecture,
Kamakura Period (1185-1333).

42 (Left) Tilmann Riemenschneider, *Saint Stephen*, lindenwood.

43 Tilmann Riemenschneider, *Saint Lawrence*, lindenwood.

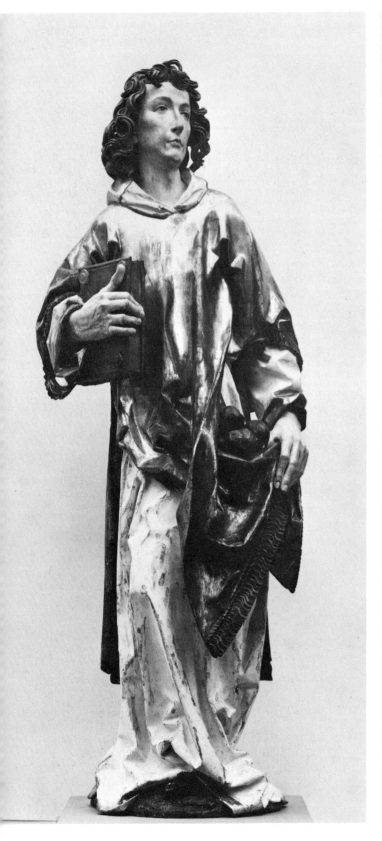
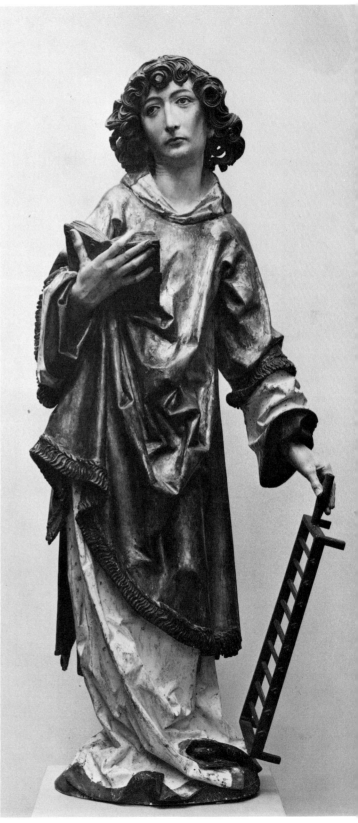

44 *Twin Figures (Ere Ibeji)*, wood, Nigeria, Guinea Coast Style Region: Town of Ila-Orangun, Yoruba Tribe, probably 2nd quarter 20th century.

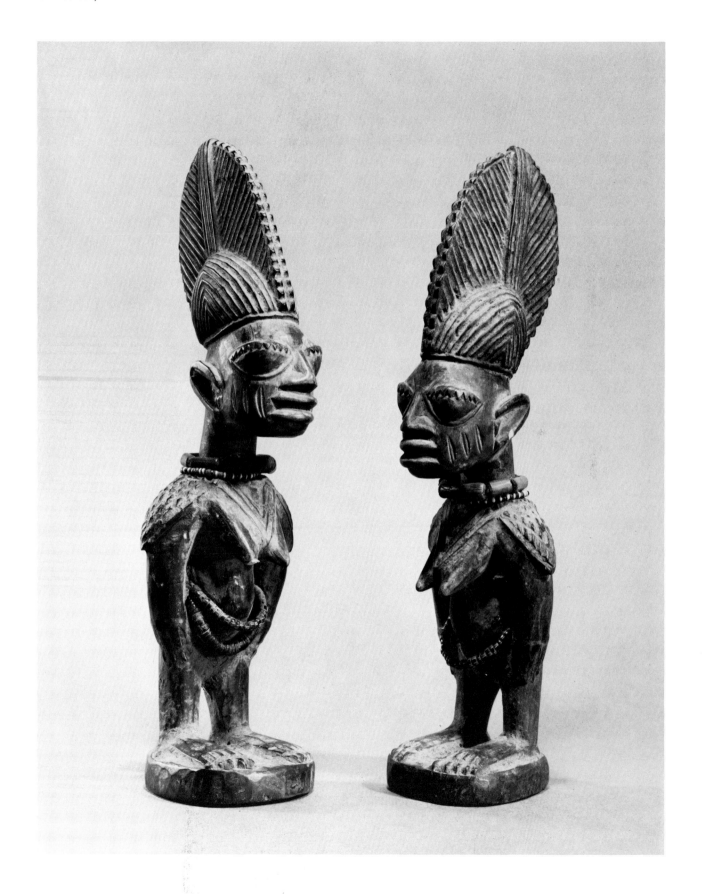

II. The Group Arrangement: The Interunited Sculptural Group

Unlike the previous theme, which consisted of two or more moveable parts which were intended to be seen together but which were often modified by the purpose and exhibition of the pieces, the examples within this category—also composed of more than one member—have been locked together by the skill of the sculptor. Often the pieces were meant to exhibit formal, frontal characteristics, such as a statue of two rulers; occasionally sculptors tried to think in more general terms, as they locked two figures together in order to probe the spatial relationships that were established. Some examples also necessitated this close bond between the forms, and an exaggeration of certain areas, in order to reinforce the symbolism of the piece.

In ancient Egypt, the same care that was lavished upon a single figure—whether a member of the secular government or an image of a god—is found in double portraiture. The *Statuette of an Official and His Wife* [45], with their arms crossing in the center as if to underscore their union, demonstrates their ruling together. The sculptor has reiterated this quality by posing the figures in frontal posture, not allowing any deviation to interfere with his equalization of parts. A small Egyptian bronze of *Isis with Horus the Child* [46] further continues the symbolism which sculptors saw between a mother and child and establishes a theme which would reappear in differing ways throughout Western culture—thereby emphasizing unity between figures. Thus, the *Madonna and Child* by the workshop of Andrea Pisano [47]—where a human and divine interplay has been established—shows the re-use of this theme in another religious context.

The theme of love was also presented by sculptors selecting interunited subjects. In both the East [48] and the West [49], tender relationships were presented appropriate to the religious and mythological tenets of a particular culture. In the case of Clodion's terra cotta, the playfulness between the young girl and the infant creates a mood of innocence and charm which is quite beguiling.

Occasional religious subjects also reflected love on a higher plane, as is the case with the fourteenth-century German sculpture of *Christ and St. John the Evangelist* [50]. The two figures create a mystical union, as St. John seems transported by his contact with the wisdom of God learned through Jesus. Indeed, the difference from standard representations of these figures is conveyed not only through St. John's pose but by the spirit of idealism which seems to infuse the apostle's face. This is a rare example of mysticism emerging through a subtle integration of form and expression.

Late nineteenth-century sculpture not only continues the bond which exists in *Solidarity* [51] or *Two Women* [52] but establishes the sculptor's interest in more aesthetic concerns which could be examined by interrelating two forms in space. While the objects are not abstract and the human content is still visible, the direction that sculpture was moving is suggested by Minne's angular construction and Matisse's more generalized statement, which concentrates on the form of the human body interlocked with another.

Exaggeration of shape and heightened emotional states were also possible in a study of bodies embracing one another. Rodin's overtly sensuous *Les Damnées* [53], while generalized in feature, shows how the sculptor meshed two female forms together so that their individuality was no longer as important as a study of the freedom of the human body. A *Woman and Child* [54] from the Ivory Coast also contains changes of form which were done to emphasize part of the body. This maternity figure, with large breasts, is an obvious fertility idol, which continues the basic theme of sculptors working with interrelated subjects by referring to the nursing of the young.

Throughout this category, emphasis is placed on tender emotional states—occasionally heightened for effect—which sculptors in both East and West realized could best be symbolized by using two figures instead of one.

45 *Statuette of an Official and his Wife*, limestone, colored, Egypt, Salamieh, Dynasty XIX, ca. 1320-1200 BC.

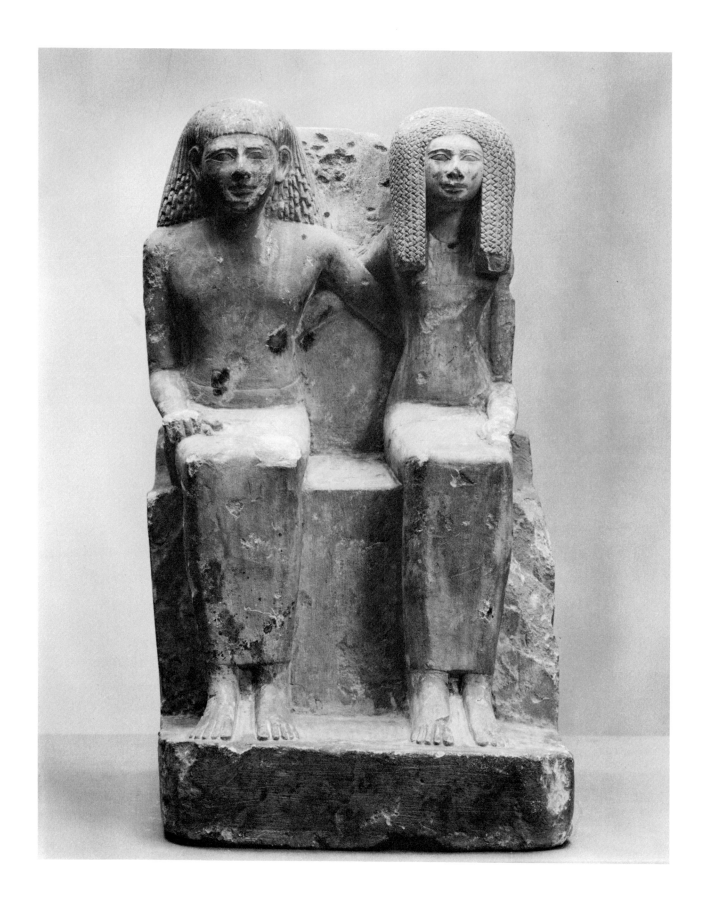

46 (Below) *Isis with Horus the Child*, bronze, Egypt, Dynasties XXVI-XXX, ca. 664-343 BC.

47 Andrea Pisano (attr.), *Madonna and Child*, marble, ca. 1330's.

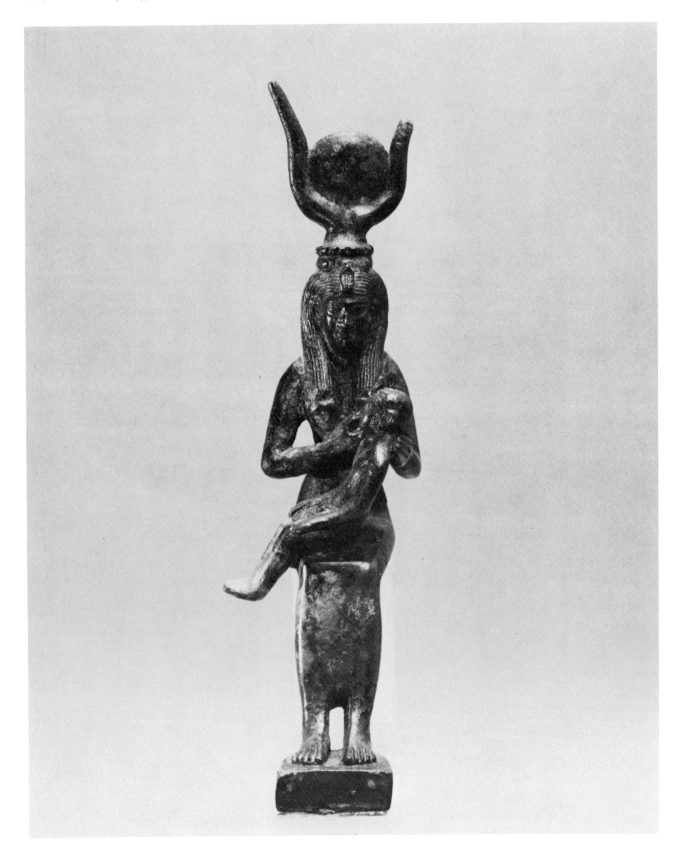

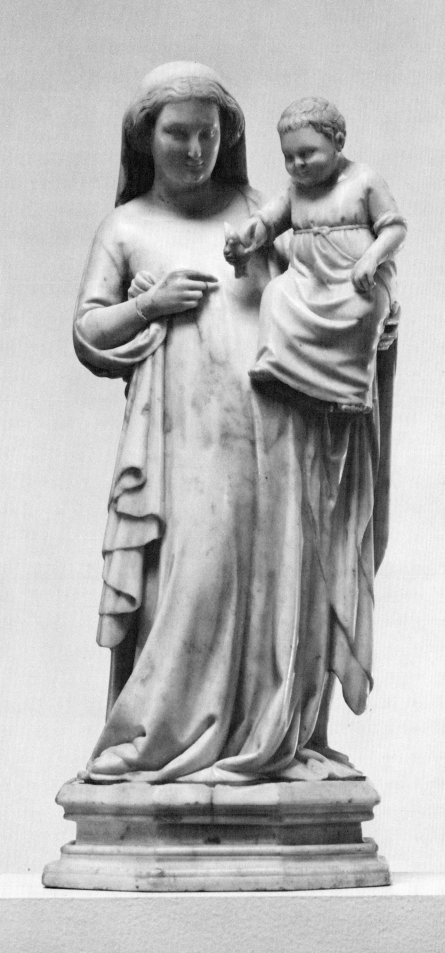

48 (Below) *Shiva and Parvati*, bronze, India, Pala Period, 9th century.

49 Claude Michel, called Clodion, *Maiden and Infant at Play*, terra cotta.

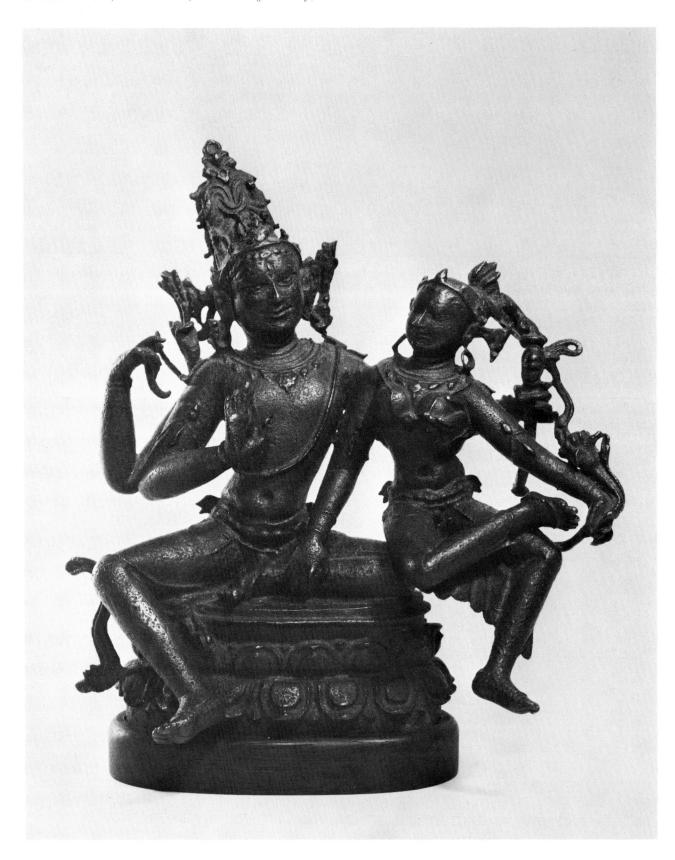

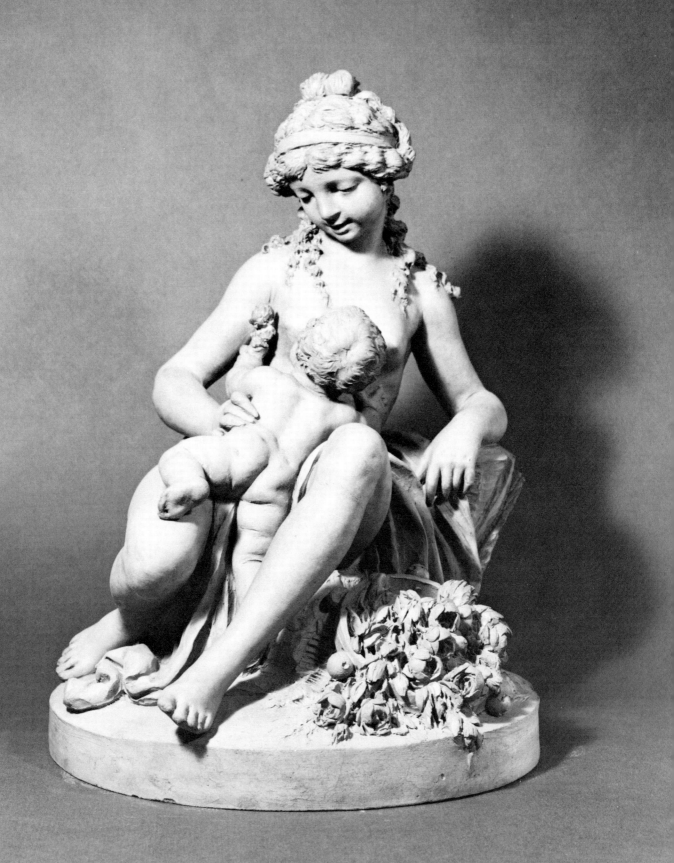

50 *Christ and Saint John the Evangelist*, painted wood, Germany, Swabia near Bodensee (Lake Constance), early 14th century.

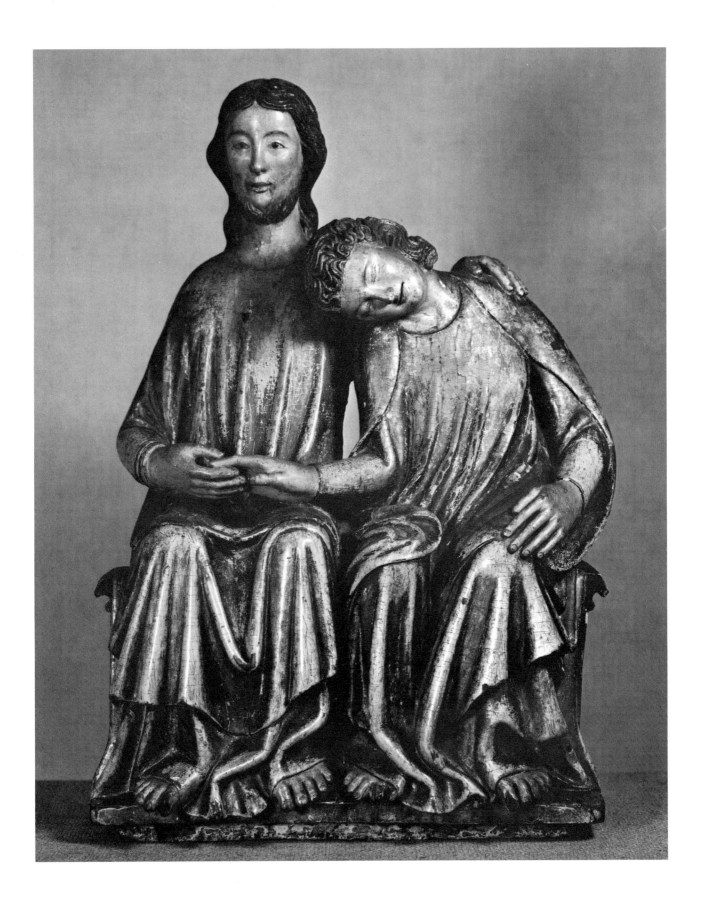

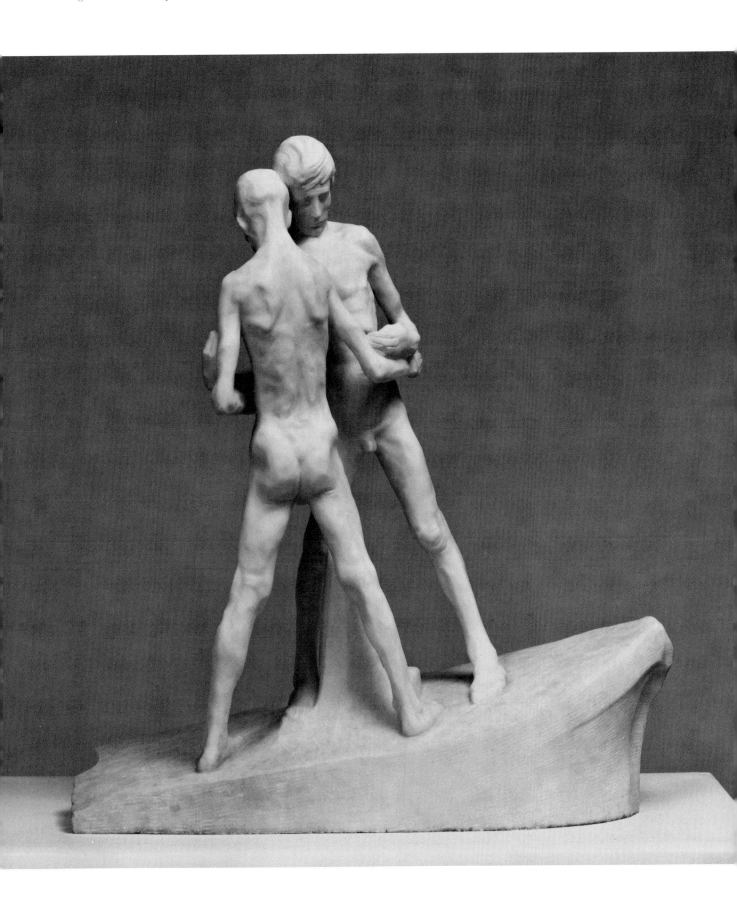

51 George Minne, *Solidarity*, marble.

52 Henri Matisse, *Two Women*, bronze.

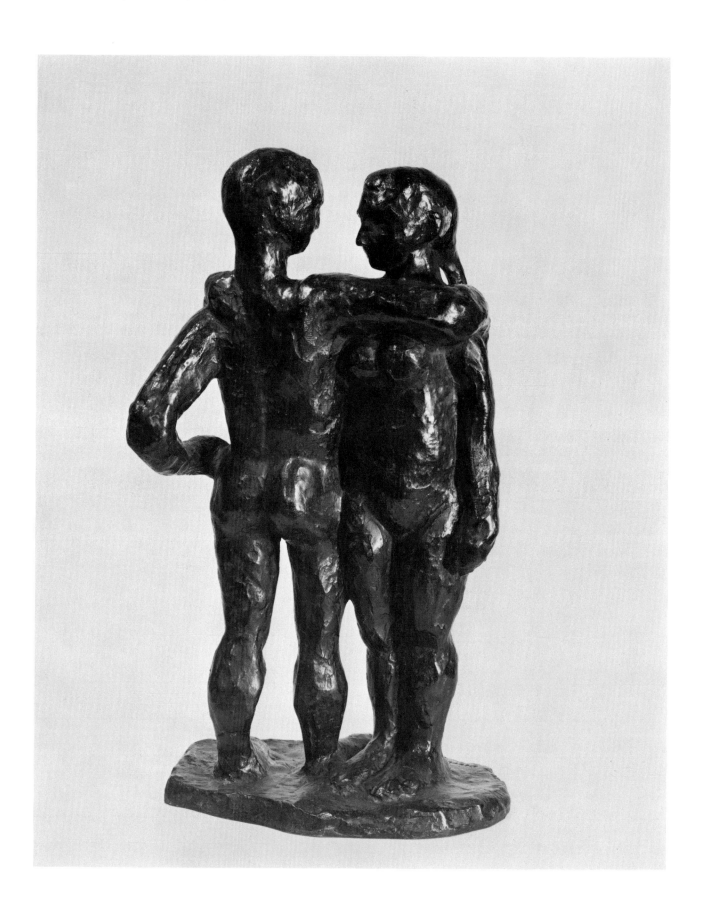

53 Auguste Rodin, *Les Damnées*, bronze.

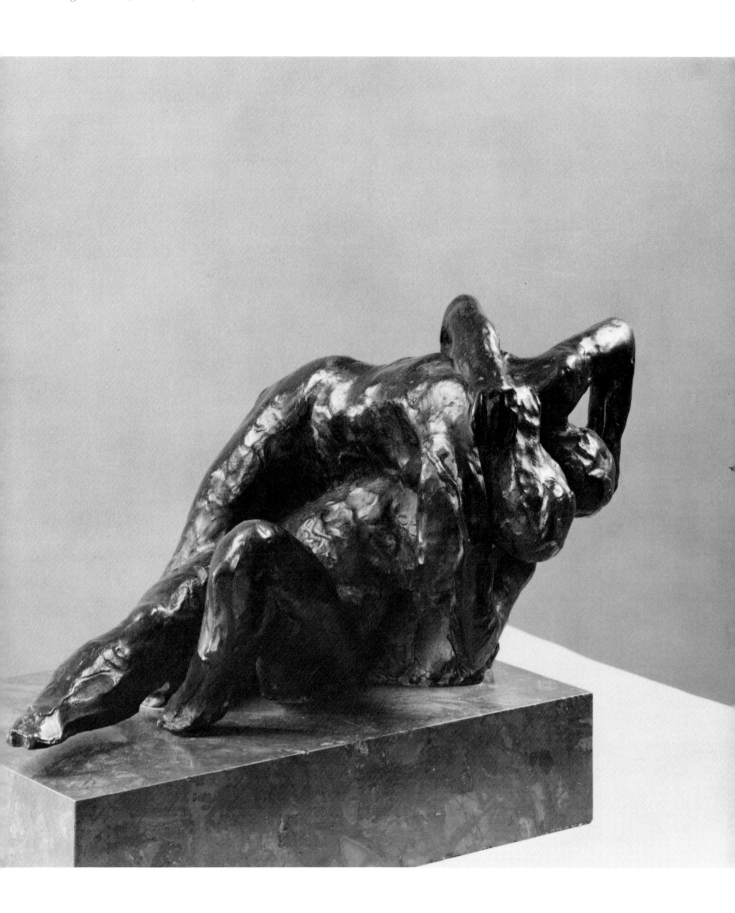

54 *Woman and Child (Ancestor or maternity figure)*, wood, Africa, Western Sudan Style Region: Ivory Coast, Korhogo District, Senufo Tribe (Siena), probably ca. 1930.

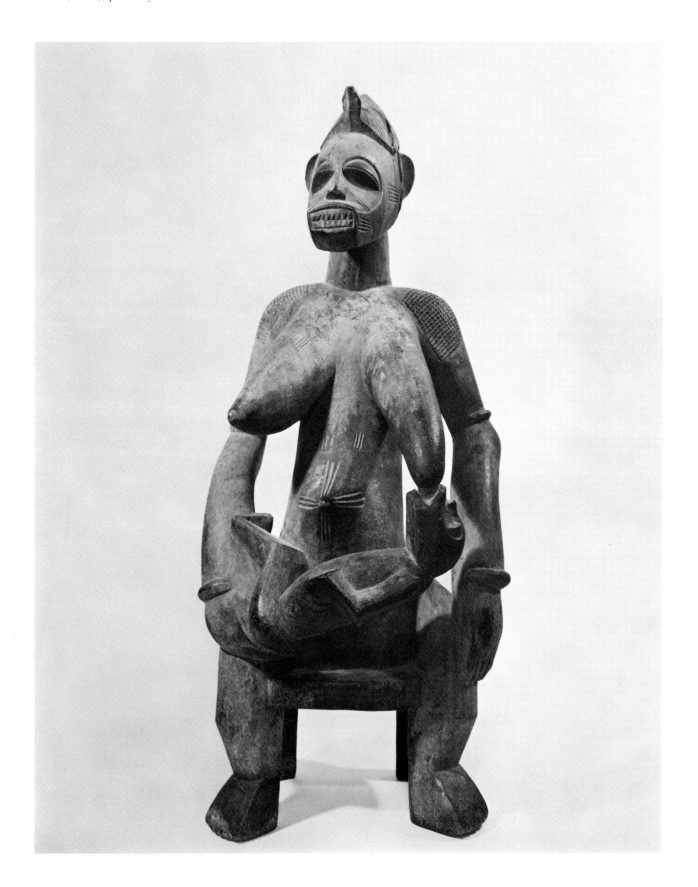

III. The Portrait: The Realistic Portrait

One large category of sculpture has been given over to examples which record individuals from a specific time or place. Often a sculptor was called on to immortalize his patrons or friends, occasionally to memorialize an ancestor for a new generation. These portrait busts were meant to "duplicate reality," to make concrete and lasting likenesses of people who had died or of close companions that one wanted to remember.

The tradition of duplicating forebears began in Rome and is recorded in a *Portrait of a Man* [55], which meticulously details facial features, capturing the subtle indentations of the muscles.

Exacting studies of individuals were maintained in other countries and periods, from the two marble heads produced in France during the first part of the sixteenth century [56, 57], to portrait studies created in the eighteenth and nineteenth centuries. In the former, the detailed exactitude of expression and dress not only records a suggestion of the life of the period, but demonstrates that sculptors never tired of emphasizing visual correctness in works imbued with dignity and careful observation. Sculptors from more recent periods sought to capture the cheerfulness and nonchalance of the French aristocracy [58] and to record the inner turbulence of a creative personality through portrait busts of artist [59] and writer [60]. In the latter examples the animation of the surface, combined with the straining expression of inner force, creates a continuing romantic icon of an artist as creative genius observed intently.

By the end of the nineteenth century, many of these carefully-composed likenesses—often mirroring the passion of the tangible personality—were subtly revised. Busts by Medardo Rosso [61], where a wax surface was placed over a plaster base, not only suggested skin but led the artist toward an even deeper probing of emotional states, such as the pathos in this artist's study of a *Jewish Boy*. By forcing one to observe the piece directly from the front and casting a lock of hair in the forehead to keynote the central axis, the sculptor makes the viewer feel the anguish of this small child on the verge of tears.

Starting with a topographical examination of the human face and attempting to render precisely what they saw in front of them, sculptors duplicated observable reality. By studying subtle nuances of feature and momentary shifts in personality, the sculptor—through portraiture—reached toward a deeper understanding of his model.

55 (Below) *Portrait of a Man*, bronze, Italy, Roman, late Republican, 40-30 BC.

58 Jean Baptiste Lemoyne, II, *Bust of a Woman*, terra cotta.

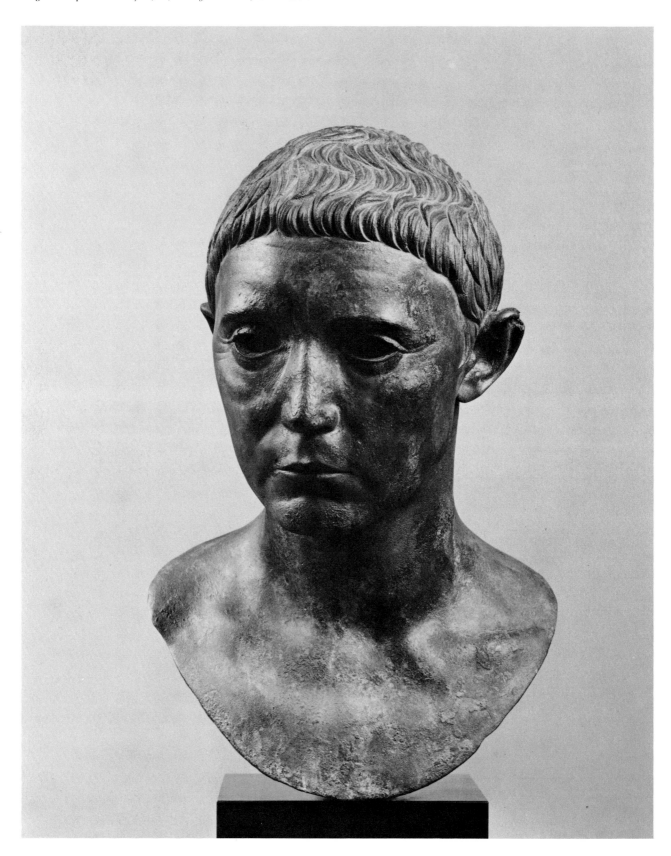

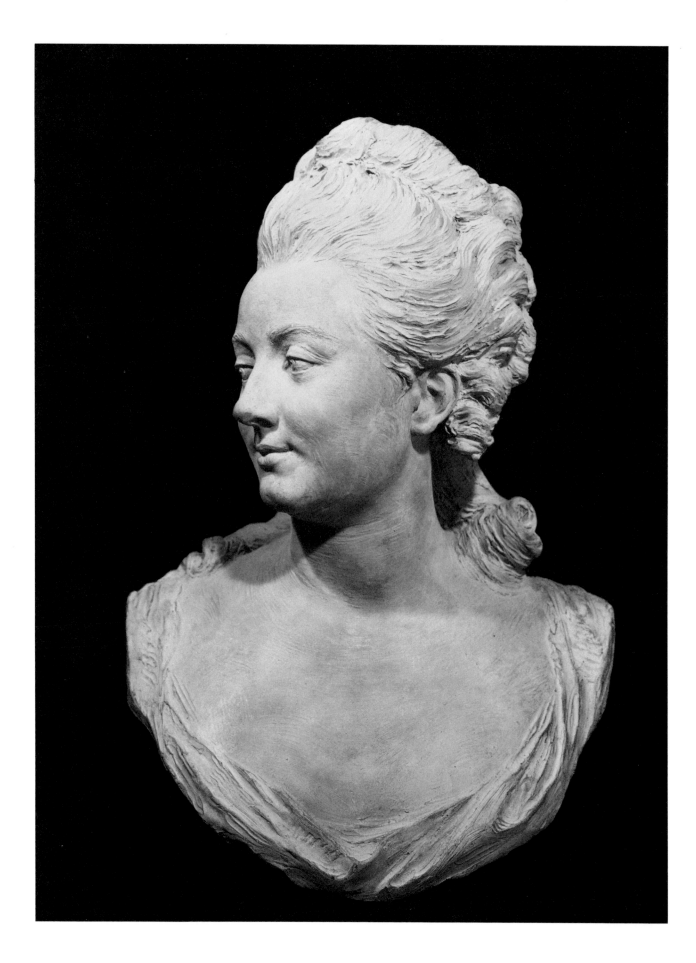

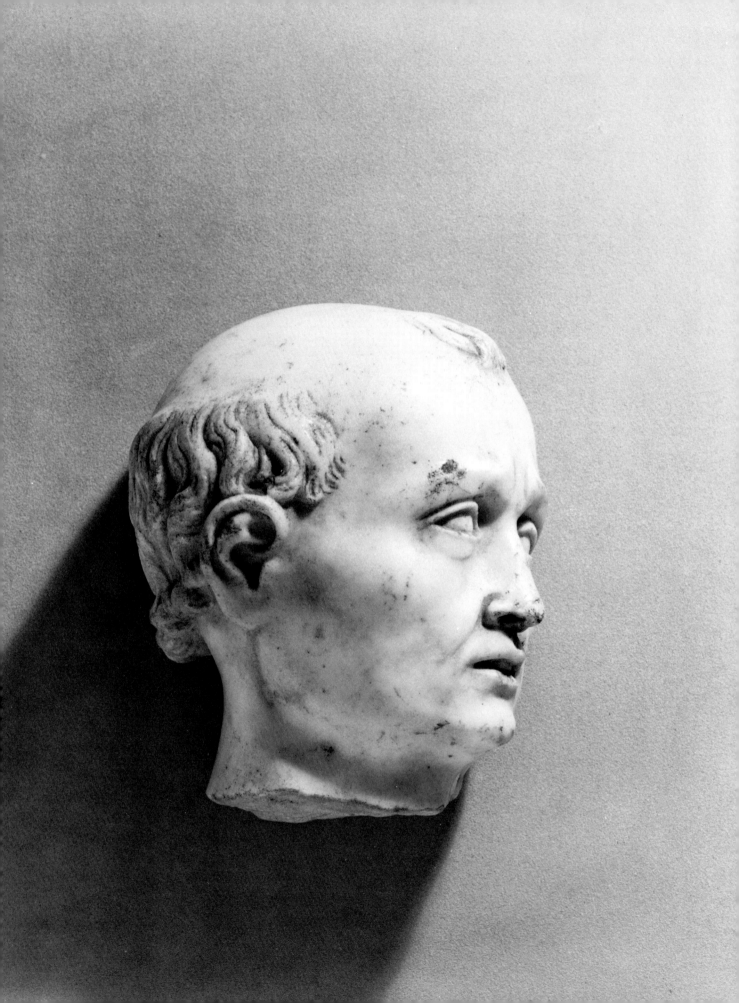

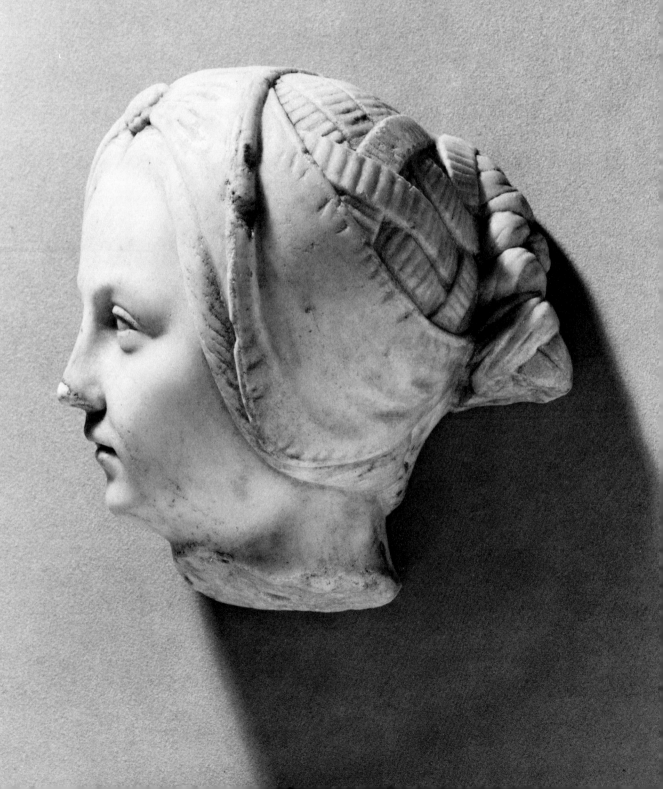

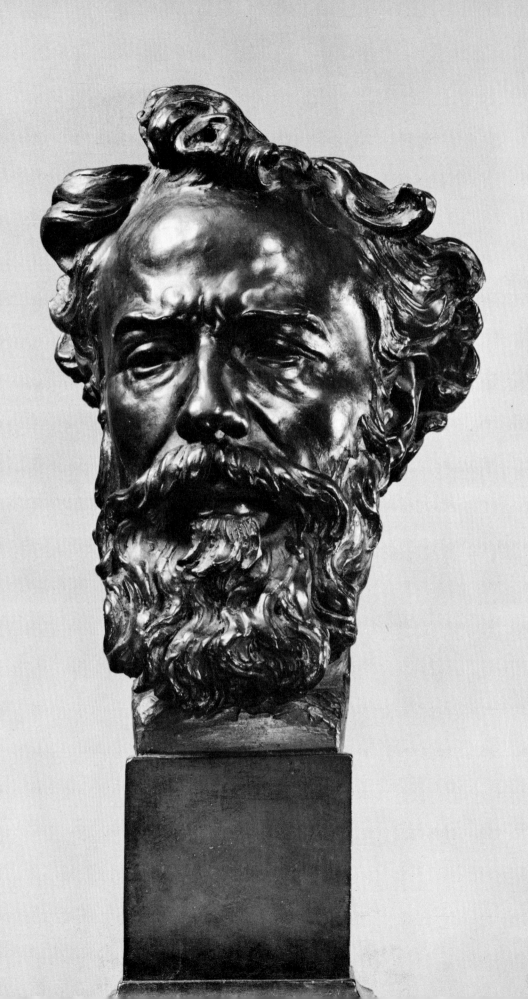

59 Jules Dalou, *Head of Alphonse Legros*, bronze.

60 Theodore Riviere, *Bust of Tolstoi*, bronze.

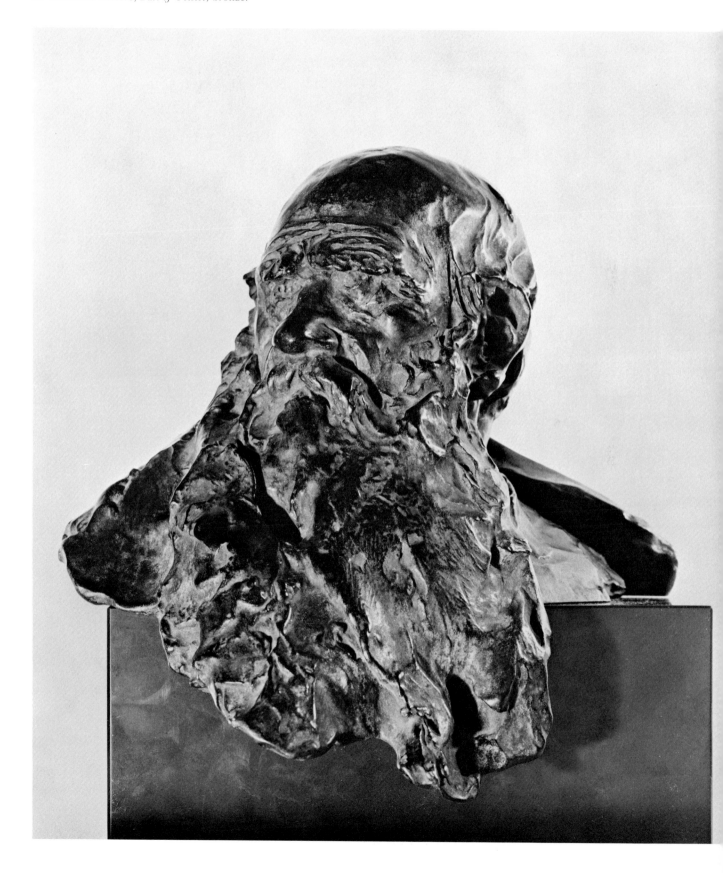

61 Medardo Rosso, *The Jewish Boy*, wax.

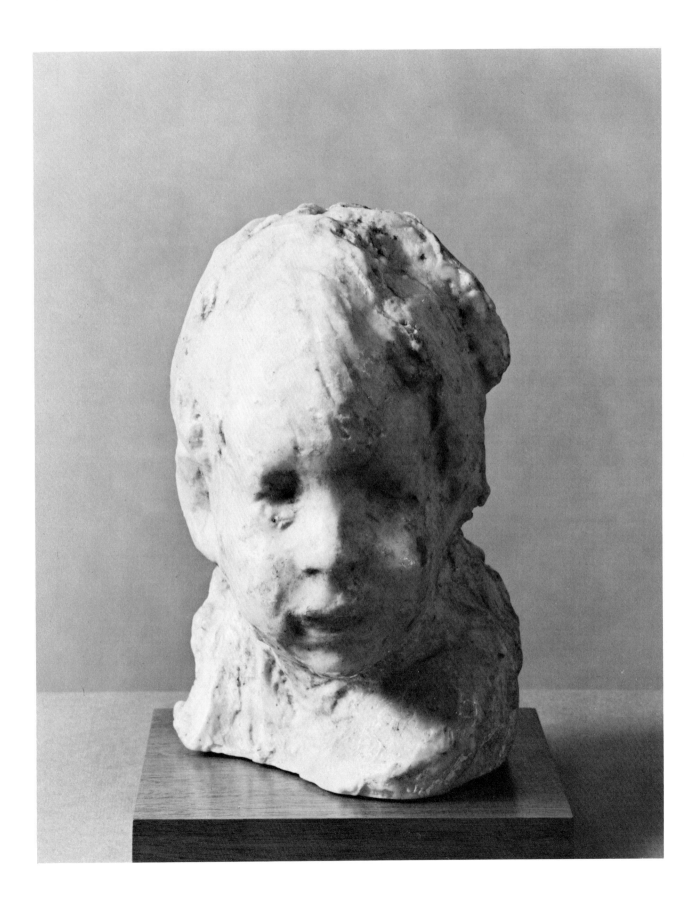

III. The Portrait: The Portrait and the Ideal

Sculptors have frequently moved away from observed reality toward themes which were motivated by visions of idealization—images that were thought perfect through a process of adding or taking away. The completed work, then, was not meant to duplicate reality as much as to satisfy an inner desire to beautify and modify form according to the highest ideals of perfection.

Examples from the classical world can be used to formulate canons of beauty, as in the portrait study of *Head of a Woman* [62], where the contours of the face are represented in the tradition of the day. Nothing is meant to individualize—to make a viewer think of a specific living person—as was the case with *Portrait of a Man* [55] in the previous grouping. Instead of providing details, the sculptor generalized form, creating a standard image of idealized female beauty. This path was re-echoed in following centuries: during the Renaissance when sculptors revived classical models, there was a desire to capture the charm and elegance of goddesses as forerunners of the beautiful women of the day. The *Bust of a Young Woman* [63] strongly suggests the highest qualities of this idealized grace. In the twentieth century, Gaston Lachaise—a student of French Beaux-Arts training—understood his lessons well, since his *Head of a Woman* [64] not only reiterates a debt to the classical past but suggests that he had gone one step further by imposing his own personal vision of womanhood upon his sculptural examples. Instead of working within the confines of a conventionalized formula which would apply to an entire age, Lachaise developed his own personal vision of an idolized feminine mystique, in which the fleshiness of the model's features shaped his sensual image.

Unusual juxtapositions from other cultures and periods are also possible, especially if one does not expect to find the sculptor recreating specific personalities, but rather using the category of the portrait to create a "type" which is appropriate to the purpose he has in mind. The Celtic *Head* [65], while suggestive of twentieth-century tendencies, suggests the form of the human head through a series of geometric modifications of the stone. In India, a similar process of conventionalization was used in the *Head of a Rishi* [66], an aged, bearded, ascetic type produced shortly before the Gupta Period, when the country achieved harmony of form similar to the Greek Golden Age.

From an examination of both these portrait themes, it is possible to see two simultaneous traditions. On one side are those artists who accurately reported what they saw in almost topographical fashion, and who eventually extended sculptural portraits into a deeper emotional sphere by examining differing phases of human expression. In the other group are artists who modified what was before them, adding or shifting emphasis, to arrive at an approximation of the human head or an idealization of form. These either reinforced the standards of the period or met the demands of the artist's own personal vision.

62 (Below) *Head of a Woman*, marble, Italy, Roman, ca. 1st century BC.

63 Tullio Lombardo, *Bust of a Young Woman*, marble.

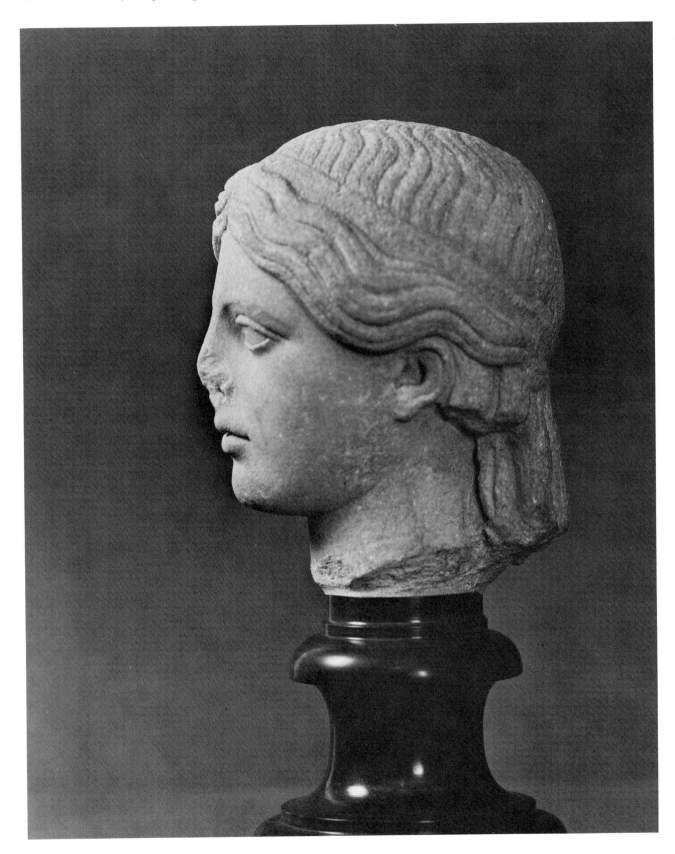

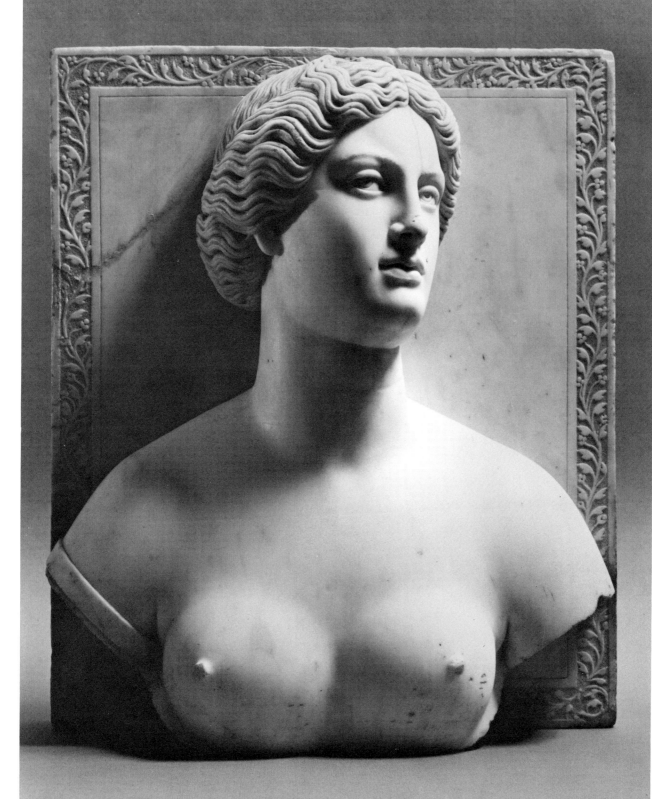

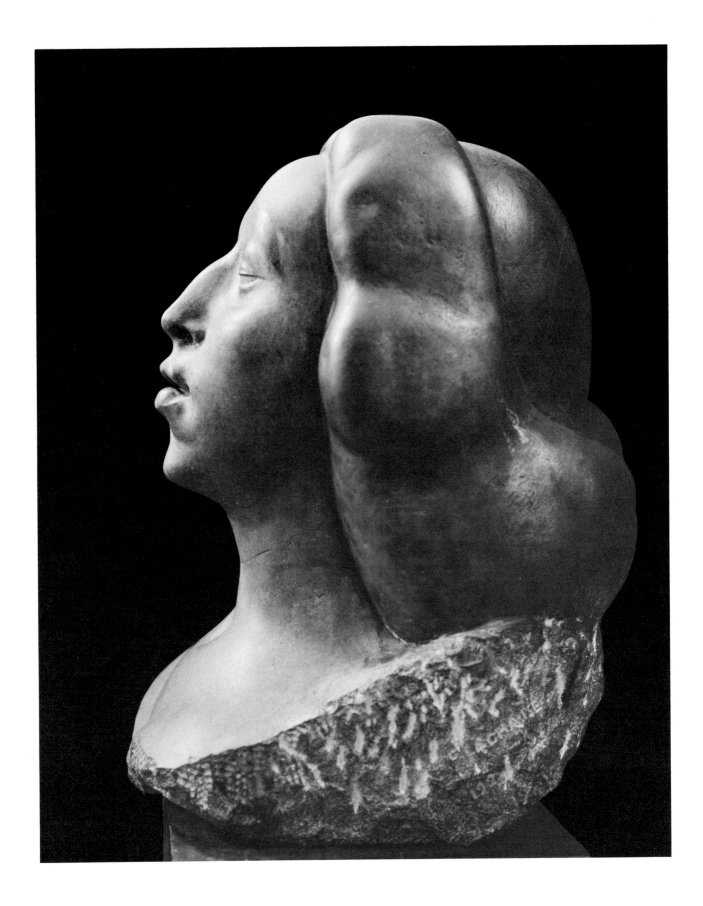

65 *Head*, stone, Celtic, 2nd-3rd century.

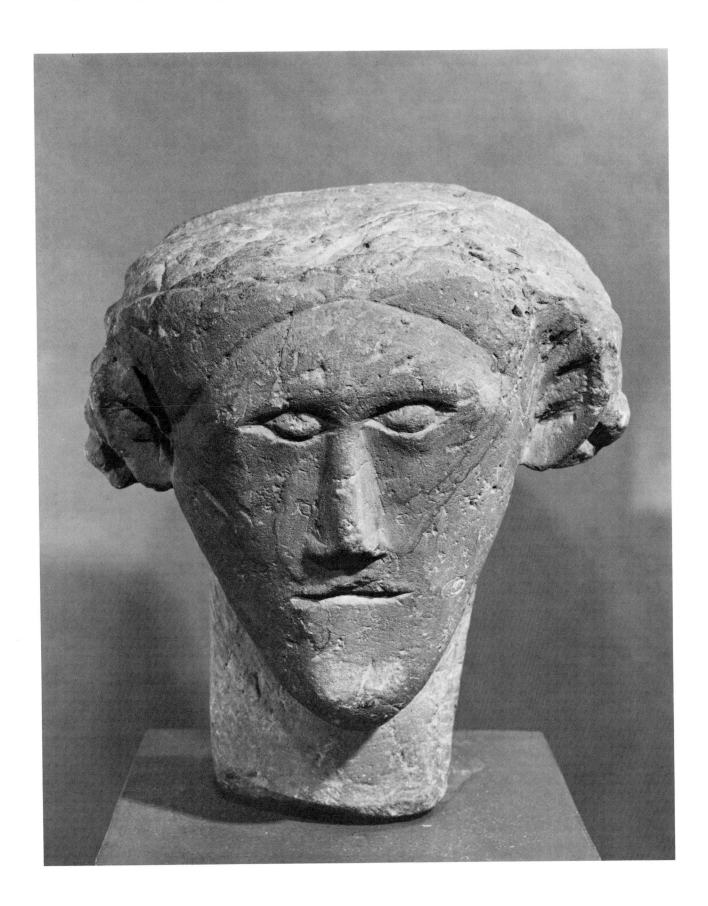

66 *Head of a Rishi*, sandstone, India, Kushan Period, 2nd century or earlier.

IV. The Relief

Purposes of relief sculpture vary with the intended location, but generally few examples in this art form are as committed as these are to telling a readable story. Examples, frequently having several figures, were often shown as part of a narrative series, so that a cycle of events could be chronicled, and a viewer could be able to move from one relief to the next understanding the events being commemorated. Occasionally a running text accompanied these images—either being incised over the forms or being placed in open sections above or below the figural zones. Aside from the purely pictographic purpose described above, some reliefs were incorporated into an architectural matrix [69] and were meant to be viewed as part of a logical scheme. Sculptural reliefs used in this fashion were connected with religious and secular cermonies. Commemorative aspects are also associated with relief sculpture as found in several examples from the Far East: a stele [70] and an urn [72], where conventionalized attitudes and ease of visual legibility coincided with similar tendencies observable in Western examples. Aside from these directions, other reliefs demonstrate how sculptors were involved with more aesthetic concerns visible in their handling of space [68] and form.

Within this thematic grouping, there are several ways in which to examine sculptural reliefs. The first, and perhaps the easiest, is recorded by Egyptian reliefs [67], which captured the life of a pharoah or the activities of servants. By reading a relief, such as one on a burial tomb [68], as a historical document as well as a work of art in itself, it is possible to reconstruct attitudes of a civilization which sculptors were called upon to immortalize.

The second way in which to focus upon a sculptural relief is epitomized by examples from the Middle Ages, where sculptors were called upon to create symbolic approximations of religious figures which often incorporated demons or monsters as their tempters. Often the placement of a central figure was easy to locate, since the form was enlarged [69] and rigidly erect. Attributes were also used to help a viewer to identify the figures upon entering the sanctuary in which these objects were displayed.

Religious examples are also found in the Far East. *Stele: Sakyamuni Trinity* [70], with a background form of a mandorla, uses other figures (smaller in size) so as not to detract from the central focus—the Buddha. A viewer, able to identify the figures in the stele, knew how to react to this commemorative monument created for the greater glory of Buddhism. Similarly, an Indian relief—*The Adoration of the Bodhi Tree* [71]—focuses

attention on the tree of enlightenment, under which the Buddha sat, by reducing the attendant figures in scale. When forms appeared on a more utilitarian object, such as an urn [72], the same principle is found. With these examples, from both the Far East and the West, it is possible to note that artists used conventionalized traditions to present messages bluntly to their audience.

Reliefs were occasionally created for other reasons, projecting a gentler, quieter mood. This is the case with a *Madonna and Child* from the circle of Bartolommeo Bellano [73], where not only is attention paid to religious iconography, but where the sculptor is able to examine aesthetic concerns more fully than his predecessors. The modelling of the figures shows differing levels of shallow space. The slightly turned pose of the Madonna underscores this preoccupation. The handling of the drapery, which clings to the Madonna and at which the Christ child tugs, shows how the sculptor was moving away from a solely iconographic point of view toward integration of naturalism with the classical past. This tendency is further enlarged upon by Henry Cros in his relief plaque in *pâte-de-verre* [74], symbolically entitled *Incantation*. Here the classically inspired nudes have been placed in shallow space, and their forms melt and merge with the surroundings. The glass medium enhances the ethereal otherworldliness, re-emphasizing the point that reliefs could present clarity of imagery as well as suggest modern aesthetic tendencies.

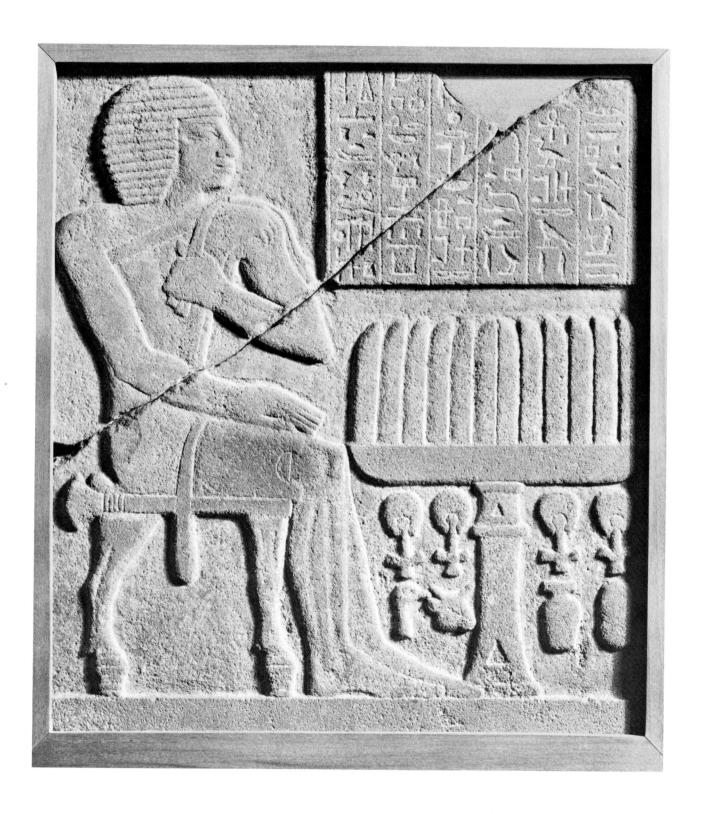

69 Engaged Capital: *Daniel in the Lion's Den*, limestone, France, basin of the Loire, mid-12th century.

70 *Stele: Sakyamuni Trinity*, micaneous limestone, China, Eastern Wei Period, dated 537.

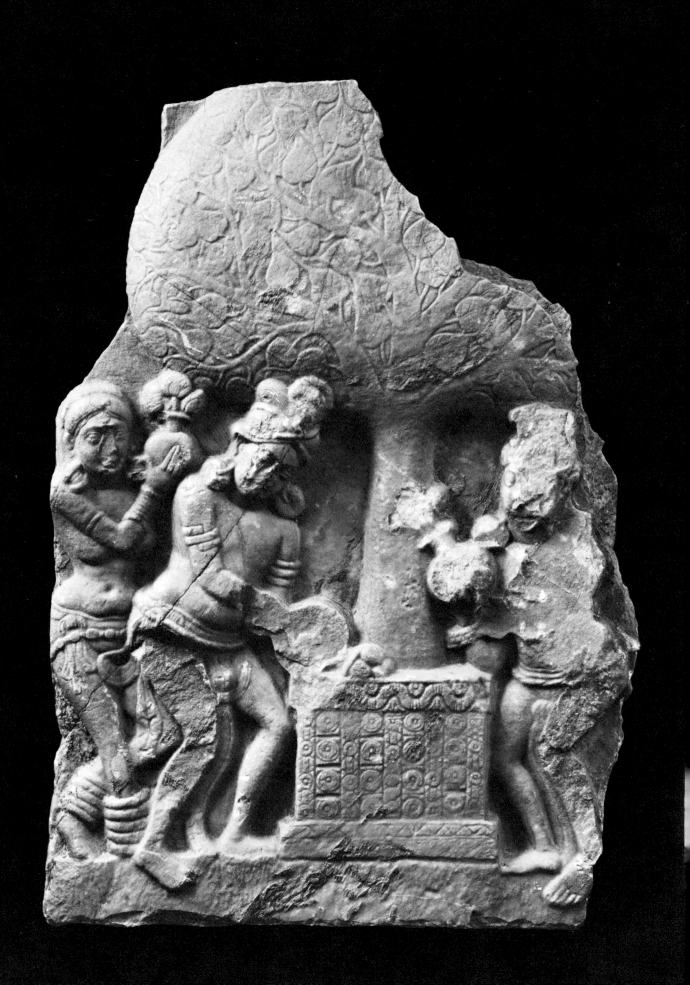

71 *Adoration of the Bodhi Tree*, limestone, India, Amaravati, 3rd century.

72 *Square Urn with High Relief of the Four Lokapalas*, marble, China, T'ang Dynasty, 8th century.

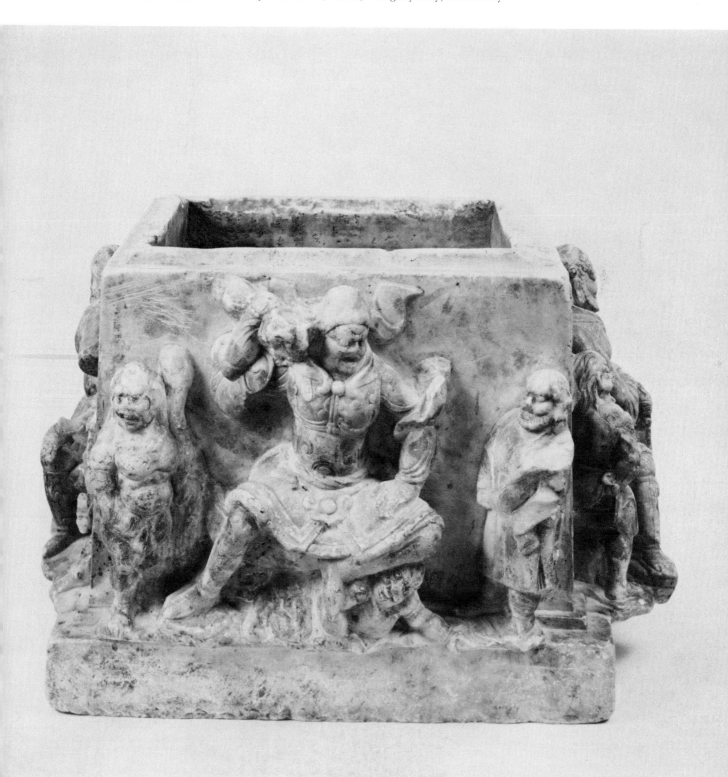

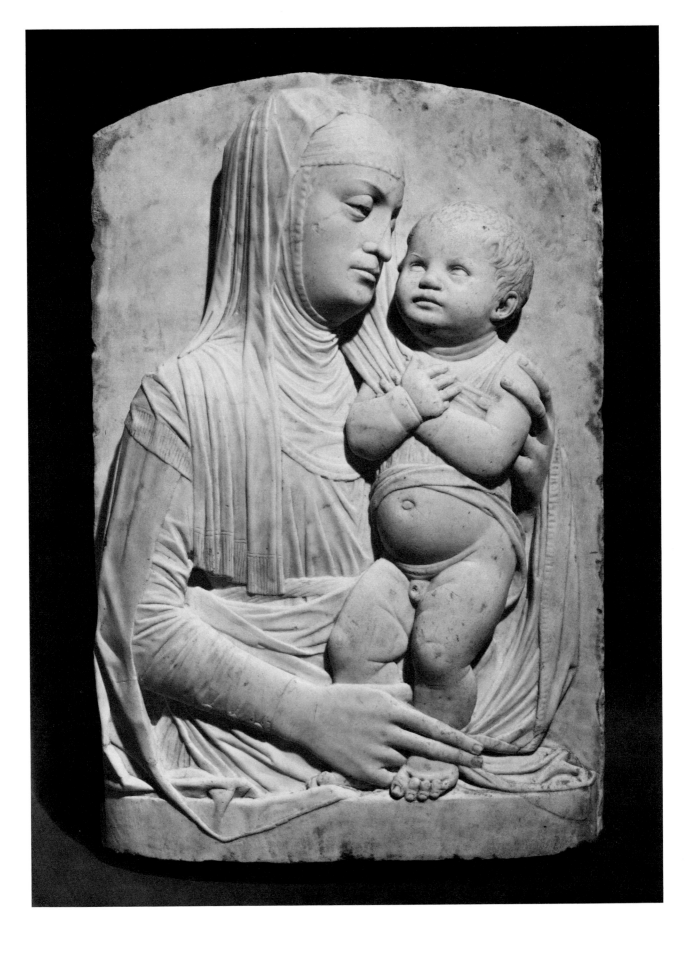

73 Circle of Bartolommeo Bellano, *Madonna and Child*, marble.

74 Henry Cros, *Incantation*, pâte de verre relief.

V. Animal Imagery

Besides the continuous interest in the human figure, other sculptural themes have been used from earliest times to the present. Animals have provided a consistent source of imagery as sculptors have chosen this category for a number of purposes: for function, for iconography, and for an inherent interest in another image visible in the world which the sculptor wanted to render in concrete terms. Often the animal shape would be shown and studied independently; in other instances, the animal would be placed either in an exaggerated depiction in order to personify a monster or in conjunction with a human being. In each of these cases it will be helpful to examine the reasons why animal imagery was so prevalent in three-dimensional form.

The Animal

In the ancient world, the bull took on significant symbolic roles, since it was an animal that was easily accessible and often domesticated. A *Recumbent Bull* [75] from 2700 BC reflects the ancient belief that the bull was a fertility symbol, and that an image of this animal carried aloft in religious ceremonies would improve fertility for all the flocks in an area controlled by a temple. A second bull, variously cited as either charging or pawing [76], from fifth-century Greece, again shows the ancient sculptor's interest in accurately recording an animal since it was associated with myths or legends that centered on the image of the bull. By far the largest of the ancient sculptures representing this animal is the Egyptian *Apis Bull* from 380-343 BC [77]. In this case the sculptor has created a dominant image, since the Apis bull cult was all-important in this country and was encouraged as a form of worship to the God Ptah. This seems a further manifestation of the bull as a sacred animal, having supreme importance not only for the civilization itself, but being a paramount image for sculptors who were creating examples to be used for religious and ceremonial functions where the image of the bull was meant to be honored and deified. In the study of this animal, the sculptor showed his mastery of anatomy and pose, but detailed realism was not always a major concern.

In the Far East, animals also played an integral role in the civilization and are found in the world of art. A Shang or Early Chou bronze vessel of an *Owl* [78] shows this preoccupation at an early date. This object was not only to be venerated, but was to be used in a ceremonial service as a ritual wine vessel. The decoration on the piece—including the demon mask on the wing area—underscores the highly conventionalized patterns that the artist was able to create from the form of a bird, often integrated with other animal shapes such as a serpent. For the most part, other examples of animal imagery with a practical purpose underplay the interconnections with other animals in favor of representing a single animal in a recognizable form.

Japanese Haniwa figures [79] placed near a burial mound were most successful when they dealt with images of animals—perhaps as a reminder of the material possessions that the departed had in life and which were to accompany him into the next world. Beyond this, the Haniwa figures became substitutes for actual forms, providing early examples of this purpose for sculpture and permitting modelling of form with an understanding of the material being employed so that a natural quality remains. Later representations of horses carried realism and duplication to more precise limits, as the Chinese tomb *Morturary Horse* [80] from the Six Dynasties Period and the elegant *Horse* [81] from the T'ang Period show an exacting study of anatomy, pose, and coloration. Occasionally a Chinese example—such as *Pole Top: Wild Ass* [82]—also captures the spontaneity of pose and the personality of the animal in a style that seems decidedly graceful, as if the Far Eastern artist were striving to go beyond merely recording visible effects.

Animal sculpture had other purposes besides those outlined above, many of which were ceremonial. The figure of a lion was often used to suggest divine protection and hence ward off evil spirits. This seems the case in a Cambodian *Lion* [83] from the twelfth century, which could have been placed along a sacred pathway or in front of a shrine, and a wood *Kara-shishi* [84] from the Kamakura Period, whose purpose was to serve as a guardian of sacred places. Thus the role of protector was also forced upon animal sculpture.

Artisans and sculptors often disguised the purpose of an object by creating an animal shape. Thus incense burners took on a recognizable animal form [85]; a rhyton appeared in the design of a horse [86]; and an aquamanile, used for washing the hands at a secular table, was made as a combination of a lion with a

75 *Recumbent Bull*, basalt, Mesopotamia, Sumerian, ca. 2700 BC.

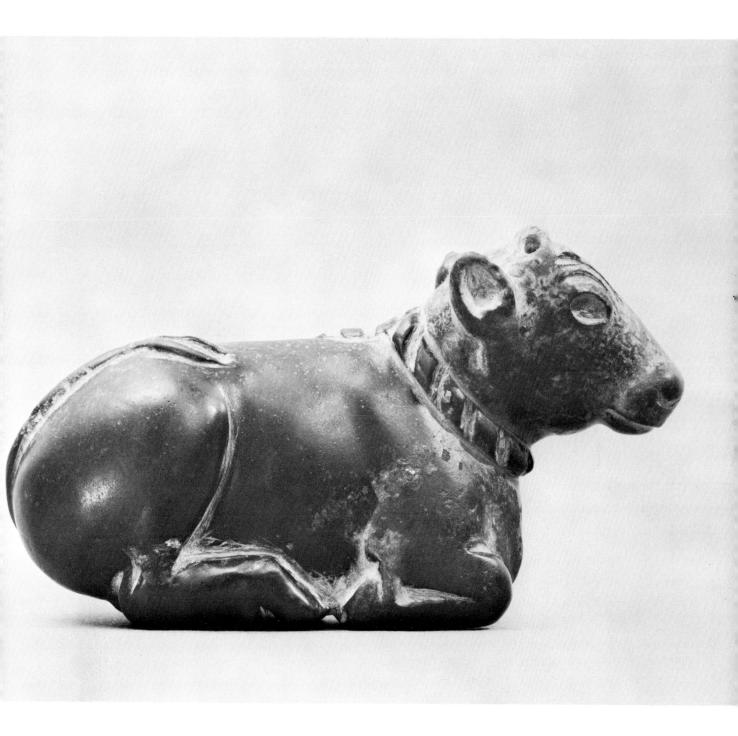

dragon's tail [87]. Another combination of two animals, the basilisk—half cock and half snake—appeared on capitals in the twelfth century [88]. The basilisk was commonly accepted as a symbol of the Devil or the Anti-Christ.

It is not surprising that, with this well-established tradition, animal sculpture appears in nineteenth-century Western art. It flourished as part of the romantic period's study of passions and temperaments in nature [89]. From all of these examples, one may see that animals were used everywhere as part of a continuing sculptural vocabulary and were used for a variety of purposes and roles depending upon the time and culture.

76 *Charging Bull*, bronze, Greece, Lucania, 5th century BC.

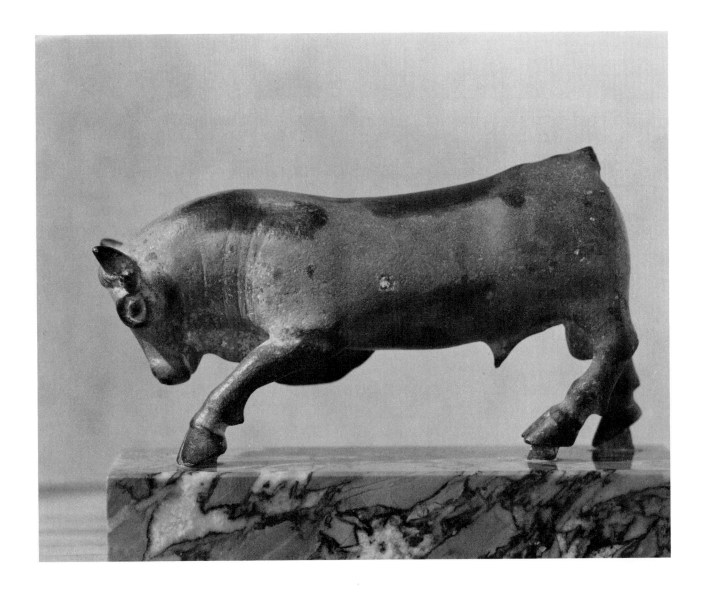

77 *Apis Bull*, green serpentine, Egypt, ca. Dynasty **XXX** (380-343 BC).

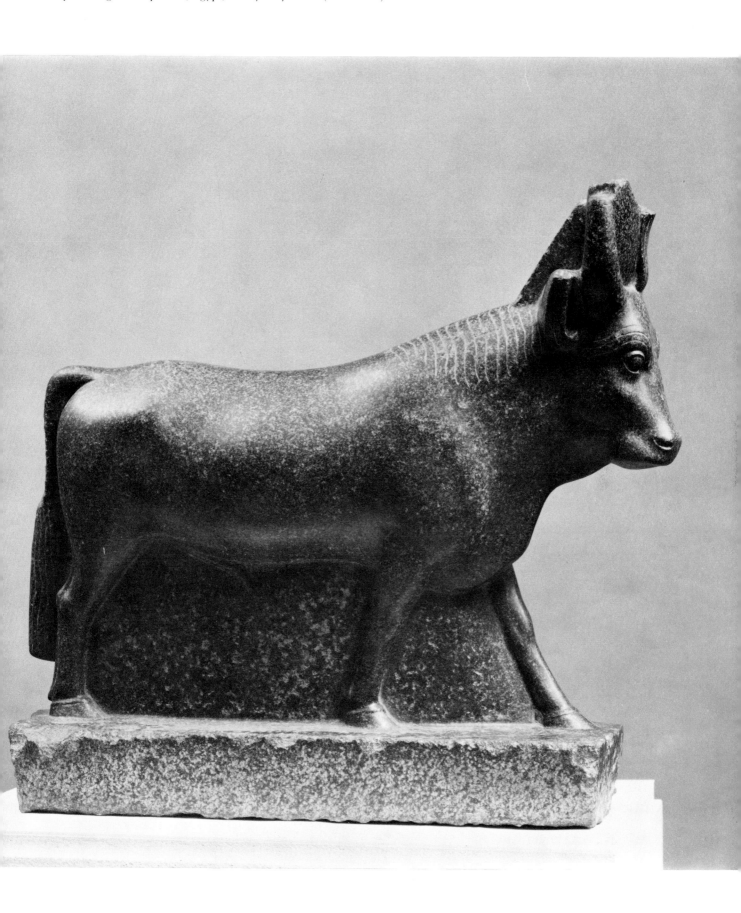

78 *Owl Tsun*, bronze, China, early Western Chou Period (1027-ca. 771 BC).

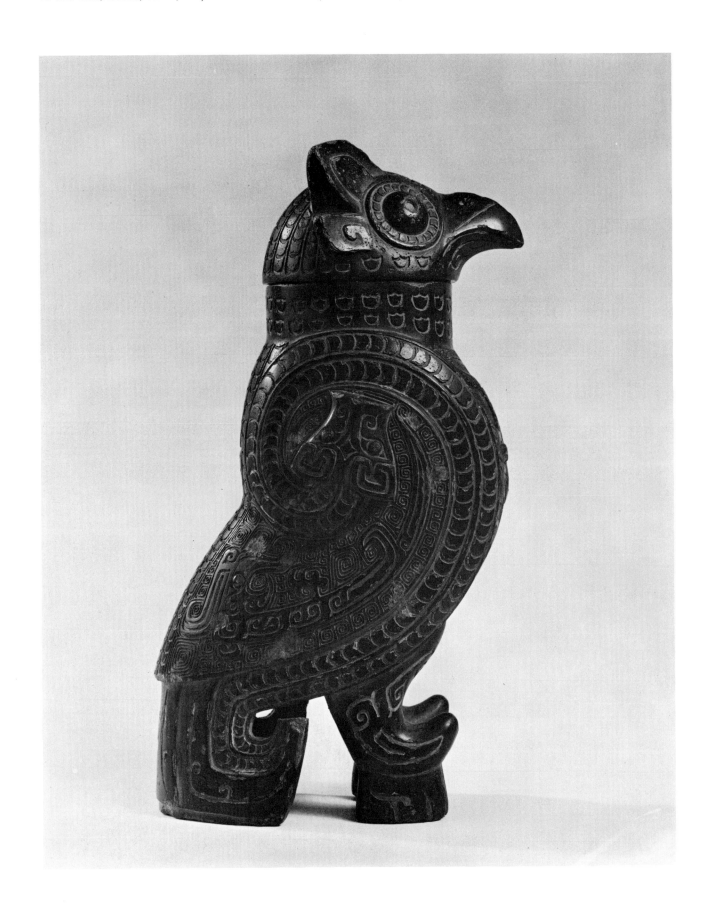

79 *Horse*, terra cotta, Japan, Kofun Period (Haniwa), 200-552.

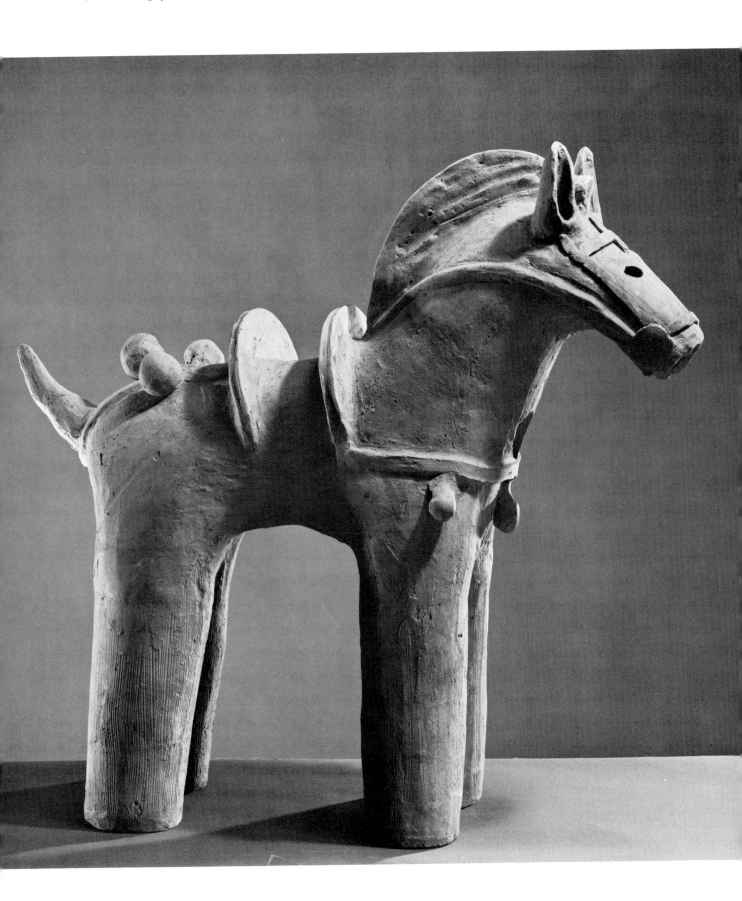

80 (Below) *Mortuary Horse*, pottery, covered with a white slip and painted in red and green pigments, North Wei Period, ca. 525.

81 *Horse*, pottery with three-color glaze, China, T'ang Dynasty, 618-907.

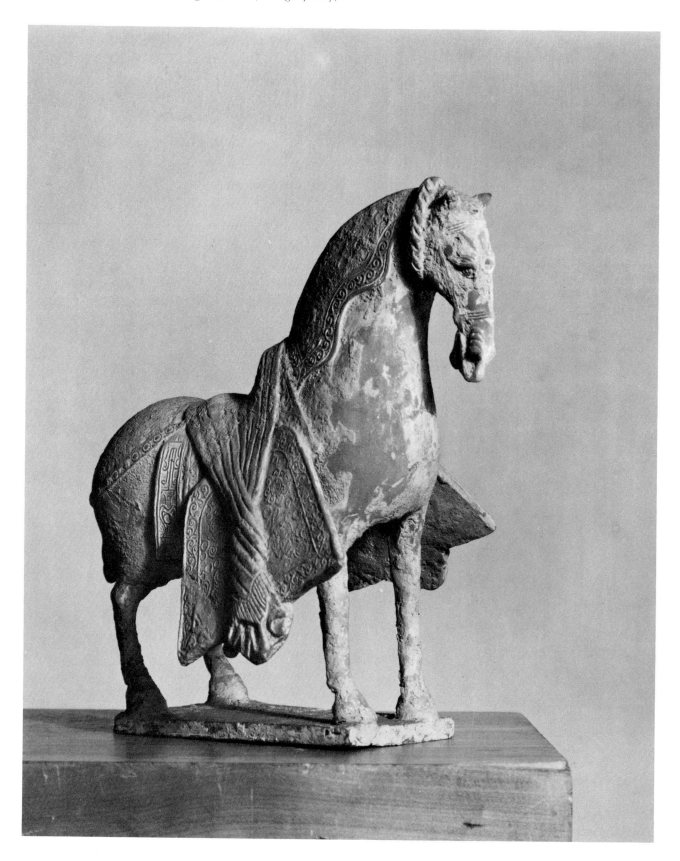

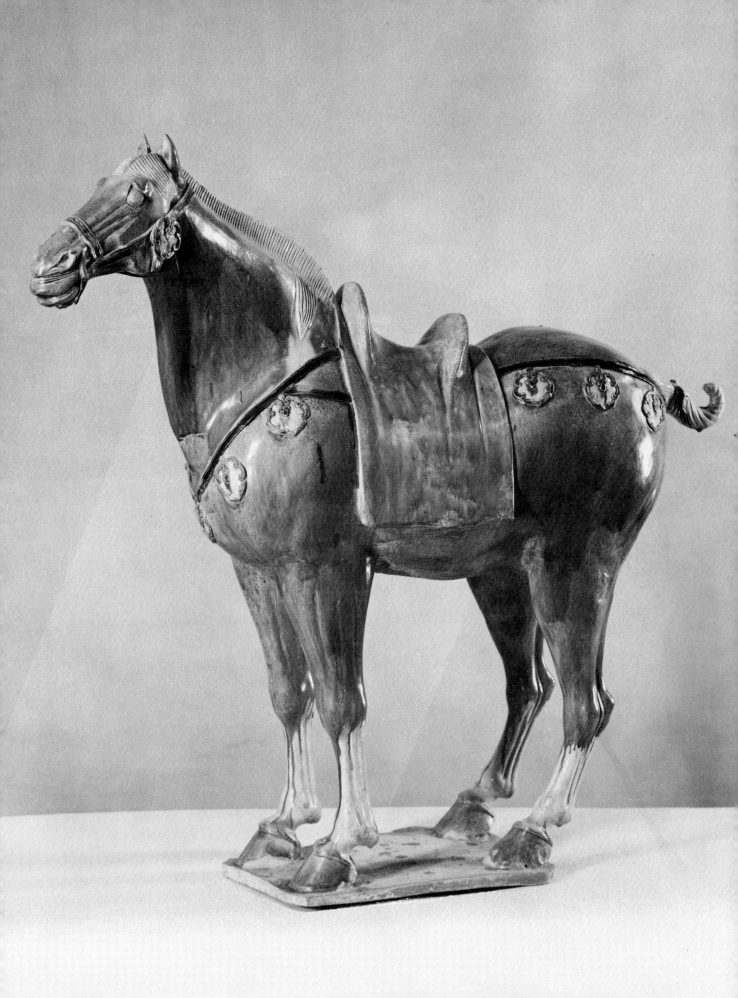

82 (Below) *Pole Top: Wild Ass*, bronze, China, Ordos Region, Han Dynasty, 206 BC-AD 220.

83 *Lion*, sandstone, Cambodia, Angkorean Period, 12th century.

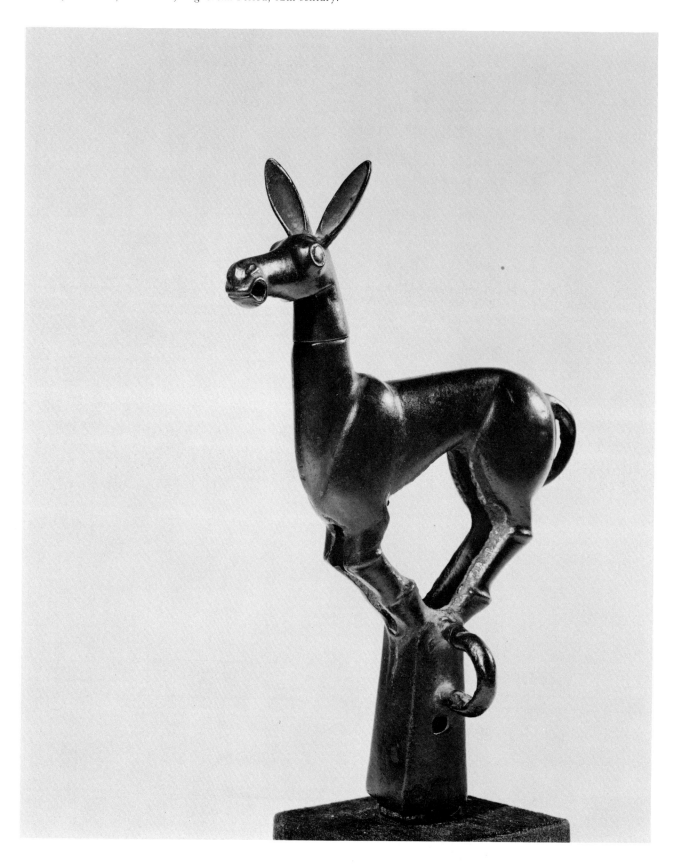

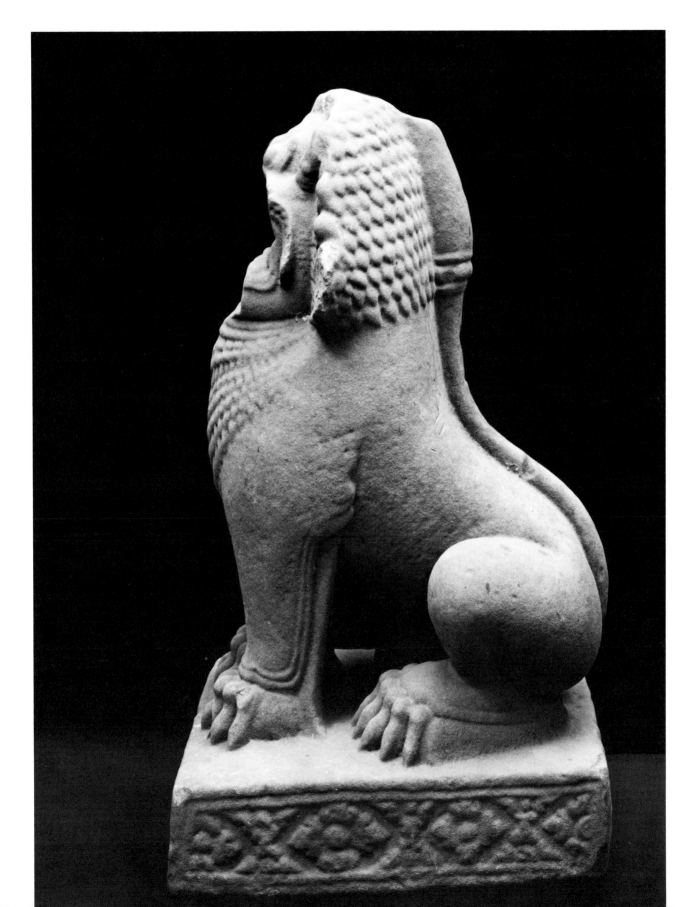

84 *Kara-shishi ("China Lion")*, wood, originally colored, Japan, Kamakura Period, 1185-1333. See also the Frontispiece.

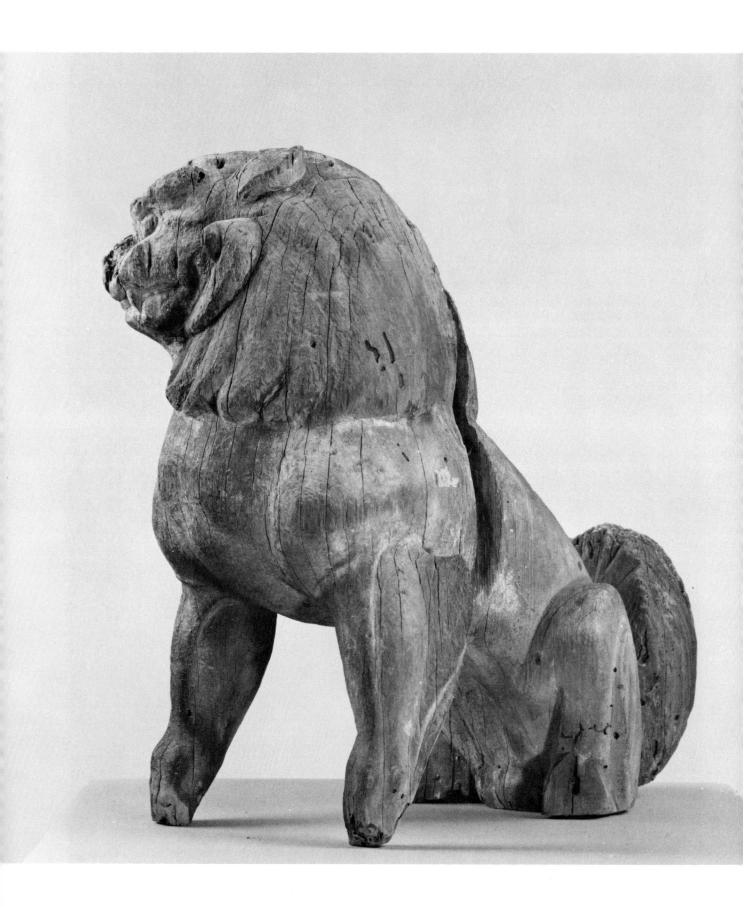

85 *Incense Burner in the Shape of a Lion*, bronze, cast and engraved, Iran, Seljuk Period, 12th century.

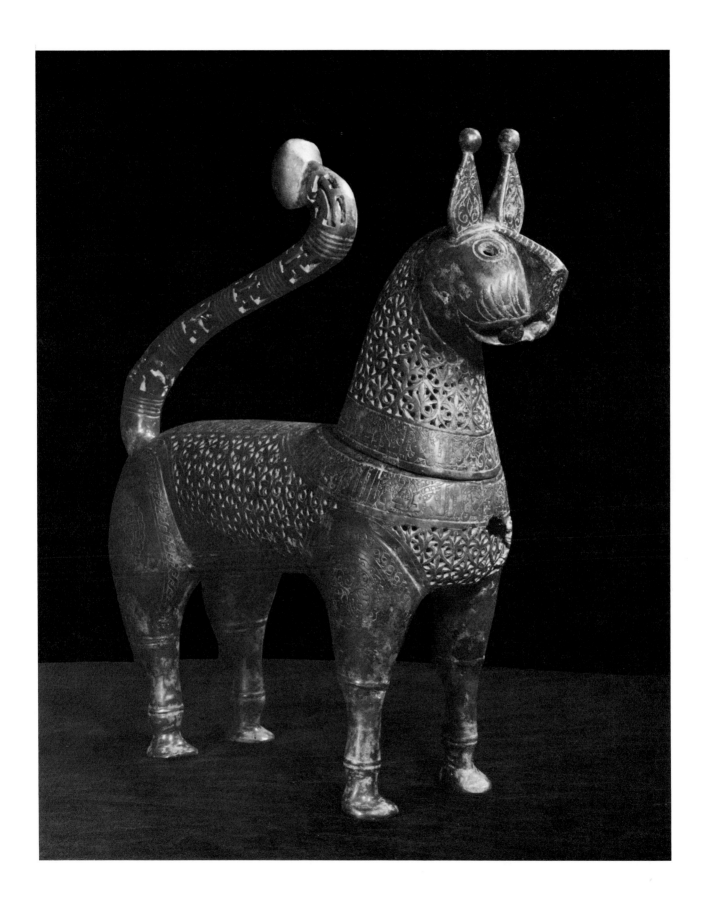

86 *Rhyton: The Allegorical Representation of a Divine Investiture,* silver: repoussé, engraved and chased with gold overlay, Iran, Sasanian Period, 3rd-4th century.

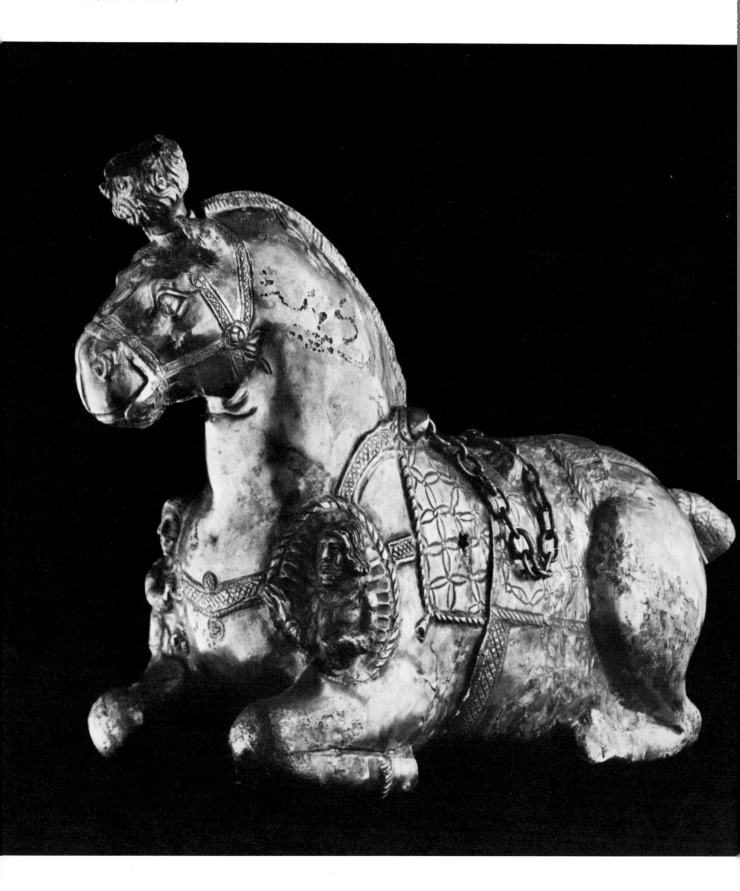

87 *Lion Aquamanile*, bronze, Northern Germany, Lower Saxony, probably Hildesheim, mid-13th century.

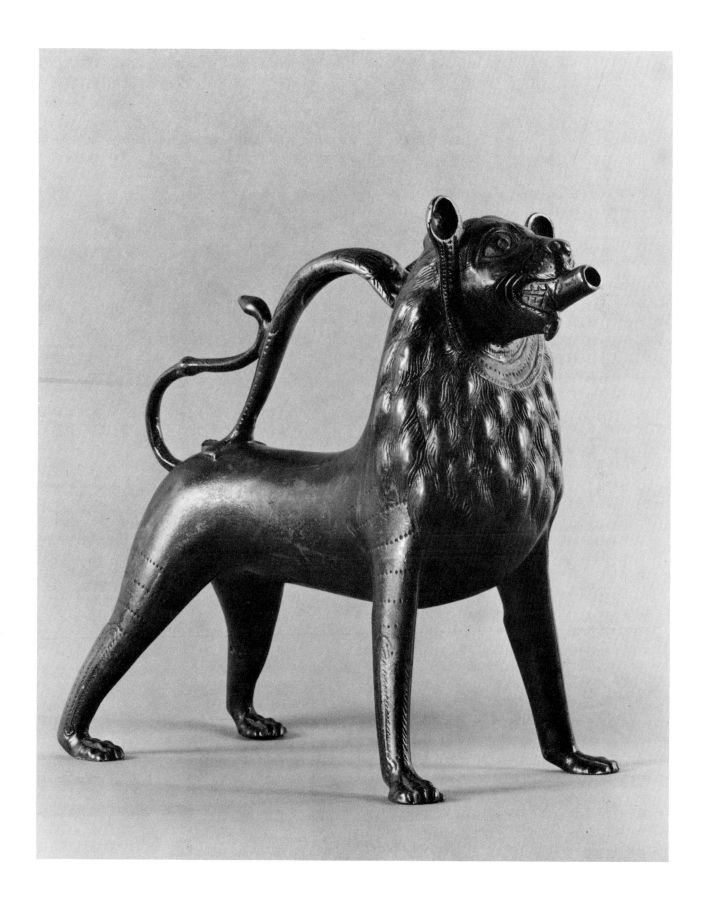

88 Engaged Capital: *Lion and Basilisk*, marble, Northern Italy, 12th century.

89 Antoine Louis Barye, *Tiger and Crocodile*, bronze.

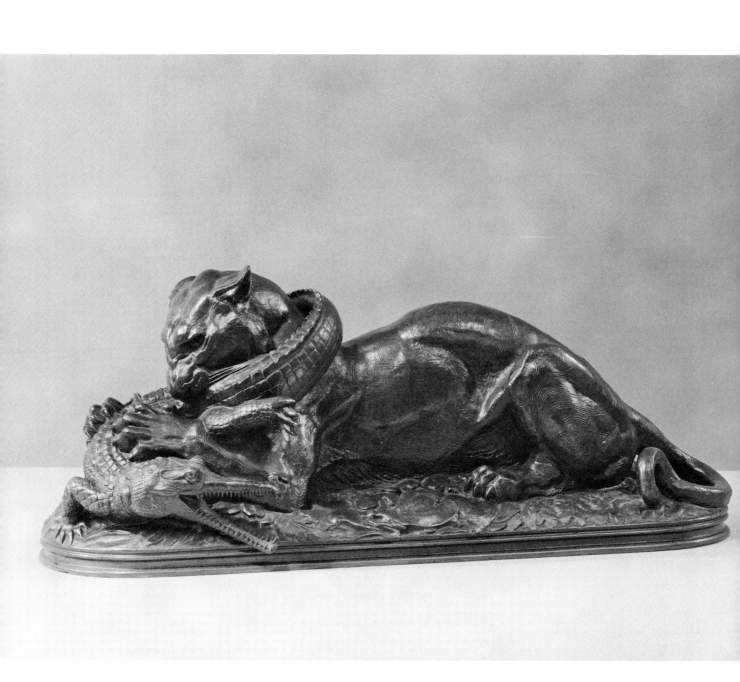

V. Animal Imagery: Man and the Animal

As a continuation of the basic interest in animal imagery, sculptors were interested in demonstrating how man and animal themes could be combined without creating a hybrid shape. During the Renaissance and shortly thereafter, subjects were selected which showed a saint interacting with an animal form.

One of the earliest pieces from the Cleveland Museum collection to use this subject is a work by Riemenschneider, in alabaster, of *St. Jerome and the Lion* [90]. In this example the lion reacts gently to the saint's interest in removing the thorn from the paw; the saint also closes his eyes in meditation as if to underscore the deeply religious quality of this miracle. A more vigorous confrontation between man and animal is often found in the theme of *St. George and the Dragon* [91]; an anonymous seventeenth-century piece seems no exception to standard depictions of this subject. While the saint stands above the monster with drawn sword, the animal writhes on its back with its paws flailing wildly in space. Perhaps the selection of this theme was not only religiously motivated but gave the artist an opportunity to concentrate on unusual movements appropriate to the age in which the work was completed.

In the Far East there was also a similar interaction between religious figures and divine attributes, as found in the *Boddhisattva* [92] from the Sui Dynasty and the *Ardhanarishvara Trident* [93] from the Chola Period. As in the West, these examples demonstrate how the animal world could be integrated with gods through the creation of religious icons.

Other cultures used animal and human shapes together in the same object. A *Malanggan Memorial Festival Pole* [94] combines bird and other animal motifs with the human figure in order to create a totemic image that was employed in a ceremony dedicated to dead clansmen. Another object, a *Night Society Bush Cow Helmet Mask* [95], combining human with animal overtones, moves us in the direction of studying the mask as a theme in itself, since it is a substitute head worn in various ceremonies.

90 Tilmann Riemenschneider, *Saint Jerome and the Lion*, alabaster.

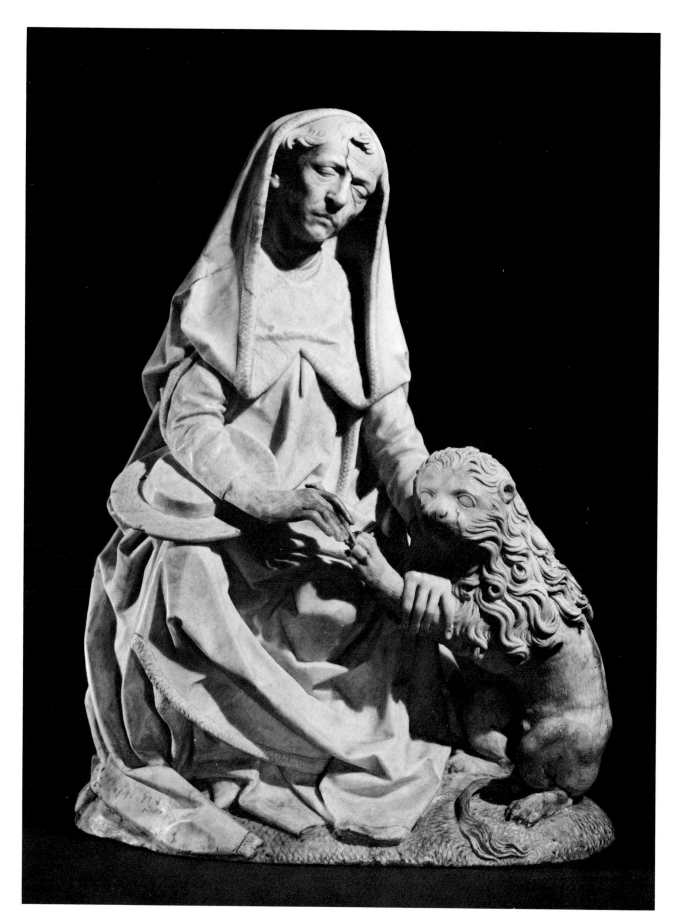

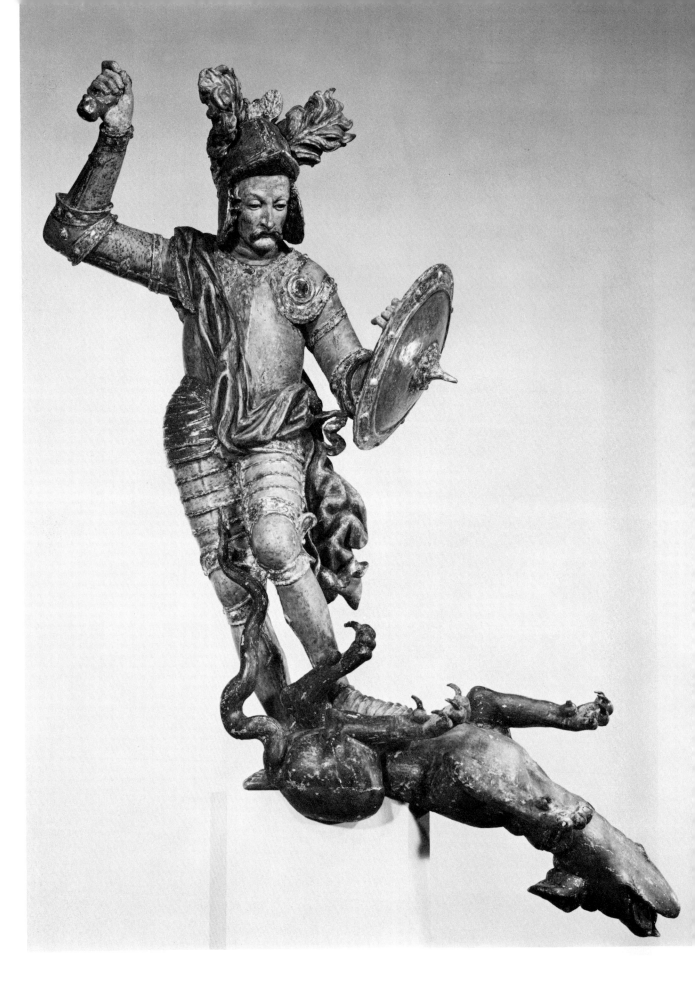

91 *Saint George and the Dragon*, polychromed wood, South Germany or Austria, late 17th century.

92 *Bodhisattva Standing on a Cow*, bronze, China, Sui Dynasty, late 6th century.

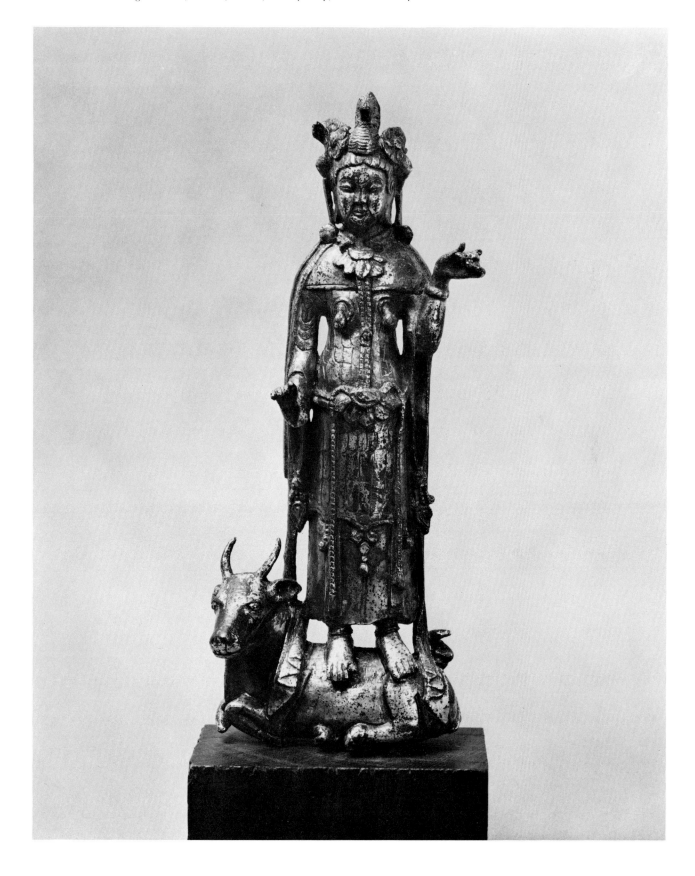

93 (Below) *Ardhanarishvara Trident. Male-female Aspect of Shiva*, bronze, India, Chola Period, 11th-12th century.

94 *Malanggan Memorial Festival Pole*, painted wood, sea snail opercula, Melanesia, New Ireland, 19th century.

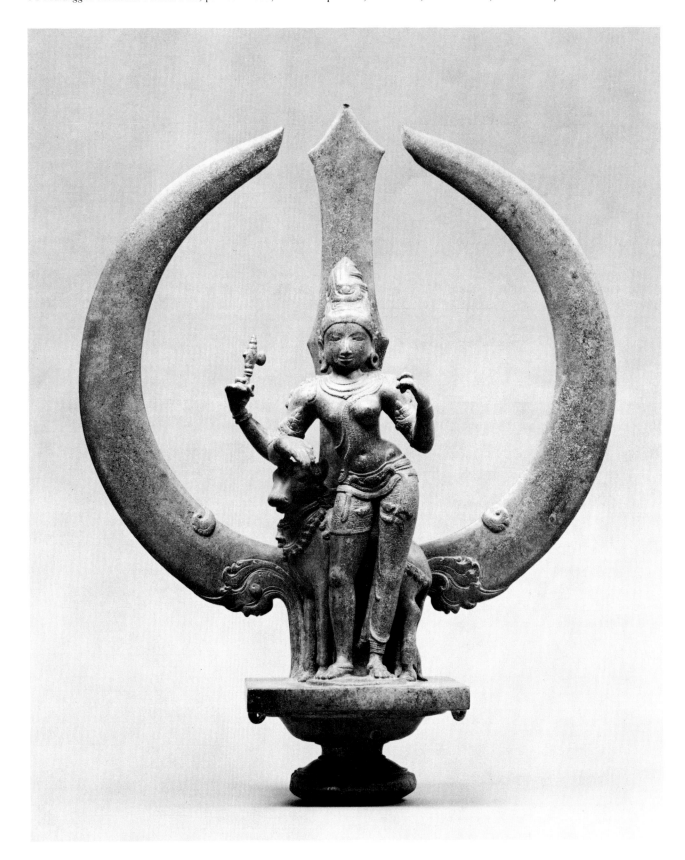

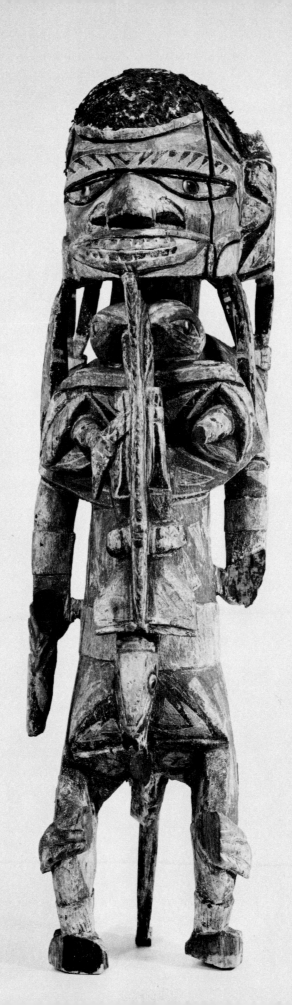

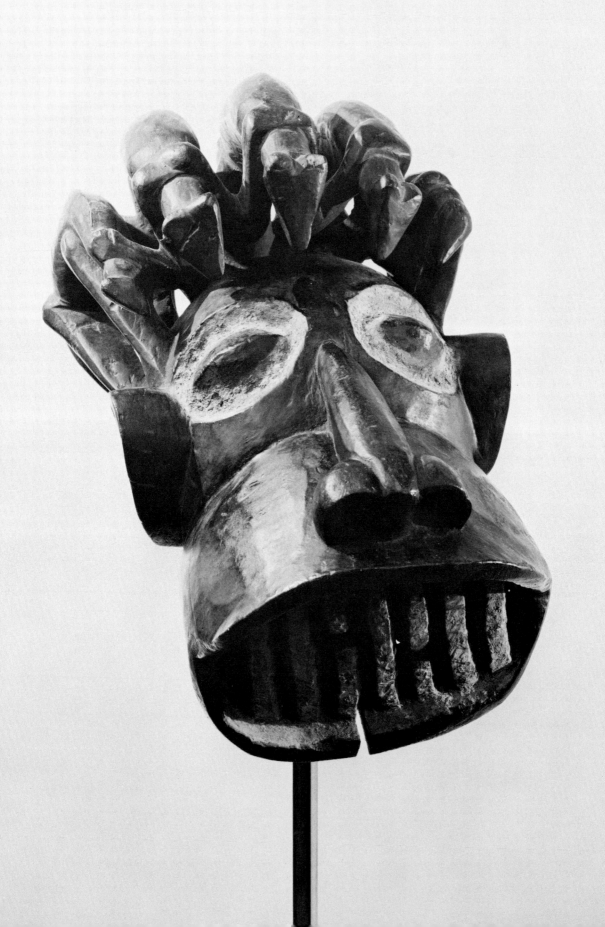

V. Animal Imagery: The Monster

Animal imagery has often been combined with human attributes and exaggeration of form to create shapes intended to frighten and terrify. The sculptures created were often used in magic rituals or safeguarded sacred sanctuaries or tombs where it was necessary to ward off evil spirits.

The monsters found in both Eastern and Western examples are often small in size, but the impression they create is a long-lasting one. *Statuette of a Two-Headed Beast* [96], dated between 1500 and 1000 BC and composed of sections which are part bull and part lion, symbolizes the strength of the lion and the fertility of the bull. Thus this sculpture became a formidable object for use in a magical ceremony. A *Siren* [97] produced in Greece in the sixth century BC depicts the mythological monster—with the body of a bird and the face of a lovely woman—who lured sailors to their death.

In China a similar interest was directed to small sculptures which captured the unusual, as in a *Bovine Monster* [98], carved from jade between 900 and 600 BC. Other Chinese examples carried the fascination with animal shapes (combined with caryatid chracteristics) to further extremes. A stone *Monster* [99] with a square mouth, pot belly, and claws gripping its haunches and a *Monster Caryatid* [100] from the late sixth century emphasize the fearsome attributes which monsters were meant to convey.

Undoubtedly the theme of the monster provided sculptors with free reign for their imaginations, as they created images which they thought peopled the unknown; hence, they conjured up shapes often fantastic in their grotesqueness, such as the *Monster Head* [101] from the Six Dynasties Period in China or a *Dragon* [102] from the Sung era.

When working within prescribed limits, sculptors also provided three-dimensional shape for gods who were difficult to imagine, such as the six-armed elephant god, the *Dancing Ganesha* [103]. In this form the combination of attributes—such as the pot belly and the form and head of an elephant—underscores the symbolism of wealth which is associated with obesity in Indian culture.

The fact that sculptural animals exist in such varied shapes is testimony to the impact they exerted on the imagination of artists in both the East and the West. As sculptors moved from simply recording the animal forms they saw around them toward the creation of hybrid examples (often with human attributes) in order to create images of monsters and unknown shapes, they extended the boundaries of sculptural expression. The use of animal imagery helped fulfill a broader range of purposes than any other sculptural theme emphasizing contacts in secular and religious spheres.

95 *Night Society Bush Cow Helmet Mask*, wood, Africa, Equatorial Forest Style Region: Cameroon Grasslands, Kom Tribe, ca. 1900.

96 (Left) *Statuette of a Two-Headed Beast* (part lion, part bull), bronze, Iran, Koffrabad (Western Gilad), 1500-1000 BC.

98 *Bovine Monster*, jade, China, Middle Chou Period (ca. 900-ca. 600 BC).

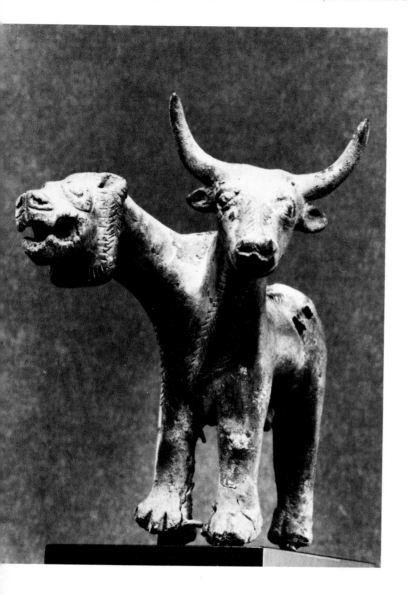

97 *Siren*, terra cotta, traces of white slip, Greece, Archaic, ca. 530 BC.

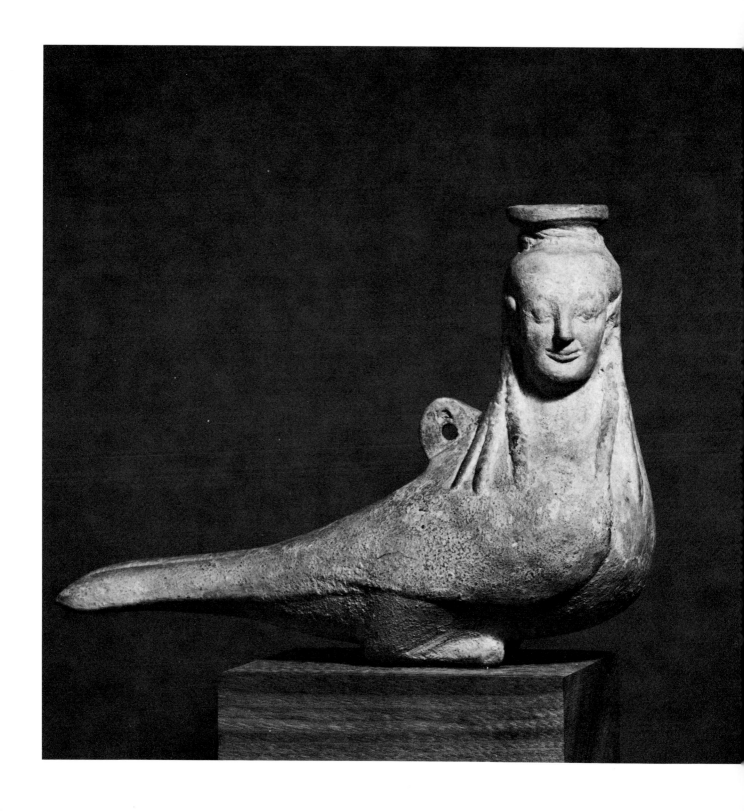

99 *Squatting Caryatid Monster*, stone, China, from Hsiang-T'ang Shan, Northern Ch'i Period, ca. 570.

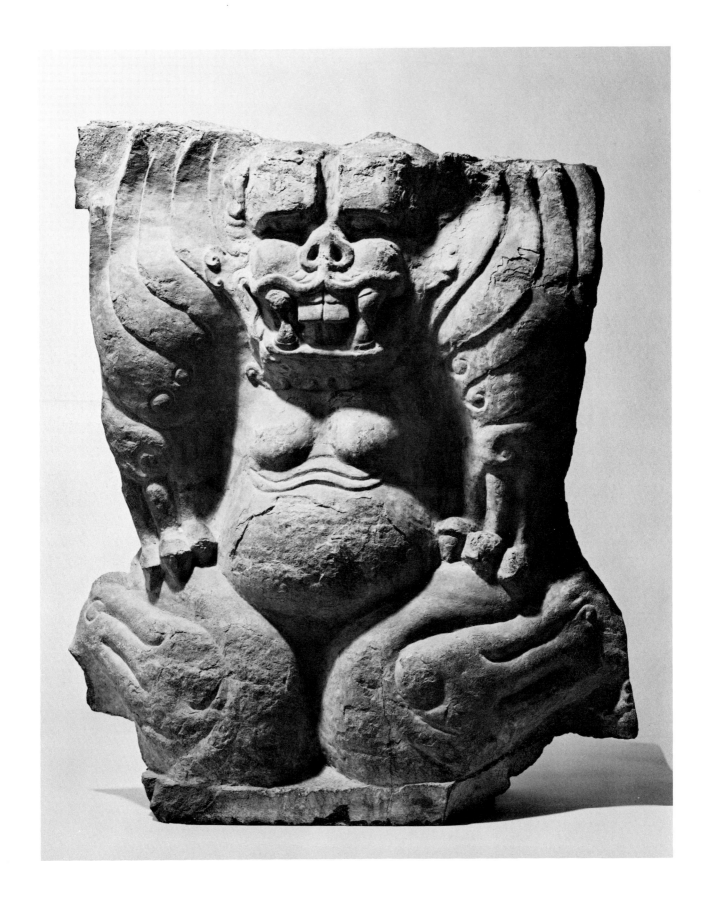

100 *Monster Caryatid*, stone, lime-encrusted reddish-brown, China, possibly from Hsiang T'ang Shan Caves, Northern Ch'i Period, late 6th century.

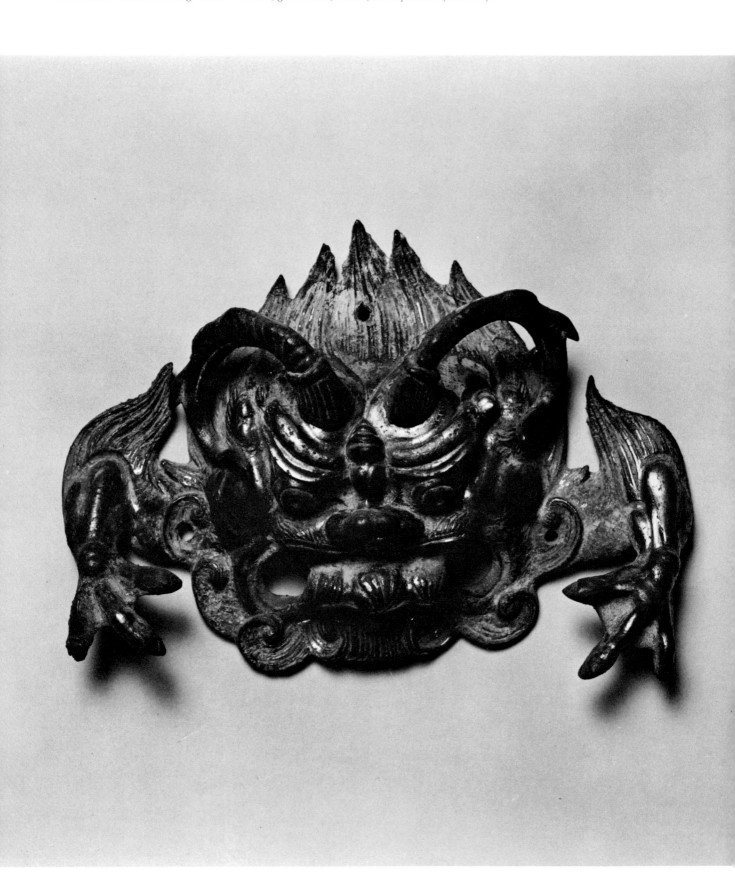

102 *Dragon*, Ch'ing-pai ware, porcelain, China, Sung Dynasty, 960-1279.

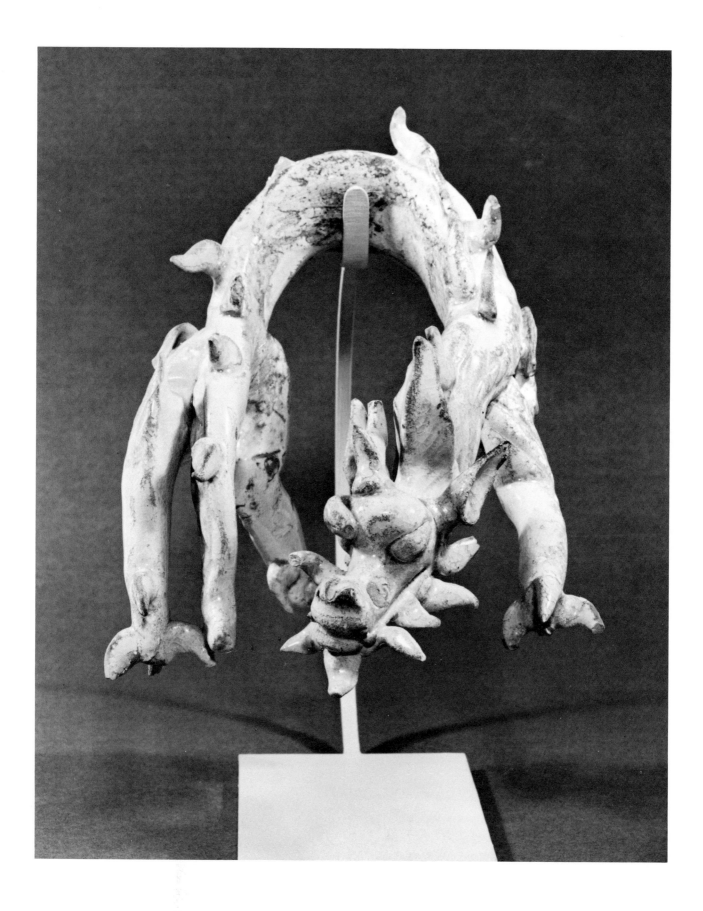

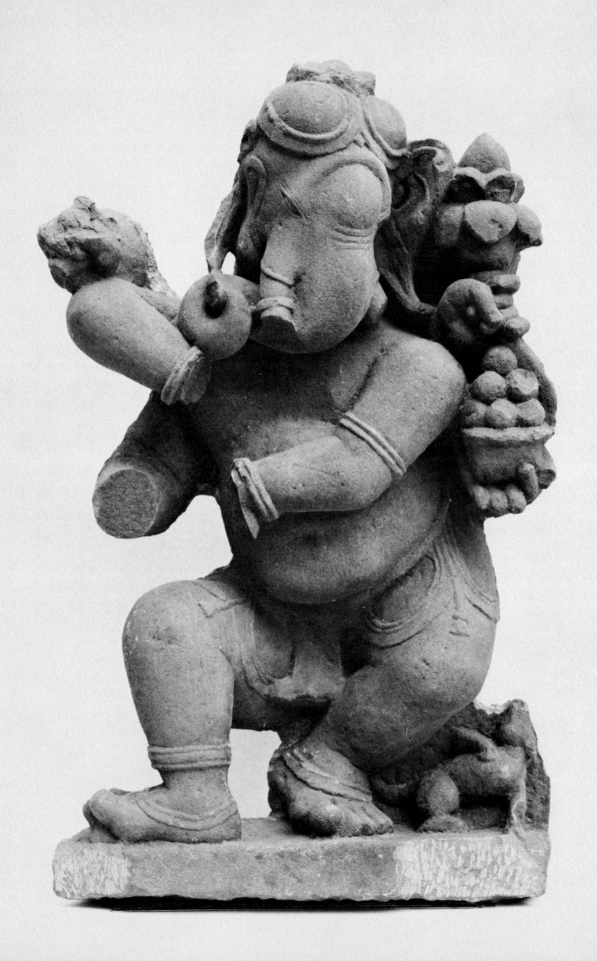

VI. The Mask

The mask is a common and varied sculptural form used in both the East and West. Employed in the West as an article worn by warring knights journeying into battle [104], the mask also has a detailed history in the Far East and Africa, where it was used in ritualistic events. Masks were introduced into Japan early in the seventh century, where they were integrated into the world of theatrical artifice. In Africa, the mask took on symbolic overtones, as various celebrants donned one for each new ritual. The mask often intervened whenever it was necessary for human beings to communicate with the spirit world—hence the belief that a mask was a replacement image, permitting secret and often impossible communication with another realm.

In the Far East, the impressiveness of the *Gigaku Mask* [105] was appropriate for a religious theatrical performance held for a large and mobile audience. The gigaku masks—worn over the entire head and made out of light materials—had to make their message accessible over a large distance; hence expressions and size were often exaggerated. The gigaku mask, with its large forms and expansive expression, is an unusual example, since most others of this type are more comical, even grotesque, in presentation. The *Noh Mask* [106], which came later in Japan, provided a new field for the portrayal of subtle moods and emotions. The dramas in which these masks were worn were held for a smaller, aristocratic group. The masks created for both theatrical events are remarkable as sculpture, since they provided images of sadness or jealousy mirrored in a mask so subtly carved that with the slightest tilt of a performer's head a new expression was produced.

The impact of the Japanese mask had an effect upon Western sculptors during the nineteenth century. They began to study their compatriots' expressions from the point of view of the theatrical mask. Rodin, in his *Mask of Hanako* [107], herself a Japanese actress, provides continuing evidence of the effectiveness of the Noh mask in permitting Western artists to seek subtler moods in their own examples.

It was in Africa, however, that the longest tradition for the use of a mask was available, and it is here that the most varied sculptural examples can be found. Masks were worn by members of different tribes, and most were not intended to be realistic, as they conjured up magical deities and were often used as accessories in dances and performances. The boldly carved geometric planes [108] and the range of mood, from exaggerated effect to muted shapes [109, 110], show how imaginative the African artist could be in creating new three-dimensional shapes. The mask, often functioning as the link with another realm or in a ritual, was worn either completely over the head or in front of the face—reiterating its use in the Far East.

103 *Dancing Ganesha*, red sandstone, India, Khajuraho Region, Medieval Period, ca. 1000.

104 *Armet*, Helmet in Maximilian style, steel, Germany, early 16th century.

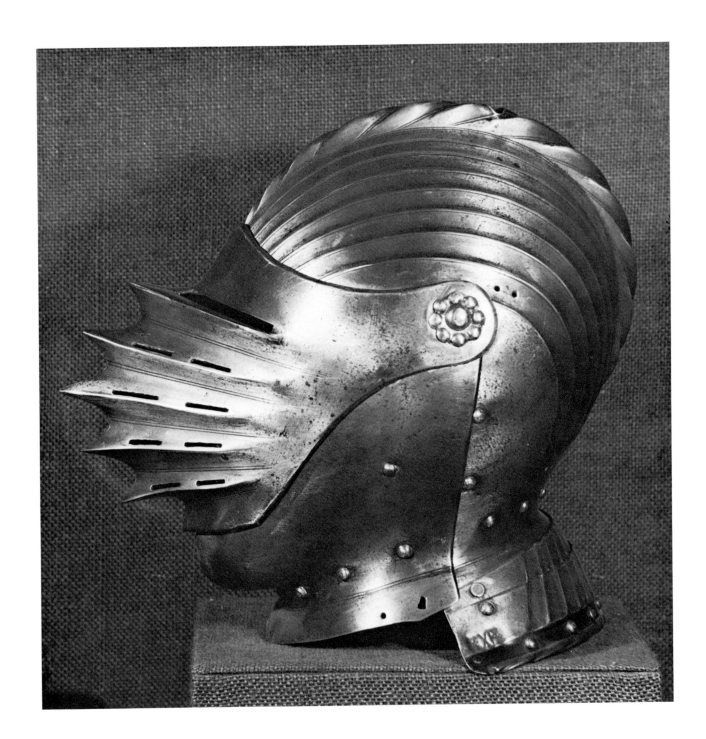

105 *Gigaku Mask : Suikojū*, Paulownia wood, lacquered and painted, Japan, Tempyo Period, 710-794.

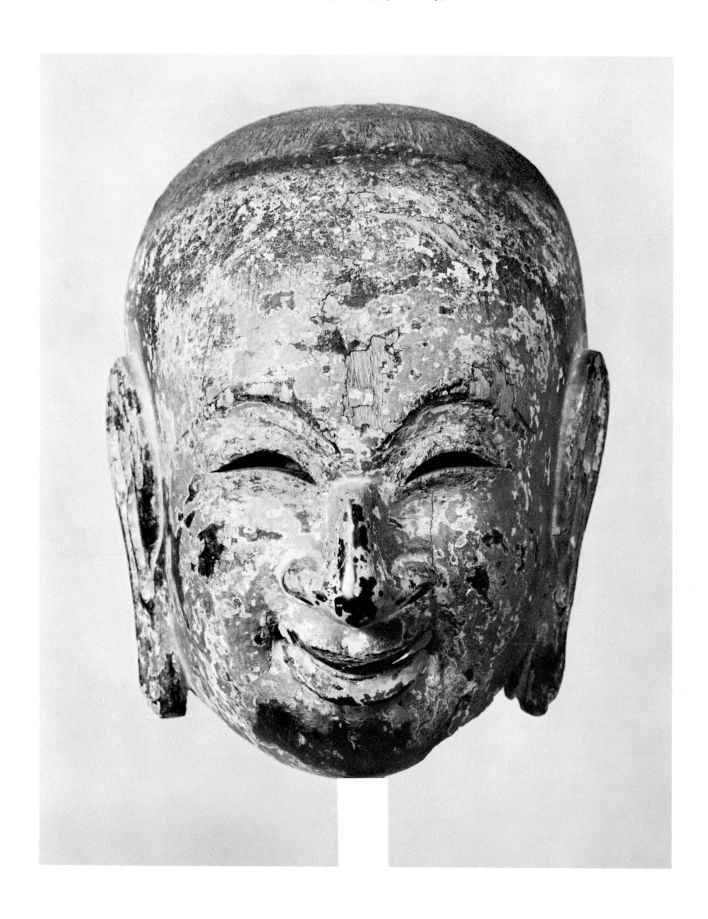

106 *Noh Mask: Waka-onna*, Paulownia wood with polychromy, Japan, Muromachi Period, 1392-1573.

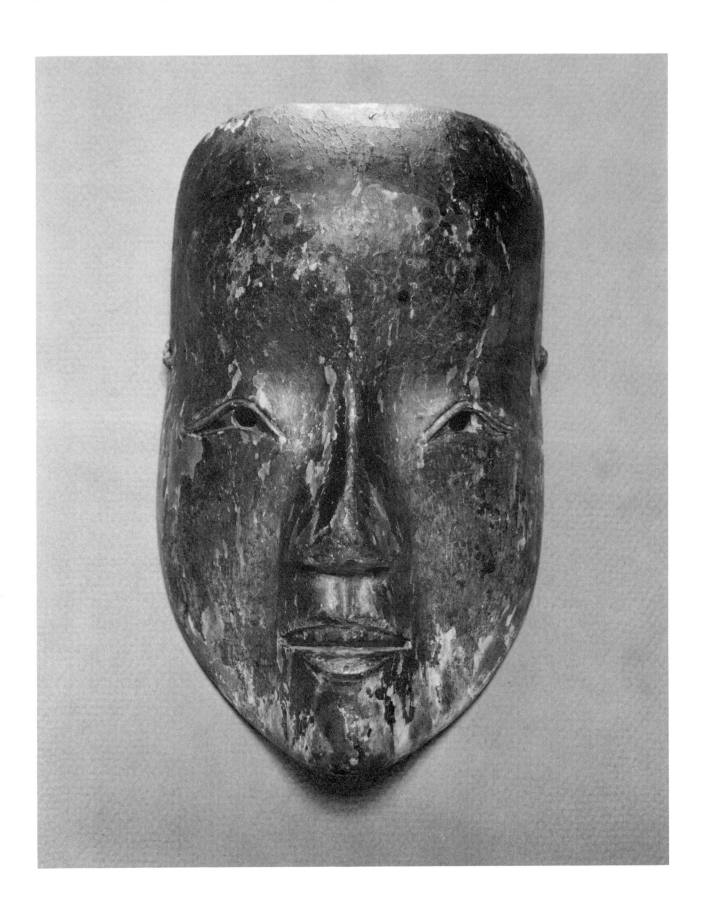

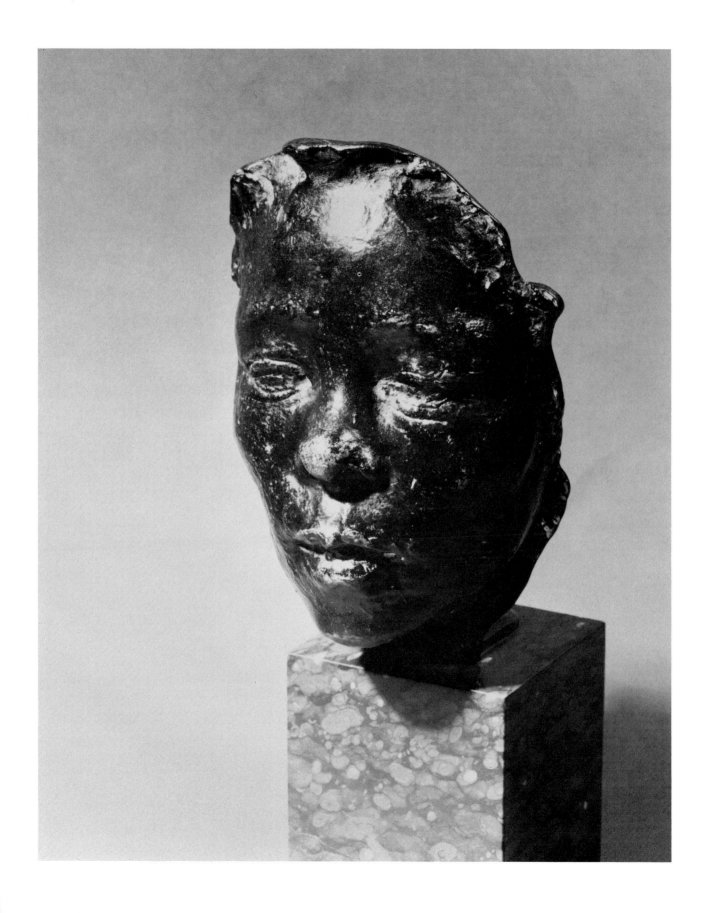

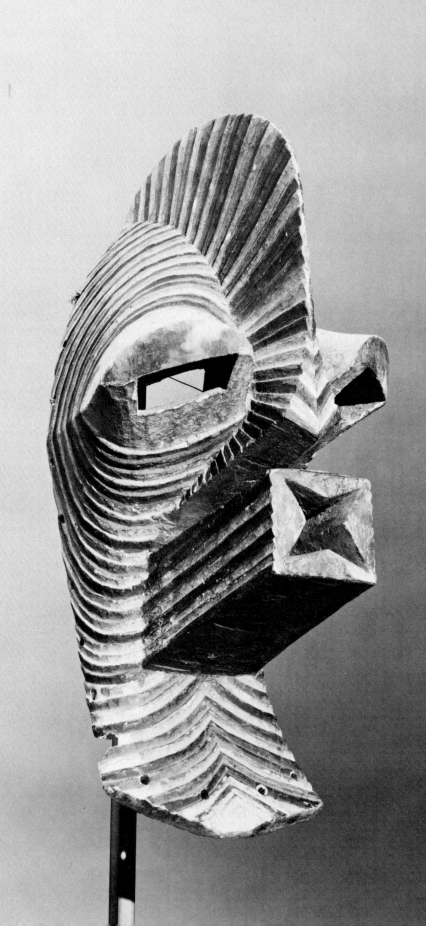

108 *Kifwebe Mask*, painted wood (Ricinodendron heudelotii), Zaire, Southern Savannah Style Region: Upper Lualaba Area, before 1960.

109 *White-Faced Mask*, wood, Africa, Equatorial Forest Style Region: Ogowe River Basin, Gaboon, probably ca. 1935.

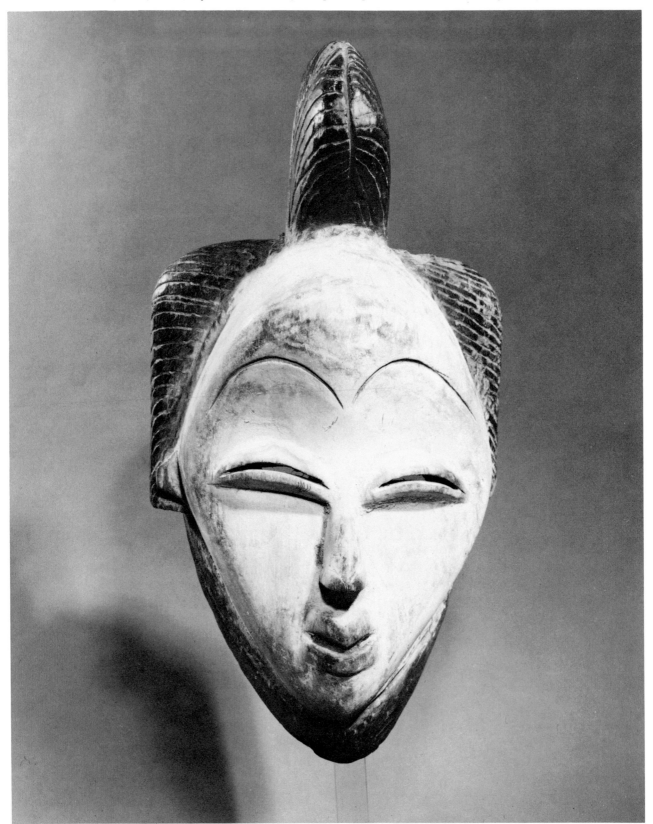

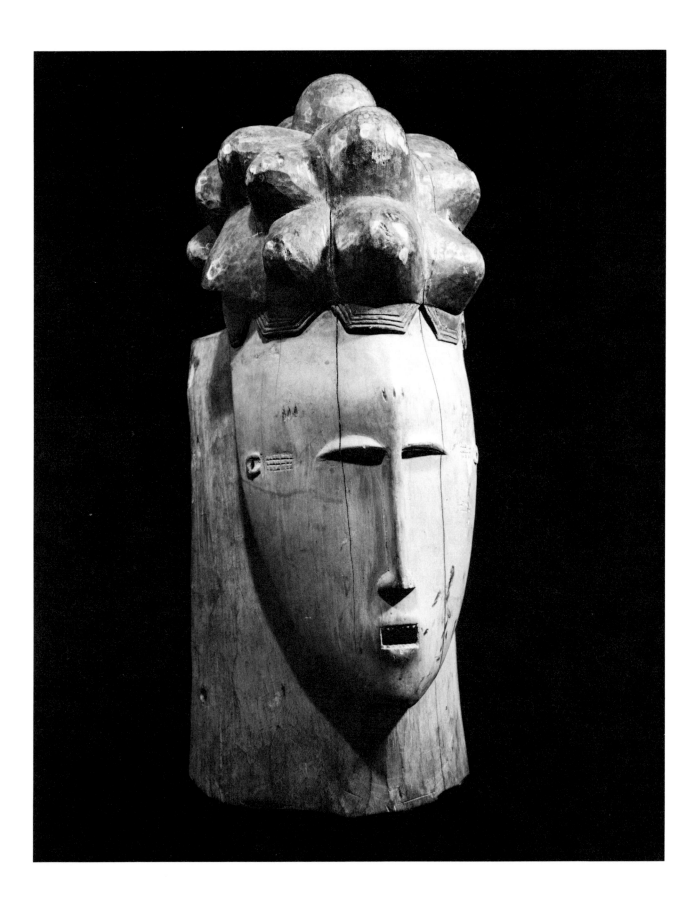

VII. The Self-Contained Fragment

Sculptors in recent times, and occasionally in previous eras, have singled out specific sections of the human figure for study. These examples were not completed as preliminary works but as self-contained units, often intended for different symbolic purposes.

In the case of the *Arm Reliquary* [111] from ca. 1175, the craftsman created a protective object in which he could place the relic of a saint. Since the image was elaborately decorated with Christ and the twelve apostles, its religious function was clear. However, the shape of the reliquary must also contain magical overtones based upon the power of the arm. Since the reliquary, with erect hand, is reminiscent of ritual oaths, it underlines the arm as a symbol of protection—a fact reiterated by its containing a holy relic destined to uphold the faith.

During the nineteenth century, the mystical effect of using a section of the human form to suggest a symbolic or otherworldly occurrence was used by Rodin. In the *Hand of God* [112], Rodin united the image of the creation of life with the creation of sculpture by the artist. In this sense he gave the sculptor God-like qualities which were used each time a new work was completed. Curiously, this symbolic icon—a fragment—with a hand holding or molding smaller figures from an inert mass of stone, is most compelling. Through the use of a minimal part of the human body—although the section most important to an artist—Rodin conveyed more than through an entire figure. His ability to concentrate and crystallize intent and image is carefully suggested in this example.

Other sculptors concentrated on other sections of the body, such as the head [61] or the torso [113], where they captured the same degree of elegance or beauty which had been sought in fuller objects. These works, however, like the symbolic pieces with which they must be compared are complete entities in their own right, even if presenting only a small part of a larger whole.

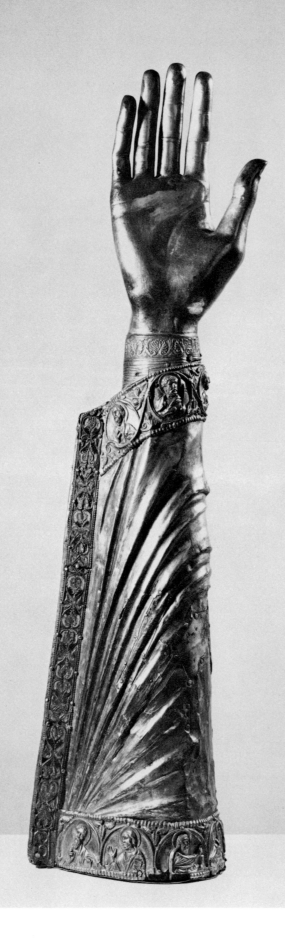

111 Follower of Eilbertus, *Arm Reliquary*, silver gilt over oak core, champlevé enamel.

112 Auguste Rodin, *Hand of God*, bronze.

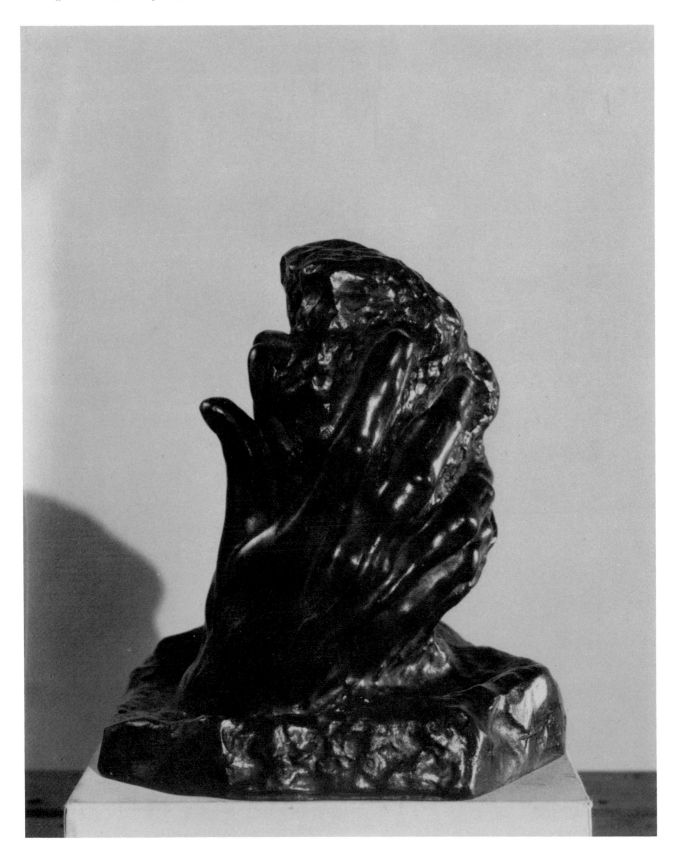

VIII. Environment and Abstraction: The Environment

During the twentieth century, sculptors have attempted to expand the boundaries of sculptural expression by moving beyond recognizable imagery and through increasing the illusion of a piece by adding other objects from the real world. While the emphasis upon abstraction seems a decidedly modern innovation, the creation of environmental pieces does have a tradition dating back to earlier periods.

The Cleveland Museum of Art possesses three examples which can be juxtaposed in order to demonstrate how sculptors extended the boundaries of sculptural expression. The first, a statuette of *St. John* [114], from the late fifteenth or early sixteenth century, uses a rock outcropping behind the figure of the saint not only as a support but to convey the suggestion of the landscape through which the figure is moving. In the nineteenth century, the little-studied Salon sculptor Albert-Ernest Carrier-Belleuse incorporated into the mythological scene of *Cupid and Psyche* several illusionistic elements: the burning brazier at the left, the bronze divan, and the suggestion of an idealized setting through the use of the marbleized base. Indeed, the graceful movement of Psyche further suggests that this artist examined Baroque and Mannerist pieces in order to reconstitute an environment, in mixed media, which would have appealed to his wealthy clients [115].

By far the strongest use of a reconstructed environment is seen in the work of the twentieth-century sculptor George Segal. In *The Red Light* [116], the solitary plaster figure moves slowly in front of the stationary front end of an actual automobile. The red light, glaringly placed at the right, catches the attention of the observer and forces him to remember that Segal is reusing some objects from our everyday experience. By doing this he is encouraging the viewer to participate. In this sense Segal moves beyond other illusionistic pieces toward a full integration of a sculptural environment. Thus, this theme is a new emphasis for contemporary sculpture.

113 Jules Dalou, *Torso*, bronze.

114 Master of the Statuettes of St. John, *Saint John*, terra cotta with traces of color.

115 Albert-Ernest Carrier-Belleuse, *Cupid and Psyche*, bronze with marble base.

VIII. Environment and Abstraction: The Abstraction

One of the more modern tendencies in sculptural representation has been to move beyond exacting duplications of reality toward works of art which (1) only suggest human or animal forms or (2) stand as totally integrated shapes without any reference to recognizable subject matter. In this way, the sculptor is able to increase the boundaries of his art, explore the use of new materials, and be unhampered by older conventions.

Several examples from the Cleveland Museum collection emphasize this direction, although not without maintaining ties with observable subjects. A *Snake*, created by the Baga Tribe in the Western Sudan region [117], demonstrates that African art can not only be studied in its own right but can be seen as an important stimulus to Western invention during the opening years of the twentieth century. By examining purely formal rhythms and subtle changes in shape— found in African examples—Western artists were able to see their own environment with an ever-changing interest in abstracting from reality.

Two contemporary sculptors, David Smith and Richard Hunt, have also expanded the sculptural vocabulary. Smith's welded steel *Pilgrim* [118], while suggesting the movements of a human figure, also displays the sculptor's witty ability to use found objects—discarded metal—in order to create a piece approachable from all sides. The interlocking curves, echoed throughout the work, allow the piece to be studied as the integration of forms in space. When other parts are noticed, such as the central iron bar or the small triangle at the top, reference is made to a human model. Hunt's *Forms Carried Aloft, No. 2* [119], while our most abstract example, suggests bone and joint— human in origin. No matter how modified this object seems or how the forms float or hang suspended in mid-air, the sculptors of this and the other two examples have not been able to break away from their inherent interest in recognizable models. This new direction is only suggested; it was to be enlarged upon by other twentieth-century sculptors.

116 George Segal, *The Red Light*, plaster and mixed media.

117 *Snake*, painted wood, Africa, Western Sudan Style Region: Guinea, Baga Tribe, Landuman Sub-tribe (?), before 1958.

118 David Smith, *Pilgrim*, steel.

119 Richard Hunt, *Forms Carried Aloft, No. 2*, brazed and welded steel.

Catalogue

1 *Kouros.* Island marble. Greece, second quarter 6th c. BC, H. 24-5/8 inches (62.5 cm.). Gift of Hanna Fund. 53.125. *Bulletin* (March 1954).

2 *Torso of Amun-pe-Yom, Priest and General.* Gray granite. Egypt, Ptolemaic Period, ca. 280-250 BC, H. 37-1/2 inches (95.2 cm.). Gift of Hanna Fund. 48.141. *Bulletin* (June 1949).

3 *Standing Buddha.* Cream sandstone. India, Gupta Period, 5th c., H. 30 inches (76.2 cm.). Purchase from the J. H. Wade Fund. 43.278. *Bulletin* (March 1944).

4 Franz Ignaz Günther, German, 1725-1775. *Male Figure.* Wood, H. 37-1/2 inches (95 cm.). Purchase from the J. H. Wade Fund. 73.101

5 Constantin Brancusi, Roumanian (French School), 1876-1957. *Male Torso.* Brass, 1917, signed, H. 18-3/8 inches (46.7 cm.). Hinman B. Hurlbut Collection. 3205.37. *Bulletin* (April 1938).

6 Richard Hunt, American, b. 1935. *Fragmented Figure Construction.* Welded steel, 1963, H. 56-1/2 inches (143.5 cm.). Gift of Mr. Arnold H. Maremont. 69.16. *Bulletin* (April 1970).

7 *Yakshi.* Red sandstone. India, Mathura, Kushan Period, 2nd c., H. 50-1/2 inches (128.2 cm.). Purchase from the J. H. Wade Fund. 68.104

8 *Gangā, Goddess of the Ganges.* Stone. India, Mathura, early Medieval Period, early 7th c., H. 42-1/2 inches (107.9 cm.). Purchase, John L. Severance Fund. 66.119. *Bulletin* (September 1966).

9 *Seated Prince.* Metamorphosed limestone. North Syria, early 15th c. BC, H. 26-1/4 inches (66.7 cm.). Purchase, Leonard C. Hanna Jr. Bequest. 69.37. *Bulletin* (January 1974).

10 *Portrait of Superintendent of Granary, Med-thu.* Limestone, colored. Egypt, Salamieh, Dynasty XVIII, ca. 1552-1306 BC, H. 12-1/2 inches (31.7 cm.). Gift of the John Huntington Art and Polytechnic Trust. 20.2004

11 *Portrait of Djed-bast-iuf-ankh, son of Wennefer.* Brown limestone. Egypt, early Dynasty XXVI (660-650 BC), H. 10-1/2 inches (26.7 cm.). Gift of the John Huntington Art and Polytechnic Trust. 14.661

12 *Narasimha Yoga Murti (Lion Incarnation of Vishnu).* Bronze. India, late Chola Period, ca. 13th c., H. 21-3/4 inches (55.2 cm.). Gift of Dr. Norman Zaworski. 73.187

13 *Nikko, the Sun Bodhisattva.* Japanese yew. Japan, Kōnin Period, ca. 800, H. 18-3/8 inches (46.7 cm.). Purchase, John L. Severance Fund. 61.48. *Bulletin* (December 1961).

14 *Maitreya in Meditation (Hanka-shiyui-zo).* Bronze. Japan, Suiko Period, 7th c., H. 18 inches (45.7 cm.). Purchase, John L. Severance Fund. 50.86. *Bulletin* (December 1950).

15 *Portrait of Hōtō Kokushi.* Wood. Japan, Kamakura Period (1185-1333), ca. 1286, H. 36 inches (91.4 cm.). Purchase, Leonard C. Hanna Jr. Bequest. 70.67

16 *Enthroned Madonna with the Writing Christ Child.* Limestone with paint and gilding. France-Netherlands, ca. 1400, H. 17-5/8 inches (44.7 cm.). Purchase, John L. Severance Fund. 70.13. *Bulletin* (December 1970).

17 Giovanni Marchiori (attr.), Italian, Venice, 1696-1778. *Bozzetto of a River God.* Terra cotta, H. 10 inches (25.4 cm.). Purchase from the J. H. Wade Fund. 62.124

18 Gerhardt Marcks, German, b. 1889. *Ragazzo.* Bronze, 1935, H. with base 16-3/4 inches (42.5 cm.). Hinman B. Hurlbut Collection. 3203.37. *Bulletin* (April 1938).

19 Ernst Barlach, German, 1870-1938. *Singing Man.* Bronze, 1928, signed, W. 21-7/8 inches (55.5 cm.). Hinman B. Hurlbut Collection. 3204.37. *Bulletin* (April 1938).

20 *Gudea, Ensi of Lagash.* Dolerite stone. Mesopotamia, Lagash, Neo-Sumerian Period, ca. 22nd c. BC, H. 56-5/16 inches (143 cm.). Purchase from the J. H. Wade Fund. 63.154. *Bulletin* (November 1963).

21 *Saint John from a Crucifixion Group.* Painted and gilt wood. Spain, Castile, ca. 1275, H. 61 inches (154.9 cm.). Gift of Mr. and Mrs. Francis F. Prentiss. 30.621

22 *Seated Madonna as the Throne of Wisdom (Sedes Sapientiae).* Lindenwood with traces of paint. Northern Europe, 12th c., H. 29-1/2 inches (74.9 cm.). Purchase from the J. H. Wade Fund. 70.56

23 *Dancing Maenad.* Bronze. Italy, Etruscan, late 6th c. BC, H. 7-3/8 inches (18.7 cm.). Purchase from the J. H. Wade Fund. 53.124. *Bulletin* (October 1955).

24 *Piping and Dancing Satyr.* Bronze. Alexandria(?), Greek, Hellenistic, 3rd-2nd c. BC, H. 8-1/4 inches (21 cm.). Purchase from the J. H. Wade Fund. 45.366. *Bulletin* (April 1946).

25 *Attendant of Manjusri.* Dry lacquer. China, late T'ang Dynasty or early Five Dynasties, 9th-10th c., H. without base 15-3/4 inches (40 cm.). Purchase, John L. Severance Fund. 53.356. *Bulletin* (January 1956).

26 *Frieze of Heavenly Dancers.* Pink sandstone. Cambodia, Angkor Thom, reign of Jayavarman VII, ca. 1181-1218, L. 34-1/2 inches (87.6 cm.). Purchase from the J. H. Wade Fund. 38.433

27 *Shiva Nataraja, Lord of the Dance.* Bronze. India, Chola Period, 11th c., H. 43-7/8 inches (111.5 cm.). Purchase from the J. H. Wade Fund. 30.331. *Bulletin* (October 1930).

28 *Figure of Zao-Gongen, a Shintoist manifestation of the Buddhist guardian deity.* Wood. Japan, Kamakura Period, 13th c., H. 42 inches (106.7 cm.). Purchase from the J. H. Wade Fund. 73.105

29 *Vajravarahi, Dancing Tantric Deity.* Lacquer and stucco. Nepal, 16th-17th c., H. 25 inches (63.5 cm.). Purchase, Andrew R. and Martha Holden Jennings Fund. 64.103

30 Hilaire-Germain Edgar Degas, French, 1834-1917. *Dancer.* Bronze, 1896-1917, H. 18 inches (45.7 cm.). Hinman B. Hurlbut Collection. 2028.47. *Bulletin* (September 1947).

31 Jacques Lipchitz, American, 1891-1973. *Detachable Figure (Dancer).* Ebony and oak, 1915, H. 38-5/8 inches (98.1 cm.). Gift of Mrs. Aye Simon. 72.367

32 *Mirror.* Bronze. Greece, Sicyon(?), ca. 470-460 BC, H. including handle 15-1/4 inches (38.7 cm.). Purchase from the J. H. Wade Fund. 50.7. *Bulletin* (January 1951).

33 *Pedestal.* Ivory. China, early T'ang Dynasty, 7th c., H. 3-1/8 inches (7.9 cm.). Gift of Mr. and Mrs. Frederick L. Mayer. 68.70. *Bulletin* (November 1968).

34 *Kneeling Figure,* propably one of the six supporting figures for the *Reliquary of Saint Germain.* Gilt bronze. France, Paris, following the contract February 8, 1408 (1409 new style), H. 5-1/2 inches (14 cm.). Purchase, Leonard C. Hanna Jr. Bequest. 64.360. *Bulletin* (November 1966).

35 *Console Table.* Painted and gilded wood, marble. Italy, Rome, late 17th c., H. 37-1/4 x L. 42-1/2 inches (94.6 x 108 cm.). The Elisabeth Severance Prentiss Collection by exchange. 68.31

36 Auguste Rodin, French, 1840-1917. *Fallen Caryatid Carrying Her Stone.* Bronze, 1880-1881(?), H. 17-1/8 inches (43.5 cm.). In Memory of Ralph King. Gift of Mrs. Ralph King, Ralph T. Woods, Charles G. King, and Frances King Schafer. 46.352. *Bulletin* (February 1947).

37 *Chief's Stool with Caryatid Figure.* Wood. Zaire, Southern Savannah Style Region: Upper Lualaba Area, Baluba Tribe, ca. 1900, H. 17-1/4 inches (43.8 cm.). Gift of Katherine C. White. 69.9

38a-d *Mortuary Figures of the Zodiac.* Gray clay with traces of slip. China, Northern Wei Period, ca. 525, H. 8-1/2 inches (21.6 cm.). The Norweb Collection. 72.76-.87

39 Claus Sluter and Claus De Werve, Franco-Netherlandish, active 1379/80-1405/6 and 1380-1439 respectively. *Three Mourners.* Vizelle alabaster (Grenoble stone), early 15th c. Purchase from the J. H. Wade Fund. 40.128 (41.6 cm.). Bequest of Leonard C. Hanna Jr. 58.66 (41.9 cm.), 58.67 (41.3 cm.). *Bulletin* (October 1940, September 1963).

40, 41 *Guardian Figures* (pair). Wood. Japan, from Shiga Prefecture, Kamakura Period (1185-1333), each H. 66-1/8 inches (168.5 cm.). Purchase, Leonard C. Hanna Jr. Bequest. 72.158, 72.159

42 Tilmann Riemenschneider, German, ca. 1460-1531. *Saint Lawrence.* Lindenwood, carved between 1502 and 1510, H. 37-1/4 inches (94.6 cm.). Purchase, Leonard C. Hanna Jr. Bequest. 59.42. *Bulletin* (November 1959).

43 Tilmann Riemenschneider, German, ca. 1460-1531. *Saint Stephen.* Lindenwood, carved between 1502 and 1510, H. 36-1/2 inches (92.7 cm.). Purchase, Leonard C. Hanna Jr. Bequest. 59.43. *Bulletin* (November 1959).

44 *Twin Figures (Ere Ibeji).* Wood. Nigeria, Guinea Coast Style Region: Town of Ila-Orangun, Yoruba Tribe, probably 2nd quarter 20th c., H. 11 inches (28 cm.). Gift of Katherine C. White. 72.332, 72.333

45 *Statuette of an Official and his Wife.* Limestone, colored. Egypt, Salamieh, Dynasty XIX, ca. 1320-1200 BC, H. 15-1/2 inches (39.4 cm.). Gift of the John Huntington Art and Polytechnic Trust. 20.2003

46 *Isis with Horus the Child.* Bronze. Egypt, Dynasties XXVI-XXX, ca. 664-343 BC, H. 6-1/2 inches (16.5 cm.). Bequest of John L. Severance. 42.774

47 Andrea Pisano (attr.), Italian, Pisan-Florentine, born Pisa ca. 1290, died Florence ca. 1348/50. *Madonna and Child.* Marble, ca. 1330's, H. 14-13/16 inches (37.6 cm.). Purchase, Leonard C. Hanna Jr. Bequest. 72.51. *Bulletin* (December 1972).

48 *Shiva and Parvati.* Bronze. India, Pala Period, 9th c., H. 7 inches (17.8 cm.). Purchase, John L. Severance Fund. 64.50. *Bulletin* (December 1964).

49 Claude Michel, called Clodion, French, 1738-1814. *Maiden and Infant at Play.* Terra cotta, H. 12-1/4 inches (31.1 cm.). Bequest of John L. Severance. 42.783

50 *Christ and Saint John the Evangelist.* Painted wood. Germany, Swabia near Bodensee (Lake Constance), early 14th c., H. 36-1/2 inches (92.7 cm.). Purchase from the J. H. Wade Fund. 28.753. *Bulletin* (February 1929).

51 George Minne, Belgian, 1866-1941. *Solidarity.* Marble, H. 26-3/4 inches (67.9 cm.). Purchase, Andrew R. and Martha Holden Jennings Fund. 68.191

52 Henri Matisse, French, 1869-1954. *Two Women.* Bronze, 1908, signed, H. 18 inches (45.7 cm.). Gift of Mr. and Mrs. Harold T. Clark. 57.144

53 Auguste Rodin, French, 1840-1917. *Les Damnées.* Bronze, H. 10-1/2 inches (26.5 cm.). Bequest of Edgar A. Hahn. 72.278

54 *Woman and Child (Ancestor or maternity figure).* Wood. Africa, Western Sudan Style Region: Ivory Coast, Korhogo District, Senufo Tribe (Siena), probably ca. 1930, H. 25 inches (63.5 cm.). Purchase, James Albert and Mary Gardiner Ford Memorial Fund. 61.198. *Bulletin* (November 1961).

55 *Portrait of a Man.* Bronze. Italy, Roman, late Republican, 40-30 BC, H. 15 inches (38.1 cm.). Gift of the John Huntington Art and Polytechnic Trust. 28.860

56, 57 *Relief Heads of a Man and a Woman.* Marble. France, Touraine, Circle of Michel Colombe, second decade 16th c., H. 5-1/2 inches (14 cm.). Gift of Mr. William G. Mather. 21.1003, 21.1004. *Bulletin* (January 1922).

58 Jean Baptiste Lemoyne, II, French, 1704-1778. *Bust of a Woman.* Terra cotta, H. 25 inches (63.5 cm.). Purchase, John L. Severance Fund. 52.566. *Bulletin* (September 1971).

59 Jules Dalou, French, 1838-1902. *Head of Alphonse Legros.* Bronze, ca. 1876, H. 22-1/2 inches (57.2 cm.). Gift of John F. Kraushaar. 25.648. *Bulletin* (September 1971).

60 Theodore Riviere, French, 1857-1912. *Bust of Tolstoi.* Bronze, H. 10-5/8 inches (27 cm.). The Norweb Collection. 65.10

61 Medardo Rosso, Italian, 1858-1928. *The Jewish Boy.* Wax, H. 8-3/4 inches (22.2 cm.). Purchase, Andrew R. and Martha Holden Jennings Fund. 70.33. *Bulletin* (September 1971).

62 *Head of a Woman.* Marble. Italy, Roman, ca. 1st c. BC, H. 8-1/4 inches (21 cm.). Gift of Mrs. Leonard C. Hanna. 24.125. *Bulletin* (February 1924).

63 Tullio Lombardo, Italian, Paduan-Venetian, ca. 1455-1532. *Bust of a Young Woman.* Marble, H. 18 inches (45.7 cm.). Lent by Ruth Blumka. 174.74

64 Gaston Lachaise, American (born in Paris), 1882-1935. *Head of a Woman.* Pink Tennessee marble, the hair tinted black, signed, H. 25-1/4 inches (64.2 cm.). Hinman B. Hurlbut Collection. 1425.24. *Bulletin* (October 1924).

65 *Head.* Stone. Celtic, 2nd-3rd c., H. 13 inches (33 cm.). Gift of Dr. and Mrs. Jacob Hirsch. 55.555. *Bulletin* (March 1958).

66 *Head of a Rishi.* Sandstone. India, Kushan Period, 2nd c. or earlier, H. 11 inches (28 cm.). Purchase, Edward L. Whittemore Fund. 71.41

67 *Stele of Djed-atum-iuf-ankh.* Yellow crystalline quartzite. Egypt, from Heliopolis(?), Dynasty XXV, ca. 650 BC, imitating style of Old Kingdom Dynasty III to early Dynasty IV, H. without frame 11 inches (28 cm.). Gift of the John Huntington Art and Polytechnic Trust. 20.1977

68 *Incised Tomb Relief with Animals.* Stone. China, early T'ang Dynasty, 7th c., L. 55-1/4 inches (140.3 cm.). Gift of Mr. and Mrs. Severance A. Millikin. 59.184. *Bulletin* (December 1959).

69 *Engaged Capital: Daniel in the Lion's Den.* Limestone. France, basin of the Loire, mid-12th c., H. 29 inches (73.7 cm.). Purchase from the J. H. Wade Fund. 62.247

70 *Stele: Sakyamuni Trinity.* Micaneous limestone. China, Eastern Wei Period, dated 537, H. 30-1/2 inches (77.5 cm.). Gift of the John Huntington Art and Polytechnic Trust. 14.567. *Bulletin* (July, November 1914; November 1926).

71 *Adoration of the Bodhi Tree.* Limestone. India, Amaravati, 3rd c., H. 31-1/2 inches (80 cm.). Purchase from the J. H. Wade Fund. 70.43

72 *Square Urn with High Relief of the Four Lokapalas.* Marble. China, T'ang Dynasty, 8th c., W. 9-5/8 inches (25 cm.). Purchase, John L. Severance Fund. 72.37

73 Circle of Bartolommeo Bellano, Italian, Paduan, ca. 1435-1496/7. *Madonna and Child.* Marble, H. 21-1/2 inches (54.6 cm.). The Cleveland Museum of Art. 20.273

74 Henry Cros, French, 1840-1907. *Incantation.* Pâté de verre relief, 1892, 13-1/8 x 9-1/8 inches (33.3 cm. x 23.2 cm.). Purchase, James Parmelee Fund. 69.24. *Bulletin* (September 1971).

75 *Recumbent Bull.* Basalt. Mesopotamia, Sumerian, ca. 2700 BC, L. 5-3/8 inches (13.7 cm.). Purchase from the J. H. Wade Fund. 70.61. *Bulletin* (January 1971).

76 *Charging Bull.* Bronze. Greece, Lucania, 5th c. BC, L. 7-1/4 inches (18.4 cm.). Purchase from the J. H. Wade Fund. 30.336. *Bulletin* (March 1931, January 1971).

77 *Apis Bull.* Green serpentine. Egypt, ca. Dynasty XXX (380-343 BC), L. 22-7/8 inches (58 cm.). Purchase, Leonard C. Hanna Jr. Bequest. 69.118. *Bulletin* (January 1971).

78 *Owl Tsun.* Bronze. China, early Western Chou Period (1027-ca. 771 BC), H. 8-1/4 inches (21 cm.). Purchase, John L. Severance Fund. 51.119. *Bulletin* (March 1952).

79 *Horse.* Terra cotta. Japan, Kofun Period (Haniwa), 200-552, L. 26 inches (66 cm.). The Norweb Collection. 57.27. *Bulletin* (April 1959).

80 *Mortuary Horse.* Pottery, covered with a white slip and painted in red and green pigments. China, North Wei Period, ca. 525, H. 8-3/4 inches (22.2 cm.). Purchase, Charles W. Harkness Endowment Fund. 29.985. *Bulletin* (March 1931).

81 *Horse.* Pottery with three-color glaze. China, T'ang Dynasty, 618-907, L. 31-5/8 inches (80.3 cm.). Anonymous gift. 55.295. *Bulletin* (April 1959).

82 *Pole Top: Wild Ass.* Bronze. China, Ordos Region, Han Dynasty, 206 BC-AD 220, 7 x 4-7/8 inches (17.8 x 12.4 cm.). Purchase, Edward L. Whittemore Fund. 62.46

83 *Lion.* Sandstone. Cambodia, Angkorean Period, 12th c., H. 37-1/2 inches (95.7 cm.). Gift of Mr. and Mrs. William E. Ward. 70.27

84a, b *Kara-shishi ("China Lion").* Wood, originally colored. Japan, Kamakura Period, 1185-1333, H. 19-1/2 inches (49.5 cm.). Purchase, Dudley P. Allen Fund. 24.352, 24.351

85 *Incense Burner in the Shape of a Lion.* Bronze, cast and engraved. Iran, Seljuk Period, 12th c., H. 14-1/8 inches (35.9 cm.). Purchase, John L. Severance Fund. 48.308. *Bulletin* (June 1957).

86 *Rhyton: The Allegorical Representation of a Divine Investiture.* Silver: repoussé, engraved and chased with gold overlay. Iran, Sasanian Period, 4th c., L. 13-5/16 inches (33.7 cm.). Purchase, John L. Severance Fund. 64.41

87 *Lion Aquamanile.* Bronze. Northern Germany, Lower Saxony, probably Hildesheim, mid-13th c., H. 10-1/2 inches (26.2 cm.). Gift of Mrs. Chester D. Tripp in honor of Chester D. Tripp. 72.167. *Bulletin* (October 1974).

88 *Engaged Capital: Lion and Basilisk.* Marble. Northern Italy, 12th c., 11-7/8 x 13 x 11-1/2 inches (30.2 x 33 x 29.2 cm.). Purchase from the J. H. Wade Fund. 72.20

89 Antoine Louis Barye, French, 1796-1875. *Tiger and Crocodile.* Bronze, L. 19-1/2 inches (49.5 cm.). Anonymous Loan. 75.71

90 Tilmann Riemenschneider, German, ca. 1460-1531. *Saint Jerome and the Lion.* Alabaster, ca. 1510, H. 14-7/8 inches (37.8 cm.). Purchase from the J. H. Wade Fund. 46.82. *Bulletin* (December 1946).

91 *Saint George and the Dragon.* Polychromed wood. South Germany or Austria, late 17th c., H. 41-3/4 inches (103.5 cm.). Gift of Mr. and Mrs. Severance A. Millikin. 59.341. *Bulletin* (December 1960).

92 *Bodhisattva Standing on a Cow.* Bronze. China, Sui Dynasty, late 6th c., H. 8-3/4 inches (22.5 cm.). Gift of Mr. and Mrs. Robert Schoelkopf, Jr. 72.363

93 *Ardhanarishvara Trident. Male-female Aspect of Shiva.* Bronze. India, Chola Period, 11th-12th c., H. 15-9/16 inches (39.5 cm.). Purchase from the J. H. Wade Fund. 69.117

94 *Malanggan Memorial Festival Pole.* Painted wood, sea snail opercula. Melanesia, New Ireland, 19th c., H. ca. 36-1/2 inches (92.7 cm.). Gift of Dr. and Mrs. Thomas Munro. 71.149

95 *Night Society Bush Cow Helmet Mask.* Wood. Africa, Equatorial Forest Style Region: Cameroon Grasslands, Kom Tribe, ca. 1900, W. 25 inches (63.5 cm.). Gift of Mr. and Mrs. William D. Wixom in memory of Mr. and Mrs. Ralph M. Coe. 71.66

96 *Statuette of a Two-Headed Beast* (part lion, part bull). Bronze. Iran, Koffrabad (western Gilad), 1500-1000 BC, L. 5-3/4 inches (14.7 cm.). Purchase, John L. Severance Fund. 69.122. *Bulletin* (January 1971).

97 *Siren.* Terra cotta. Greece, Archaic, ca. 530 BC, L. 7-1/8 inches (18.1 cm.). Purchase from the J. H. Wade Fund. 28.193. *Bulletin* (October 1968).

98 *Bovine Monster.* Jade. China, Middle Chou Period (ca. 900-ca. 600 BC), H. 5-5/16 inches (13.5 cm.). Gift of Severance A. Millikin. 53.628. *Bulletin* (December 1954).

99 *Squatting Caryatid Monster.* Stone. China, from Hsiang-T'ang Shan, Northern Ch'i Period, ca. 570, H. 29-1/2 inches (74.9 cm.). The Fanny Tewksbury King Collection. 57.360

100 *Monster Caryatid.* Stone, lime-encrusted reddish-brown. China, possibly from Hsiang T'ang Shan Caves, Northern Ch'i Period, late 6th c., W. 15-3/4 inches (40 cm.). Anonymous gift. 57.357

101 *Monster-Head Door-Ring Holder: P'u-shou.* Gilt bronze. China, Six Dynasties (220-589), W. 7-7/8 inches (20 cm.). Purchase from the J. H. Wade Fund. 30.731. *Bulletin* (April 1931).

102 *Dragon.* Ch'ing-pai ware, porcelain. China, Sung Dynasty, 960-1279, H. 6-5/8 inches (16.8 cm.). Purchase, John L. Severance. Fund. 64.42

103 *Dancing Ganesha.* Red sandstone. India, Khajuraho Region, Medieval Period, ca. 1000, H. 24-1/8 inches (61.3 cm.). Purchase, John L. Severance Fund. 61.93. *Bulletin* (November 1961).

104 *Armet.* Helmet in Maximilian style, steel. Germany, early 16th c., H. 12 inches (30.5 cm.). Gift of Mr. and Mrs. John L. Severance. 16.1855

105 *Gigaku Mask: Suikojū.* Paulownia wood, lacquered and painted. Japan, Tempyo Period, 710-794, H. 11 inches (27.9 cm.). Purchase, John L. Severance Fund. 49.158. *Bulletin* (February 1975).

106 *Noh Mask: Waka-onna.* Paulownia wood with polychromy. Japan, Muromachi Period, 1392-1573, H. 7-3/4 inches (19.8 cm.). Purchase, John L. Severance Fund. 72.69. *Bulletin* (February 1975).

107 Auguste Rodin, French, 1840-1971. *Mask of the Japanese Actress Hanako (Ohta Hisa).* Bronze, H. 6-7/8 inches (17.5 cm.). Gift of Carrie Moss Halle in memory of Salmon Portland Halle. 60.90

108 *Kifwebe Mask.* Painted wood (Ricinodendron heudelotii). Zaire, Southern Savannah Style Region: Upper Lualaba Area, before 1960, H. 28 inches (71.2 cm.). Purchase from the J. H. Wade Fund. 72.2

109 *White-Faced Mask.* Wood. Africa, Equatorial Forest Style Region: Ogowe River Basin, Gaboon, probably ca. 1935, H. 15 inches (38.2 cm.). Gift of Katherine C. White. 72.329

110 *Mask.* Wood. Africa, Guinea Coast Style Region: Ivory Coast, Baule Tribe, probably ca. 1940-1950, H. 16-1/4 inches (41.2 cm.). Gift of Katherine C. White. 74.203

111 Follower of Eilbertus, German, ca. 1175. *Arm Reliquary.* Silver gilt over oak core, champlevé enamel, H. 20 inches (51 cm.). Gift of the John Huntington Art and Polytechnic Trust. 30.739. *Bulletin* (November 1930).

112 Auguste Rodin, French, 1840-1917. *Hand of God.* Bronze, signed, W. 6-1/2 inches (16.5 cm.). Bequest of James Parmelee. 40.579. *Bulletin* (February 1941).

113 Jules Dalou, French, 1838-1902. *Torso.* Bronze, signed 1917, H. 19-1/2 inches (49.5 cm.). Gift of Miss Loie Fuller. 18.571. *Bulletin* (September 1971).

114 Master of the Statuettes of St. John, Italian, active ca. 1500. *Saint John.* Terra cotta with traces of color, H. 30-1/2 inches with base (77.5 cm.). Bequest of John L. Severance. 42.781. *Bulletin* (November 1942).

115 Albert-Ernest Carrier-Belleuse, French, 1824-1887. *Cupid and Psyche.* Bronze with marble base, H. 21 inches (53.3 cm.). Given in memory of Milton S. Fox by Mrs. Milton S. Fox and family. 74.82

116 George Segal, American, b. 1924. *The Red Light.* Plaster and mixed media, 1972, H. 114 inches (289.5 cm.). Purchase, Andrew R. and Martha Holden Jennings Fund. 74.22 A-D

117 *Snake.* Painted wood. Africa, Western Sudan Style Region: Guinea, Baga Tribe, Landuman Sub-tribe(?), before 1958, H. 58-1/4 inches (148 cm.). The Norweb Collection. 60.37. *Bulletin* (March 1961).

118 David Smith, American, 1906-1965. *Pilgrim.* Steel, 1957, H. 81-1/2 inches (207 cm.). Contemporary Collection of The Cleveland Museum of Art. 66.385. *Bulletin* (September 1967).

119 Richard Hunt, American, b. 1935. *Forms Carried Aloft, No. 2.* Brazed and welded steel, 1960, signed, H. 50-1/2 inches 128.2 cm.). Contemporary Collection of The Cleveland Museum of Art. 62.52. *Bulletin* (October 1963).